THE NON-DESIGNER'S DESIGN BOOK

FOURTH EDITION

design
and
typographic
principles
for the
visual
novice

Robin Williams

Peachpit Press
San Francisco
California

THE NON-DESIGNER'S DESIGN BOOK
FOURTH EDITION

ROBIN WILLIAMS

©2015 by Robin Williams

First edition published 1993.

Peachpit Press
www.peachpit.com
Peachpit is a division of Pearson Education.
To report errors, please send a note to errata@peachpit.com.

Editor:	Nikki McDonald
Interior design and production:	Robin Williams
Cover design and production:	John Tollett
Proofreader:	Jan Seymour
Prepress:	David Van Ness

The quote by Jan White on page 209 is from the out-of-print book *How to Spec Type*, by Alex White. Reprinted courtesy of Roundtable Press, Inc. Copyright 1987 by Roundtable Press, Inc.

The portions of "Ladle Rat Rotten Hut" and other stories, such as "Guilty Looks Enter Tree Beers," "Center Alley," and "Violate Huskings" are from a long out-of-print book by Howard L. Chace called *Anguish Languish*. It is our understanding that these delightful stories are now in the public domain. They are easily found on the Internet.

ISBN 13: 978-0-13-396615-2
ISBN 10: 0-13-396615-1

Printed and bound in the United States of America

To Carmen Sheldon,
my comrade in *Design*,
my friend in *Life*.
with great love,
R.

More matter is being printed and published today than ever before, and every publisher of an advertisement, pamphlet, or book expects his material to be read. Publishers and, even more so, readers want what is important to be clearly laid out. They will not read anything that is troublesome to read, but are pleased with what looks clear and well arranged, for it will make their task of understanding easier. For this reason, the important part must stand out and the unimportant must be subdued

The technique of modern typography must also adapt itself to the speed of our times. Today, we cannot spend as much time on a letter heading or other piece of jobbing as was possible even in the nineties.

Jan Tschichold 1935

typefaces
Modernica Light and **Black**

CONTENTS

Designing with Type

12 Type Contrasts 187

A Few Extras

13 Does it Make Sense? 219

14 Answers & Suggestions 223

15 Typefaces in this Book 229

Back matter 234

Is this book for you?

This book is written for all the people who need to design things, but have no background or formal training in design. I don't mean just those who are designing fancy packaging or lengthy brochures—I mean the assistants whose bosses now tell them to design the newsletters, church volunteers who are providing information to their congregations, small business owners who are creating their own advertising, students who understand that a better-looking paper often means a better grade, professionals who realize that an attractive presentation garners greater respect, teachers who have learned that students respond more positively to information that is well laid out, statisticians who see that numbers and stats can be arranged in a way that invites reading rather than snoring, and on and on.

This book assumes you don't have the time or interest to study design and typography, but would like to know how to make your pages look better. Well, the premise of this book is age-old: Knowledge is power. Most people can look at a poorly designed page and state that they don't like it, but they don't know what to do to fix it. In this book I will point out four basic concepts that are used in virtually every well-designed job. These concepts are clear and concrete. Once you recognize the concepts, you will notice whether or not they have been applied to your pages. If you don't know what's wrong with it, how can you fix it? Once you can name the problem, you can find the solution.

This book is not intended to take the place of four years of design school. I do not pretend you will automatically become a brilliant designer after you read this little book. But I do guarantee you will never again look at a page in the same way. I guarantee that if you follow these basic principles, your work will look more professional, organized, unified, and interesting. And you will feel empowered.

With a smile,

Robin

Introduction

This short chapter explains the four basic principles in general, each of which will be explained in detail in the following chapters. But first I want to tell you a little story that made me realize the importance of being able to name things, since *naming* these principles is the key to having power over them.

The Joshua tree epiphany

Many years ago I received a tree identification book for Christmas. I was at my parents' home, and after all the gifts had been opened I decided I would identify the trees in the neighborhood. Before going out, I read through some of the identification clues and noticed that the first tree in the book was the Joshua tree because it only took two clues to identify it. Now, the Joshua tree is a really weird-looking tree and I looked at that picture and said to myself, "Oh, we don't have that kind of tree in Northern California. That is a weird-looking tree. I would know if I saw that tree, and I've never seen one before."

So I took my book and went outside. My parents lived in a cul-de-sac of six homes. Four of those homes had Joshua trees in the front yards. I had lived

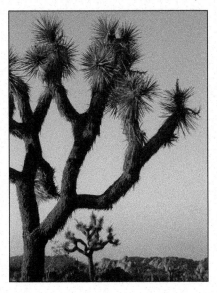

in that house for thirteen years, and I had never seen a Joshua tree. I took a walk around the block, and there must have been a sale at the nursery when everyone was landscaping their new homes—at least 80 percent of the homes had Joshua trees in the front yards. And I had never seen one before! Once I was conscious of the tree—once I could name it—I saw it everywhere. Which is exactly my point: Once you can name something, you're conscious of it. You have power over it. You're in control. You own it.

So now you're going to learn the names of several design principles. And you are going to be in control of your pages.

**Good Design Is As Easy
as 1-2-3**

1. Learn the principles.
They're simpler than you might think.
2. Recognize when you're not using them.
Put it into words -- name the problem.
3. Apply the principles.
You'll be amazed.

typefaces
Times New Roman
Regular and **Bold**

Good design
is as easy as…

Learn the basic principles.
They're simpler than you might think.

Recognize when you're not using them.
Put it into words—name the problem.

Apply the principles.
Be amazed.

typefaces
Brandon Grotesque Black,
Regular, and *Light Italic*

Train your Designer Eye: Find at least five differences that help to make the second example communicate more clearly. (Suggestions on page 225.)

The four basic principles

The following is a brief overview of the basic principles of design that appear in every well-designed piece of work. Although I discuss each one of these principles separately, keep in mind they are really interconnected. Rarely will you apply only one principle.

Contrast

The idea behind contrast is to avoid elements on the page that are merely *similar*. If the elements (type, color, size, line thickness, shape, space, etc.) are not the *same*, then make them **very different.** Contrast is often the most important visual attraction on a page—it's what makes a reader look at the page in the first place. It also clarifies the communication.

Repetition

Repeat visual elements of the design throughout the piece. You can repeat colors, shapes, textures, spatial relationships, line thicknesses, fonts, sizes, graphic concepts, etc. This develops the organization and strengthens the unity.

Alignment

Nothing should be placed on the page arbitrarily. Every element should have some visual connection with another element on the page. This creates a clean and sophisticated look.

Proximity

Items relating to each other should be grouped close together. When several items are in close proximity to each other, they become one visual unit rather than several separate units. This helps organize information, reduces clutter, and gives the reader a clear structure.

Umm . . .

When distilling these four principles from the vast maze of design theory, I thought there must be some appropriate and memorable acronym within these conceptual ideas that would help people remember them. Well, uh, there is a memorable—but rather inappropriate—acronym. Sorry.

Although you can now find this acronym in relation to design all over the web, this book is its origin.

Good
communication
is as

stimulating

as black coffee . . .

and just
as hard
to sleep after.

ANNE MORROW LINDBERGH

typeface
Transat Text Standard

Proximity

In the work of new designers, the words and phrases and graphics are often strung out all over the place, filling corners and taking up lots of room so there won't be any empty space. There seems to be a fear of empty space. When pieces of a design are scattered all over, the page appears unorganized and the information may not be instantly accessible to the reader.

The Principle of Proximity states: **Group related items together.** Move them physically close to each other so the related items are seen as one cohesive group rather than a bunch of unrelated bits.

Items or groups of information that are *not* related to each other should *not* be in close proximity (nearness) to the other elements, which gives the reader an instant visual clue to the organization and content of the page.

A very simple example, below, illustrates this concept. That's the Principle of Proximity—on a page (as in Life), **physical closeness implies a relationship.**

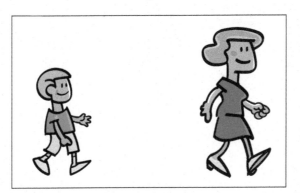

If we see these two walking down the street, their relationship is unclear. Are they related? Do they even know each other?

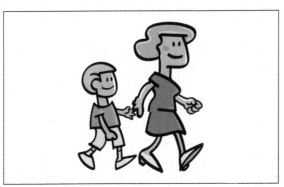

Now the proximity of these two people makes it clear there is some sort of relationship between them. This same thing happens on the page.

Take a look at this typical business card layout, below. How many separate elements do you see in that small space? That is, how many times does your eye stop to look at something?

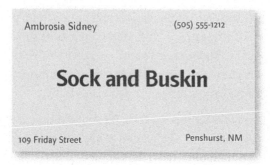

Does your eye stop five times? Of course—there are five separate items on this little card.

Where do you begin reading? In the middle, probably, because that phrase is boldest.

What do you read next—do your eyes move left to right?

What happens when you get to the bottom-right corner, where does your eye go?

Do you wander around making sure you didn't miss any corners?

And what if we confuse the issue even further:

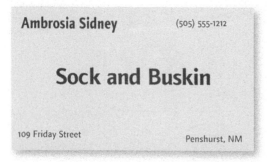

Now that there are two bold phrases, where do you begin? Do you start in the upper left? Do you start in the center?

After you read those two items, where do you go? Perhaps you bounce back and forth between the words in bold, nervously trying to also catch the words in the corners.

Do you know when you're finished?

Does your friend follow the same pattern you did?

When several items are in close proximity to each other, they become *one* visual unit rather than several *separate* units. As in Life, **the proximity, or the closeness, implies a relationship.**

By grouping similar elements into one unit, several things happen instantly: The page becomes more organized, you understand where to begin reading the message, and you know when you are finished. And the "white space" (the space around the text) automatically becomes more organized as well.

A problem with the previous card is that not one of the items on the card seems related to any other item. It is not clear where you should begin reading the card, and it is not clear when you are finished.

If we do one thing to this business card—**if we group related elements together, into closer proximity**—see what happens:

Sock and Buskin
Ambrosia Sidney

109 Friday Street
Penshurst, NM
(505) 555-1212

Now is there any question about where you begin to read the card? Where do your eyes go next? Do you know when you're finished?

With that one simple concept, this card is now organized both **intellectually** and **visually.** And thus it communicates more clearly.

typefaces
Finnegan Regular and **Bold**

The use of proximity can be a subtle yet important thing. Always question whether elements are close to the elements they belong with. Watch for elements that have inappropriate relationships.

AREAS OF EXPERTISE

- Strategic Planning and Execution
- Internet and New Media Development
- User Experience Improvements
- Software and Internet UX Design

- Market and Consumer Research
- New Product Development and Launch
- Process Design and Reengineering
- Organizational Turnarounds

Notice the bullets in these two columns and how far away they are from their associated points. The bullets in the middle are actually closer to some of the items in the left column. It almost looks like four individual columns, two of which are columns of bullets.

AREAS OF EXPERTISE

- Strategic Planning and Execution
- Internet and New Media Development
- User Experience Improvements
- Software and Internet UX Design

- Market and Consumer Research
- New Product Development and Launch
- Process Design and Reengineering
- Organizational Turnarounds

Now the relationships are clarified—we can instantly see to which point each bullet belongs. We can instantly see that there are two columns of bullet points, rather than a column of bullets, some info, a column of bullets, and more information.

Travel Tips

1 Take twice as much money as you think you'll need.

2 Take half as much clothing as you think you'll need.

3 Don't even bother taking all the addresses of the people who expect you to write.

Travel Tips

1 Take twice as much money as you think you'll need.

2 Take half as much clothing as you think you'll need.

3 Don't even bother taking all the addresses of the people who expect you to write.

The numbers appear to be a unit of their own, unrelated to the text.

When the numbers are closer to the information, we see the relationship of the numbers to the text.

When grouping items into close proximity, you typically need to make some changes, such as in the size or weight or placement of text or graphics. Body copy (the main bulk of reading text) does not have to be 12 point! Information that is subsidiary to the main message, such as the volume number and year of a newsletter, can often be quite small.

You already know what should be emphasized and you know how the information should be organized. You just need to use your software and your confidence to make it happen.

Sally's Psychic Services
Providing psychic support in Santa Fe
Contact lost loved ones, including pets. Get help
with important decisions. Find clarity in a
fog of unknowns.
Special rate for locals
sally@santafepsychic.com
santafepsychic.com
Phone consultations available 555-0978

This postcard is visually boring—nothing pulls your eyes in to the body copy to take a look, except perhaps the two hearts. But just as importantly, it takes a moment to find the critical information.

Sally's Psychic Services
Providing psychic support in Santa Fe

Contact lost loved ones, including pets.
Get help with important decisions.
Find clarity in a fog of unknowns.

Sally@SantaFePsychic.com
SantaFePsychic.com

Special rate for locals!
PHONE CONSULTATION 555.0978

Without doing much else (yes, it does need more; see pages 82 and 83), simply grouping related elements into units and providing appropriate space between the units makes the information more accessible.

Train your Designer Eye: Find at least eight small differences that help to make the second example appear a wee bit more professional. (Suggestions on page 225.)

The idea of proximity doesn't mean that *everything* is closer together; it means elements that are *intellectually connected,* those that have some sort of communication relationship, should also be *visually connected.* Other separate elements or groups of elements should *not* be in close proximity. The closeness *or* lack of closeness indicates the relationship.

typefaces
Facade Condensed
Formata Regular
and **Medium**

You do not have to read the copy to be able to **answer these questions:**
 On the left, how many readings are in the series?
 On the right, how many readings are in the series?

You *know* how many readings are listed in the right-hand flyer because the information for each is grouped into logical proximity (plus the event titles are now bold, using the Principle of Contrast). Notice the *spacing* between the three readings is the same, indicating that these three groups are somehow related. Even if the text is too small to read, you instantly know there are three events.

Even though the small block of text at the bottom of the flyer is too small to read at this size, you know what it is, right? It's the tickets and contact information. You *instantly* know this unit is not another event. You know that because the *proximity* between it and the other text blocks is different.

First we need to intellectually group the information together (in your head or sketched onto paper); *you know how to do that.* Then physically set the text in groups on the page.

Train your Designer Eye: Find at least five differences that help to make the second example appear cleaner and communicate better. (Suggestions on page 225.)

In the list below, on the left side, what do you assume about all those flowers? Probably that they have something in common, right? In the list below-right, what do you assume? It appears that the last three flowers are somehow different from the others. You understand this instantly. And you understand it without even being conscious of it. You know the last three flowers are somehow different *because they are physically separated from the rest of the list.*

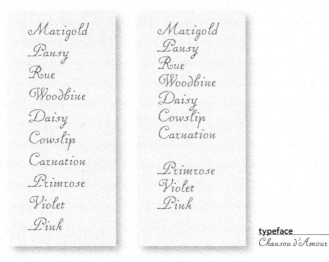

typeface
Chanson d'Amour

The spacing arrangement indicates relationships, so the immediate implication is that the last three flowers are different.

It's really amazing how much information we get from a quick glance at a page. Thus it becomes your responsibility to make sure the reader gets the **correct** information.

When you create a flyer, a brochure, a newsletter, or whatever, you already know which pieces of information are logically connected, you *know* which information should be emphasized and what can be de-emphasized. Express that information graphically by grouping it.

Correspondences
Flowers, herbs, trees
Ancient Greeks and Romans
Historical characters
Quotes on motifs
Women
Death
Morning
Snakes
Language
Iambic pentameter
Rhetorical devices
Poetic devices
First lines
Collections
Small printings
Kitschy
Dingbats

Correspondences
Flowers, herbs, trees
Ancient Greeks and Romans
Historical characters

Quotes on motifs
Women
Death
Morning
Snakes

Language
Iambic pentameter
Rhetorical devices
Poetic devices
First lines

Collections
Small printings
Kitschy volumes
Dingbats

typefaces
Arno Pro Regular
Bailey Sans Bold

In this list, everything is close to everything else, so it is difficult to see the relationships or the organization even with the headings in bold.

The same list has been visually separated into groups by adding a little space between each set. I'm sure you already do this automatically—I'm just suggesting that you now do it **consciously** and thus with more strength.

It is critical that you learn to use the *paragraph space before and after* settings in your software, which is how you can apply exactly the amount of space between elements in a text block.

Above, I tightened the leading, or linespacing, between the listed items, bringing them into closer proximity to each other. This gave me enough room to set more space above each bold heading.

Shown below is a newsletter banner. How many separate elements are in this piece? Does any item of information seem related to any other, judging from the placement of the items?

Take a moment to decide which items should be grouped into closer proximity and which should be separated.

The two items in the top-right corner are in close proximity to each other, implying a relationship. But *should* those two have a relationship?

Below, more appropriate relationships have been established.

Notice I did several other things along the way. I changed the corners from rounded to just barely dull, giving the piece a cleaner, stronger look; enlarged the name to fill the space better; made some of the text a pale shade of the dark teal so it would compete less with the rest of the elements.

Train your Designer Eye: Find at least three other small differences that help to make the second example communicate more clearly. (Suggestions on page 226.)

typefaces
Peoni Pro
Quicksand
Clarendon Roman

You're probably already using the Principle of Proximity in your work, but you may not be pushing it as far as you could to make it truly effective. Really look at the elements and see which items *should* be grouped together.

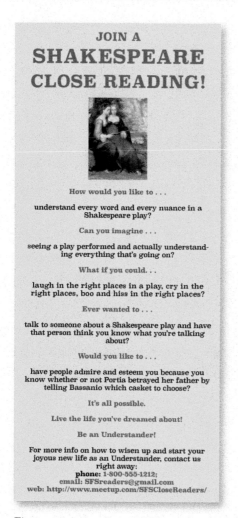

The person who designed this rack card hit two Returns after each headline **and** paragraph. Thus the headlines are each the same distance from the body copy above and below, making the heads and body copy pieces appear as separate, unconnected items. You can't tell if the headline belongs to the text above it or below it because the distances are the same.

There is lots of white space available here, but it's all broken up. And there is white space where it doesn't belong, like between the headlines and their related texts. When white space is "trapped" like this, it tends to visually push the elements apart.

Group the items that have relationships. If there are areas on the page where the organization is not perfectly clear, see if items are in proximity that *shouldn't* be.

JOIN A
Shakespeare
CLOSE READING!

How would you like to . . .
understand every word and every nuance
in a Shakespeare play?

Can you imagine . . .
seeing a play performed and actually
understanding everything that's going on?

What if you could. . .
laugh in the right places in a play,
cry in the right places,
boo and hiss in the right places?

Ever wanted to . . .
talk to someone about a Shakespeare play
and have that person think you know
what you're talking about?

Would you like to . . .
have people admire and esteem you because you
know whether or not Portia betrayed her father
by telling Bassanio which casket to choose?

It's all possible.
Live the life you've dreamed about!
Be an Understander!

For more info on how to wisen up
and start your joyous new life as
an Understander, join us right away:
1.800.555.1212
SFSreaders@gmail.com
meetup.com/SFSCloseReaders

Train your Designer Eye:
Find at least five other small differences that help to make this example communicate more clearly. (Suggestions on page 226.)

typefaces
SuperClarendon Bold
and Roman

If we move the headlines closer to their related paragraphs of text, several things happen:

The organization is clearer.

The white space is not trapped between elements.

There is more room on the page, which allows us
to enlarge the graphic.

Obviously, I changed the centered alignment to flush left (the Principle of Alignment, as explained in the next chapter). That's just the click of a button, but you do need to know your software to be able to add the space you want between paragraphs instead of hitting Returns! Look for the *paragraph space after* and *before* options.

Proximity is really just a matter of being a little more conscious, of doing what you do naturally but pushing the concept a little harder. Once you become aware of the importance of the relationships between lines of type, you will start noticing its effect. Once you start noticing the effect, you have power over it, you are in control, you own it.

GERTRUDE'S PIANO BAR

STARTERS:
GERTRUDE'S FAMOUS ONION LOAF - 8
SUMMER GARDEN TOMATO SALAD - 8
SLICED VINE-RIPENED YELLOW AND RED
TOMATOES WITH FRESH MOZZARELLA AND BASIL
BALSAMIC VINAIGRETTE
HAMLET'S CHOPPED SALAD - 7
CUBED CUCUMBERS, AVOCADO, TOMATOES,
JARLSBERG CHEESE, AND ROMAINE LEAVES
TOSSED IN A LIGHT LEMON VINAIGRETTE
CARIBBEAN CEVICHE - 9
LIME-MARINATED BABY SCALLOPS WITH RED
PEPPER, ONIONS, CILANTRO, JALAPENOS, AND
ORANGE JUICE
SHRIMP COCKTAIL - 14
FIVE LARGE SHRIMP WITH HOUSE-MADE COCKTAIL
SAUCE
ENTREES:
NEW YORK STEAK, 16 OZ - 27
ROTISSERIE CHICKEN - 17
NEW ORLEANS LUMP CRAB CAKES
WITH WARM VEGETABLE COLESLAW, MASHED
POTATOES, SPINACH AND ROMESCO SAUCE - 18
GRILLED PORTOBELLO MUSHROOM
STUFFED WITH RICOTTA CHEESE, GARLIC, ONIONS
AND SPINACH, SERVED OVER MASHED POTATOES
- 18
NEW ZEALAND RACK OF LAMB - 26
BARBEQUED BABY BACK RIBS - 24
AUSTRALIAN LOBSTER TAIL, 10 OZ - MARKET PRICE
SURF & TURF
AUSTRALIAN LOBSTER & 8OZ FILET - MARKET
PRICE

typeface
Times New Roman Regular

Lest you think no menu could be this bad, know that a waiter let me take this right out of a restaurant. The biggest problem, of course, is that all the information is one big chunk. Imagine trying to figure out what is offered to eat.

Before redesigning this information, sketch out the separate pieces that belong together; group the elements.

Once you have the groups of information, you can play with them. You have a computer—try lots of options. Using style sheets is the most effective way to play with options. If you don't know how to use the style sheets in your application, learn immediately! They're amazing!

Below, I put *more* space between the separate menu items. Of course, one should never use all caps when there is a lot of text because it is so hard to read (see page 161), so I changed it to caps and lowercase. And I made the type a couple of point sizes smaller, both of which gave me a lot more room to work with so I could put more space between the elements.

Gertrude's Piano Bar

Starters

Gertrude's Famous Onion Loaf - 8

Summer Garden Tomato Salad - 8
sliced vine-ripened yellow and red tomatoes
with fresh mozzarella and basil Balsamic vinaigrette

Hamlet's Chopped Salad - 7
cubed cucumbers, avocado, tomatoes, Jarlsberg cheese,
and romaine leaves tossed in a light lemon vinaigrette

Caribbean Ceviche - 9
lime-marinated baby scallops with red pepper, onions,
cilantro, jalapenos, and orange juice

Shrimp Cocktail - 14
five large shrimp with house-made cocktail sauce

Entrees

New York steak, 16 ounce - 27

Rotisserie Chicken - 17

New Orleans Lump Crab Cakes - 18
with warm vegetable coleslaw, mashed potatoes, spinach,
and Romesco sauce

Grilled Portobello Mushroom - 18
stuffed with Ricotta cheese, garlic, onions and spinach,
served over mashed potatoes

New Zealand Rack of Lamb - 26

Barbequed Baby Back Ribs - 24

Australian Lobster Tail, 10 ounce - Market Price

Surf & Turf
Australian Lobster & 8 ounce Filet - Market Price

typefaces
Ciao Bella Regular
Times New Roman Bold
and Regular

The biggest problem with the original menu is that there is no separation of information. In your software, learn how to format so you can make exactly the amount of space you need before and after each element; build that information into your style sheets.

The original text in all caps took up all the space so there was very little extra, blank, white space to rest your eyes. The more text you have, the less you can get away with using all caps.

Train your Designer Eye: Name at least four other differences that help to clean up this menu. (Suggestions on page 226.) Also see the following two pages.

In the example on the previous page, there is still a bit of a problem separating "Starters" from "Entrees." Let's indent each section—the extra space defines these two groups even further, yet clearly communicates that they are still similar groups. It's all about space. The Principle of Proximity helps you focus on space and what it can do for communication.

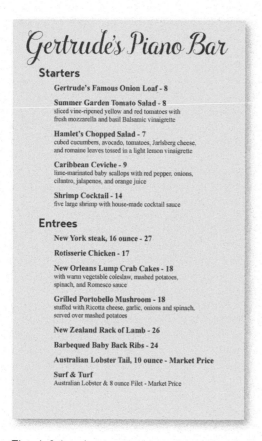

That left-hand space under each heading helps to separate and clarify these two groups of information.

Notice that I also made the descriptive text blocks a point size smaller than the names of the dishes, which is typical in a menu. Besides helping to communicate more clearly, this also gives us a little more room to work with.

Rarely is the Principle of Proximity the only answer to a design project. The other three principles are intrinsic to the process and you will usually find yourself using all four. But take them one at a time—start with proximity. In the example below, you can imagine how all of the other principles would mean nothing if the appropriate spacing was not developed.

Gertrude's Piano Bar

Starters

Gertrude's Famous Onion Loaf	8
Summer Garden Tomato Salad	8
sliced vine-ripened yellow and red tomatoes, fresh mozzarella, and basil Balsamic vinaigrette	
Hamlet's Chopped Salad	7
cubed cucumbers, scallions, avocado, tomatoes, jarlsberg cheese, and romaine leaves tossed in a light lemon vinaigrette	
Caribbean Ceviche	9
lime-marinated baby scallops with red pepper, onions, cilantro, jalapenos, and orange juice	
Shrimp Cocktail	14
five large shrimp with house-made cocktail sauce	

Entrees

New York Steak, 16 ounce	27
Rotisserie Chicken	17
New Orleans Lump Crab Cakes	18
with warm vegetable coleslaw, spinach, mashed potatoes, and Romesco sauce	
Grilled Portobello Mushroom	18
stuffed with ricotta cheese, garlic, onions and spinach, served over mashed potatoes	
New Zealand Rack of Lamb	26
Barbequed Baby Back Ribs	24
Australian Lobster Tail, 10 oz.	Market Price
Surf & Turf	Market Price
Australian Rock Lobster and 8-ounce Filet	

typefaces
Ciao Bella Regular
Transat Text Bold and Light

I chose a more interesting typeface than Times New Roman—that's easy to do. I experimented with indenting the descriptions of the menu items to help clarify each item a little further, but decided to use a second color instead.

The prices of the items were originally tucked into the text (with dorky hyphens); if we align them all out on the right they are easily visible and consistently arranged. That's the Principle of Alignment, which is coming right up in a couple of pages.

Can you see that this menu not only appears more professional, but it is easier to order from?

Put it into words

The examples in these chapters are necessarily very simple so as to make the point very clear. But with your new consciousness of the importance of the Principle of Proximity, take a new look at the designed pieces all around you.

To do: Find examples of projects that lack the use of proximity to clarify the information. **Put into words what you think the problem is.** Perhaps sketch on a piece of paper how you might organize the information more effectively.

A table of contents in a book or magazine is a great place to look for a lack or use of proximity. Too often the page numbers are far from the chapter or article title.

Every designed piece uses all four principles; that is, it is rare that a lack of proximity will be the only problem in a piece that you find amateurish or disorganized. But at least you can already pinpoint this particular issue.

This is an actual ad from an event program. It has many problems, of course, including the copy, but you can probably immediately notice that it does not take advantage of the Principle of Proximity.

Train your Designer Eye: Name at least five ways in which you could improve this piece using only the Principle of Proximity. (Suggestions on page 226.)

You might want to continue working with this poor ad as you experiment with the other principles.

ister in 1619 after the unauthorized printing of the play in that year by William Jaggard, Hayes printed another quarto of *The Merchant* in 1637.

Hayes or Heyes, Thomas (d. 1603). London bookseller. Hayes, whose shop was located at St. Paul's Churchyard, was the publisher of the First Quarto (1600) of *The Merchant of Venice*. After Hayes' death, the copyright of the play passed to his son Lawrence (fl. 1600–1637), who confirmed the copyright in 1619 after William Jaggard had printed the play without obtaining copyright. In 1637 Lawrence Hayes printed another edition of the play.

Hayman, Francis (1708–1786). Artist, theatrical scene painter, and illustrator. The range of Hayman's artistic activities makes him an important figure in relation to Shakespeare.

A pupil of the portraitist Robert Brown (d. 1753), Hayman was a very young man when he came to London and found employment as a scene painter at Drury Lane. His reputation grew, and he contributed four large figure compositions to the decoration of Vauxhall Gardens, three of which have been lost. The fourth, a study of the play scene from *Hamlet*, is particularly interesting because it departs from the common practice of making Hamlet the central figure in any illustration of the play. Hamlet is not even shown; attention is focused instead on the King, who watches the players in apparent alarm. The dramatic and economic disposition of the figures is characteristic of Hayman's artistic virtues. Considered the finest history painter of his day, he excelled in compositions involving a number of figures. Although his color was weak and his figure drawing somewhat mannered, he was a good draftsman and could treat complicated subject matter with clarity and verve.

Hayman was a founding member of the Royal Academy and contributed paintings of scriptural subjects to its exhibitions. A *bon vivant* and a member of Hogarth's circle, he was also one of the most important book illustrators of his time, and his collaboration with Hubert Gravelot in the Hanmer edition of 1744 produced the finest of the early illustrated editions of Shakespeare. See ART; BOYDELL'S SHAKESPEARE GALLERY. [W. M. Merchant, *Shakespeare and the Artist*, 1959.]

Haymarket Theatre. Playhouse. Built in 1720 by John Potter, a carpenter, the Haymarket is the second oldest playhouse still in use in London. In 1747 it was taken over by Samuel Foote (1720–1777), a playwright and actor with a great gift for mimicry. Foote was succeeded by George Colman and his son. Early in the 19th century, Ira Aldrich appeared at the Haymarket as Aaron and Othello.

In 1820, the old theatre was demolished and the Modern Haymarket was constructed. Samuel Phelps made his successful debut as Shylock there in 1837. Among other successes at the theatre in the 1850's and 1860's was the London debut of Edwin Booth. In 1887 the Haymarket's lessee was Herbert Beerbohm Tree, who, during the next 10 years, presented a series of lavish Shakespearean productions. [W. J. Macqueen-Pope, *Haymarket: Theatre of Perfection*, 1948.]

Hayward, Sir John (c. 1564–1627). Elizabethan historian. Hayward's account of the deposing of Richard II and the subsequent rule of Henry IV (*The First Part of the Life and Raigne of King Henrie the IIII*) was widely regarded as a veiled allegory supporting the earl of Essex in his rivalry with the queen. As a result of the publication, Hayward was brought to trial in 1600 and imprisoned for at least two years. After the death of Elizabeth, he was released and devoted the remainder of his life to historical research.

Attempts have been made to connect Hayward's work with Shakespeare's *Richard II*. The history was published in 1599, two years after the printing of the First Quarto of *Richard II*. In its original form the book contained a dedication to the earl of Essex. The dedication was removed from later copies of the book, either at the request of Essex or of the government authorities, but this did not prevent the subsequent suppression of the book and imprisonment of Hayward. He was convicted of writing a pointed political allegory in which Bolingbroke is equivalent to Essex and Richard II to Elizabeth. That Elizabeth was already sensitive to this comparison is known from another source (see William LAMBARDE). From the standpoint of Shakespeare, the interesting aspect of the book is that it has a number of verbal parallels with *Richard II*. On this basis some commentators have attempted to see the Shakespeare play as another, earlier example of political allegory, written to support the Essex faction. The conjecture is, of course, supported by the special performance of *Richard II* given at the request of the Essex followers on the eve of the rebellion. Nevertheless, the evidence of dates seems to indicate that Shakespeare's play was merely the source of Hayward's work and did not necessarily share in any allegorical scheme which that work might have had. [*Richard II*, Arden Edition, Peter Ure, ed., 1956.]

Hazlitt, William (1778–1830). Essayist and critic. Born at Maidstone, Kent, and educated at Hackney College, a Unitarian seminary, Hazlitt remained loyal to liberal political and philosophical principles throughout his life. In 1802 he went to Paris to study painting, but soon turned to free-lance writing. His essays cover a variety of subjects, from art and literary criticism to economics, politics, and philosophy. His most important critical works are *The Characters of Shakespear's Plays* (1817), *The English Poets* (1818), and *The Dramatic Literature of the Age of Elizabeth* (1820). *A View of the English Stage* (1818) is a collection of his reviews. Although his continuing interest in politics and art is reflected in his *Life of Napoleon Bonaparte* (4 vols., 1828–1830) and his *Life of Titian* (1830), Hazlitt is best known for the familiar essays which he published in the *Examiner* and the *London Enquirer*. These were collected in *The Round Table* (1817), *Table Talk* (2 vols., 1821–1822), *The Plain Speaker* (1826), *Sketches and Essays* (1839), and *Winterslow* (1850).

In his Shakespearean criticism Hazlitt manages to convey his experience of the plays, often in a manner suggestive of the close attention modern critics give to the text. He points to the personality and particularity of Shakespeare's characters, who "speak like men, not like authors." Hazlitt's appreciation of Shakespeare's metaphors and his language challenges the neoclassical view, propounded by Dryden, that Elizabethan taste and Shakespeare's style were un-

This is an actual page from an informational dictionary.

How many entries are on this page?

How easy is it to find the entry for William Hazlitt?

You can imagine how much easier it would be *to find the information you need* if this page used the Principle of Proximity to create relationships between the related paragraphs instead of creating one giant block of text.

Yes, adding a wee bit of space between each entry would add a few more pages to the book, but that is a small price to pay for better communication, especially in a book like this that has over a thousand pages—a few more would be well worth it.

Summary of proximity

When several items are in close **proximity** to each other, they become one visual unit rather than several separate units. Items relating to each other should be grouped together. Be conscious of where your eye is going: Where do you start looking; what path do you follow; where do you end up; after you've read it, where does your eye go next? You should be able to follow a logical progression through the piece, from a definite beginning to a definite end.

The basic purpose

The basic purpose of proximity is to **organize.** Other principles come into play as well, but simply grouping related elements together into closer proximity automatically creates organization. If the information is organized, it is more likely to be read and more likely to be remembered. As a by-product of organizing the communication, you also create more appealing (more organized) *white space* (designers' favorite thing).

How to get it

Squint your eyes slightly and **count** the number of visual elements on the page by counting the number of times your eye stops. If there are more than three to five items on the page (of course it depends on the piece), see which of the separate elements can be grouped together into closer proximity to become one visual unit.

What to avoid

Avoid too many separate elements on a page.

Avoid leaving equal amounts of white space between elements unless each group is part of a related subset.

Avoid even a split second of confusion over whether a headline, subhead, caption, graphic, or the like belongs with its related material. Create a relationship among elements with close proximity.

Don't create relationships with elements that don't belong together! If they are not *related,* move them apart from each other.

Don't stick things in the corners or in the middle just because the space is empty.

Alignment

New designers tend to put text and graphics on the page wherever there happens to be space, often without regard to any other items on the page. What this creates is the slightly-messy-kitchen effect—you know, with a cup here, a plate there, a napkin on the counter, a pot in the sink, a spill on the floor. It doesn't take much to clean up the slightly messy kitchen, just as it doesn't take much to clean up a slighty messy design that has weak alignments.

The Principle of Alignment states: **Nothing should be placed on the page arbitrarily. Every item should have a visual connection with something else on the page.** The principle of alignment forces you to be conscious—no longer can you just throw things on the page and see where they stick.

When items are aligned on the page, the result is a stronger cohesive unit. Even when aligned elements are physically separated from each other, there is an invisible line that connects them, both in your eye and in your mind. Although you might have separated elements to indicate their relationships (using the Principle of Proximity), the Principle of Alignment tells the reader that even though these items are not close, they belong to the same piece.

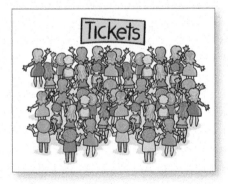

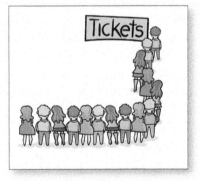

We occasionally experience a lack of alignment in Life, as in the scene at this ticket counter. It creates discomfort; it appears to be unorganized; we don't know how to be effective.

Alignment creates a calm center; it communicates more clearly; we know what to do.

Take a look at this business card, the same one you saw in the last chapter. Part of its problem is that nothing is aligned with anything else. In this little space, there are elements with three different alignments: flush left, flush right, and centered. The two groups of text in the upper corners are not lined up along the same baseline, nor are they aligned at the left or right edges with the two groups at the bottom of the card, which don't line up on the same baseline, either.

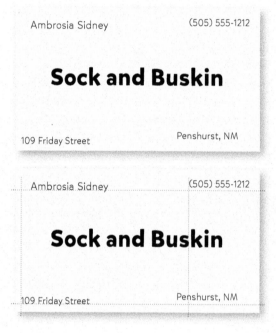

The elements on this card look like they were just thrown on and stuck. Not one of the elements has any connection with any other element on the card.

Get in the habit of drawing lines between elements to determine where the connections are lacking.

Take a moment to decide which of the items above should be grouped into closer proximity, and which should be separated.

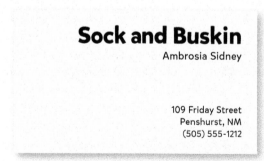

By moving all the elements over to the right and giving them one alignment, the information is instantly more organized. (Of course, grouping the related elements into closer proximity is also critical.)

The text items now have a common boundary; this boundary connects the elements.

In the example (repeated below) that you saw in the Proximity chapter, the text is also aligned—it's aligned down the center. A centered alignment often appears a bit weak. If text is aligned, instead, on the left or the right, the invisible line that connects the text is much stronger because it has a hard vertical edge to follow. This gives left- and right-aligned text a cleaner and more dramatic look. Compare the two examples below, then we'll talk about it on the following pages.

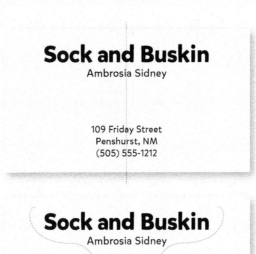

This example has a nice arrangement with the text items grouped into logical proximity. The text is center-aligned over itself, and centered on the page.

Although centered is a legitimate alignment, the edges are "soft"; you don't really see the strength of the line.

This has the same logical arrangement as above, but it is now right-aligned. Can you see the "hard" edge on the right?

There is a strong invisible line connecting the edges of these two groups of text. You can actually see the edge. **The strength of this edge is what gives strength to the layout.**

Do you tend to automatically center everything? A centered alignment is the most common alignment that beginners use—it's very safe, it feels comfortable. A centered alignment creates a more formal look, a more sedate look, a more ordinary and oftentimes downright dull look. Take notice of the design layouts you like. I guarantee most designs that have a sophisticated look are not centered. I know it's difficult, as a beginner, to break away from a centered alignment; you'll have to force yourself to do it at first. But combine a strong flush right or left alignment with good use of proximity and you will be amazed at the change in your work.

A Return to the
Great Variety of Readers
The History and Future
of Reading Shakespeare

by
Patricia May Williams

February 26

A Return to the
Great Variety of Readers
The History and Future
of Reading Shakespeare

Patricia May Williams
February 26

This is a typical report cover, yes? This standard format presents a dull, almost amateurish look, which may influence someone's initial reaction to the report.

The strong flush-left alignment gives the report cover a more sophisticated impression. The author's name is far from the title, but that invisible line connects the two text blocks.

typefaces
Clarendon Roman and Light

I was very pleased to see that my MA graduation certificate is flush left instead of centered!

Stationery has so many design options! But too often it ends up with a flat, centered alignment. You can be very free with placement on a piece of stationery—but remember alignment.

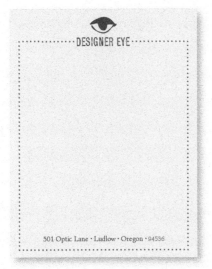

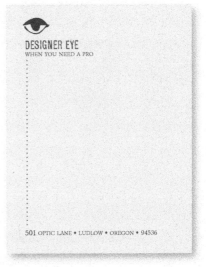

This isn't bad, but the centered layout is a little dull, and the border closes the space, making it feel confined.

A flush-left alignment makes the page a little more sophisticated. Limiting the dotted line to the left side opens the page and emphasizes the alignment.

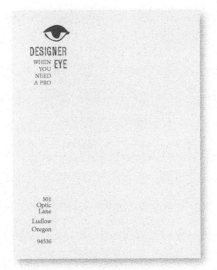

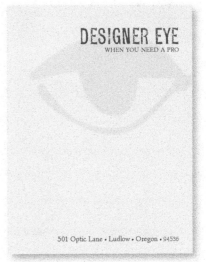

The text is flush right, but placed on the left side. The letter you type will have a strong flush left to align with the flush right of this layout.

Be brave! Be bold!

typefaces
PROFUMO
Minister Light

I'm not suggesting that you *never* center anything! Many beautiful design projects are centered. Just be conscious of the effect a centered alignment has—is that really the look you want to portray? Sometimes it is. For instance, many weddings are rather sedate, formal affairs, so if you want to center your wedding announcement, do so consciously and joyfully.

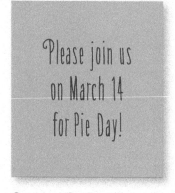

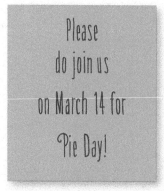

typeface
Amorie Modella Medium

Centered. Really rather stable and maybe dull, even with the cute font.

If you're going to center text, then at least make it obvious that it is centered!

Experiment with uncentering the block of centered type.

If you're going to center the text, experiment with making it more dramatic in some other way.

Train your Designer Eye: On the opposite page, find at least three small design differences in each of numbers 2, 3, and 4 (different from number 1) that help to make these three examples communicate more clearly and present a more interesting visual appearance than the first one. If it is more visually interesting, it is more likely to be read and remembered. (Suggestions on page 226.)

Sometimes you can add a bit of a twist on the centered arrangement, such as centering the type but setting the block of type itself off center. Or set the type high on the page to create more tension. Or set a very casual, fun typeface in a very formal, centered arrangement. What you don't want to do is set Times 12-point with double Returns!

O ye gods!

Render me worthy
of this noble wife.

Brutus in
Julius Caesar

1. This is the kind of layout that gives "centered" a bad name: Boring typeface, type that is too large, crowded text, double Returns, claustrophobic border.

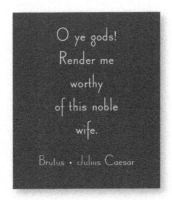

O ye gods!
Render me
worthy
of this noble
wife.
Brutus • Julius Caesar

2. A centered alignment needs extra care to make it work. This layout uses a classic typeface sized fairly small (relatively), more space between the lines, lots of white space around the text, no border.

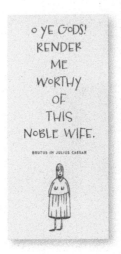

3. Emphasize a tall, slender centered layout with a tall, slender piece of paper, perhaps half of a letter-sized page.

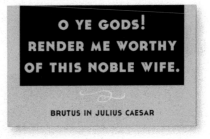

4. Emphasize a wide, centered layout with a wide spread. Try your next flyer sideways.

typefaces
Times New Roman
Canterbury Old Style
SEASONED HOSTESS
CASSANNET BOLD AND REGULAR

I want to emphasize that even though I suggest you take
the centered alignment off your list for a while,
there are a great many brilliant projects that use a centered alignment.
But it must be a *conscious* choice, not the default choice
simply because you haven't taken the time
to experiment with anything else.

fonts
OSTRICH MEDIUM
AND CONDENSED LIGHT

Badges, such as these, are very popular right now,
and they are often centered.

(Check CreativeMarket.com for hundreds of badge templates
with which to experiment.)

A centered alignment works best when it is clearly intentional.
And when the alignment is intentional and strong,
you can be creative with other elements and
it still looks like a purposeful design
instead of random elements
randomly placed on the page.

You can see a very strong line going right down the middle of this page.
That allows us to play with the other elements
but still maintain an organized,
cohesive presentation.

You're accustomed to working with text alignments. Until you have more training, stick to this guideline: **Choose one.** That is, choose one text alignment on the page—all text is either flush left, flush right, or centered.

This text is *flush left.*
Some people call it
quad left, or you can say
it is left aligned.

This text is *flush right.*
Some people call it
quad right, or you can
say it is right aligned.

This text is *centered.*
If you are going to
center text,
make it
obvious.

In this paragraph it is
difficult to tell if this text
was centered purposely
or perhaps accidentally.
The line lengths are not
the same, but they are not
really different. If you cannot
instantly tell that the type
is centered, why bother?

This text is *justified.* Some people call it quad left and right, and some call it blocked—the text lines up on both sides. Whatever you call it, don't do it unless your line length is long enough to avoid awkward g a p s　b e t w e e n　t h e　w o r d s because the gaps are really annoying, don't you think?

Occasionally you can get away with using both flush right and flush left text on the same page, but make sure you align them in some way!

Jerry Caveglia

A saga
of adventure
and romance
and one moccasin

In this example, the title and byline are flush left, but the description is centered. There is no common alignment between the two elements of text—they don't have any connection to each other.

Jerry Caveglia

A saga
of adventure
and romance
and one moccasin

Although these two elements still have two different alignments (the top is flush left and the bottom is flush right), the edge of the descriptive text below aligns with the right edge of the thin rule and text above, connecting the elements with an invisible line.

Train your eyes to notice the invisible lines.

typefaces
Roswell Two ITC Standard
Warnock Pro Light Caption
 and Light Italic Caption

When you place other items on the page, make sure each one has some visual alignment with another item on the page. If lines of text are across from each other horizontally, align their baselines. If there are several separate blocks of text, align their left or right edges. If there are graphic elements, align their edges with other edges on the page.

Nothing should be placed on the page arbitrarily!

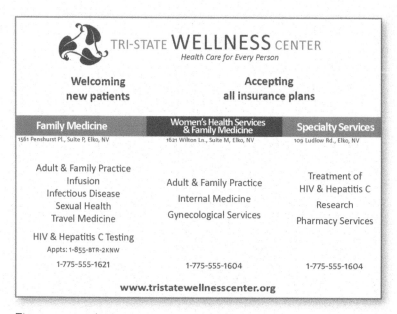

This is a typical advertisement in which the designer has been given the task of putting a lot of information into a small space. It can be improved immensely with one thing: alignment.

To do: Take a pencil and draw the vertical and horizontal alignments in this piece. You'll find that all units are centered *but they are not aligned with any other centered units.* Let's do one thing: Create vertical and horizontal alignments.

Also circle all the areas of white space. The white space is pretty messy.

typefaces
Calibri Regular, *Italic,* and **Bold**

Lack of alignment is probably the biggest cause of unappealing documents. Our eyes *like* to see order; it creates a calm, secure feeling in its clarity. Plus it helps to communicate the information.

In any well-designed piece, you will be able to draw lines to the aligned objects, even if the overall presentation of material is a wild collection of odd things and has lots of energy.

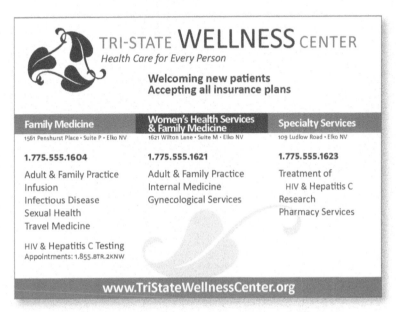

Simply lining up the elements makes a big difference here. Notice not one item is on the page arbitrarily—every item has some visual connection with another item on the page. This process opened up the space at the top of the ad so the name and logo could be larger.

I placed the phone numbers at the tops of each column of information. In the previous ad, where these numbers are aligned across the bottom, they trap white space inside the border.

Obviously, I added the blue bar at the bottom, which is a technique from the Principle of Repetition discussed in Chapter 4.

To do: Take a pencil and draw the alignments in this ad. Also draw shapes around the white space on both the ad on the opposite page and in this one. Can you see how the white space is now more organized?

Train your Designer Eye: Find at least a dozen differences, most of them tiny, that make this ad appear more professional and communicate more clearly. (Suggestions on page 226.)

A problem with the publications of many new designers is a subtle lack of alignment, such as centered headlines and subheads over indented paragraphs. With a quick glance, which of the examples on these two pages presents a cleaner and sharper image?

THE UNDISCOVER'D COUNTRY

FROM WHOSE BOURN

Be absolute for death; either Death or Life shall thereby be the sweeter. Reason thus with Life: If I do lose thee, I do lose a thing that none but fools would keep: a breath thou art, servile to all the skyey influences that dost this habitation where thou keep'st, hourly afflict. Merely, thou art Death's Fool; for him thou labor'st by thy flight to shun and yet runn'st toward him still.

NO TRAVELER

Thou art not noble; for all the accommodations that thou bear'st are nursed by baseness. Thou'rt by no means valiant; for thou dost fear the soft and tender fork of a poor worm. Thy best of rest is sleep, and that thou oft provokest, yet grossly fear'st thy death, which is no more.

Thou art not thyself, for thou exist'st on many a thousand grains that issue out of dust. Happy thou art not; for what thou hast not, still thou strivest to get,

and what thou hast, forget'st. Thou art not certain; for thy complexion shifts to strange effects, after the moon. If thou art rich, thou'rt poor; for, like an ass whose back with ingots bows, thou bear's thy heavy riches but a journey, and Death unloads thee.

RETURNS

Friend hast thou none, for thine own bowels—which do call thee 'sire,' the mere effusion of

thy proper loins—do curse the gout, serpigo, and the rheum for ending thee no sooner. Thou hast nor youth nor age, but, as it were, an after-dinner's sleep, dreaming on both; for all thy blessed youth becomes as aged, and doth beg the alms of palsied eld. And when thou art old and rich, thou

typefaces
BRANDON PRINTED SHADOW
BRANDON PRINTED
Archer Book

This is a very common sight: headlines are centered; text is flush left and thus the right is "ragged"; paragraph indents are typewriter wide (that is, five spaces or half an inch, as you may have learned in school); the illustration is centered in a column.

Never center headlines over flush left body copy or text that has an indent because if the text does not have clear left and right edges, you cannot tell that the headline is actually centered. It looks random.

All these unaligned spots create a messy page: wide indents, ragged right edge of text, centered heads with open space on both sides, centered illustration.

To do: Draw lines on this example to see where elements are aligned and where they are not.

All those minor misalignments add up to create a visually messy page. Find a strong line and stick to it. Even though it may be subtle and your boss couldn't say what made the difference between this example and the one before it, the more sophisticated look comes through clearly.

THE UNDISCOVER'D COUNTRY

FROM WHOSE BOURN
Be absolute for death; either Death or Life shall thereby be the sweeter. Reason thus with Life: If I do lose thee, I do lose a thing that none but fools would keep: a breath thou art, servile to all the skyey influences that dost this habitation where thou keep'st, hourly afflict. Merely, thou art Death's Fool; for him thou labor'st by thy flight to shun and yet runn'st toward him still.

NO TRAVELER
Thou art not noble; for all the accommodations that thou bear'st are nursed by baseness. Thou'rt by no means valiant; for thou dost fear the soft and tender fork of a poor worm. Thy best of rest is sleep, and that thou oft provokest, yet grossly fear'st thy death, which is no more.

Thou art not thyself, for thou exist'st on many a thousand grains that issue out of dust. Happy thou art not; for what thou hast not, still thou strivest to get, and what thou hast, forget'st. Thou art not certain; for thy complexion shifts to strange effects, after the moon. If thou art rich, thou'rt poor; for, like an ass whose back with ingots bows, thou bear's thy heavy riches but a journey, and Death unloads thee.

RETURNS
Friend hast thou none, for thine own bowels—which do call thee 'sire,' the mere effusion of thy proper loins—do curse the gout, serpigo, and the rheum

for ending thee no sooner. Thou hast nor youth nor age, but, as it were, an after-dinner's sleep, dreaming on both; for all thy blessed youth becomes as aged, and doth beg the alms of palsied eld. And when thou

text
Headlines from *Hamlet*
Body copy from
 Measure for Measure

Find a strong alignment and stick to it. If the text is flush left, set the heads and subheads flush left.

First paragraphs are traditionally not indented. The purpose of indenting a paragraph is to tell you there is a new paragraph, but you already know the first paragraph is a new paragraph.

The professional typographic indent is one **em** (an em is as wide as the point size of your type), which is about two spaces, not five.

These columns are wide enough for the type to be set justified (aligned on both sides) without big gaps between the words.

If there are photographs or illustrations, align them with an edge and/or a baseline.

Train your Designer Eye: Find at least three other small differences that help to give this example a more professional appearance. (Suggestions on page 227.)

Even a piece that has a good start on a nice design might benefit from subtle adjustments in alignment. Strong alignment is often the missing key to a more professional look. Check every element to make sure it has a visual connection to something else on the page.

Read Shakespeare out loud and in community! Volume 1 - September 27

WHY READ SHAKESPEARE ALOUD?

Experience the entire play instead of the shortened stage version. Read plays you'll rarely (sometimes never) see on stage. Understand more words. Discover more layers. Take it personally. See more ambiguities and make up your own mind about them. Spend time to process the riches. Memorize your favorite lines. Savor the language and imagery. Write notes in your book for posterity. Hear it aloud. Absorb the words visually as well as aurally. Share a common experience. Create community. Expand your knowledge. Invigorate your brain. Make new friends. Enjoy the performance more fully.

You thought you were only supposed to see Shakespeare on stage? Interactions with Shakespeare have changed over the centuries. For the first three hundred years Shakespeare was primarily seen as a literary dramatist and the plays were read by millions of people of all backgrounds. For the past half century, though, academia and theater have been the primary custodians, taking Shakespeare away from the community of active readers.

Social reading groups spread Shakespeare across America in the late nineteenth and early twentieth centuries. These were groups of adults (mostly women) who read and discussed the plays in community—without an expert to tell them what to think or an actor to tell them how it should be interpreted. They had not been told it was too difficult or complex to read—they just did it.

But do not fear! A joyous resurgence in Shakespeare reading groups is afoot! Here is your chance to spend a little time invigorating your mind, savoring the language and the imagery in a way you cannot do at a performance, and making new friends. Join your local Shakespeare reading group or start a new one!

WHAT DOES ONE DO AT A READING?

We simply pick up the book and read. As my friend Steve Krug says, "It's not rocket surgery." And it's worth it.

INSIDE:

How to start a new group........2
Dividing up the parts...............3
Leading a discussion...............4
Options for reading................8

This newsletter has a good start, but the immediate *visual* impression is a little sloppy, which affects the viewer's impression of the *content*.

To do: Draw vertical lines to see clearly how many different alignments there are.

typefaces

VENEER REGULAR

Mikado Regular and Light

Check for illustrations that hang out over the edge just a bit, or captions that are centered under photos, headlines that are not aligned with the text, rules (lines) that don't align with anything, or a combination of centered text and flush left text.

iREAD
SHAKESPEARE

Read Shakespeare out loud and in community! Volume 1 • September 27

WHY READ SHAKESPEARE ALOUD?

Experience the entire play instead of the shortened stage version. Read plays you'll rarely (sometimes never) see on stage. Understand more words. Discover more layers. Take it personally. See more ambiguities and make up your own mind about them. Spend time to process the riches. Memorize your favorite lines. Savor the language and imagery. Write notes in your book for posterity. Hear it aloud. Absorb the words visually as well as aurally. Share a common experience. Create community. Expand your knowledge. Invigorate your brain. Make new friends. Enjoy the performance more fully.

You thought you were only supposed to see Shakespeare on stage? Interactions with Shakespeare have changed over the centuries. For the first three hundred years Shakespeare was primarily seen as a literary dramatist and the plays were read by millions of people of all backgrounds. For the past half century, though, academia and theater have been the primary custodians, taking Shakespeare away from the community of active readers.

Social reading groups spread Shakespeare across America in the late nineteenth and early twentieth centuries. These were groups of adults (mostly women) who read and discussed the plays in community—without an expert to tell them what to think or an actor to tell them how it should be interpreted. They had not been told it was too difficult or complex to read—they just did it.

But do not fear! A joyous resurgence in Shakespeare reading groups is afoot! Here is your chance to spend a little time invigorating your mind, savoring the language and the imagery in a way you cannot do at a performance, and making new friends. Join your local Shakespeare reading group or start a new one!

WHAT DOES ONE DO AT A READING?

We simply pick up the book and read. As my friend Steve Krug says, "It's not rocket surgery." And it's worth it.

INSIDE

Can you see what has made the difference between this example and the one on the previous page?

To do: Draw lines along the strong alignments, both vertical and horizontal.

Train your Designer Eye: Find at least three other design details that help to make this example communicate more professionally. (Suggestions on page 227.)

I want to repeat: Find a strong line and use it. If you have a photo or a graphic with a strong flush side, align the side of the text along the straight edge of the photo, as shown below.

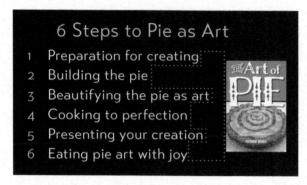

There is a nice, strong, invisible line along the left edge of the type, and there is a nice strong line along the left edge of the image. Between the text and the image, however, there is "trapped" white (empty) space, and the white space is an awkward shape, which you can see with the green dotted line. When white space is trapped, it pushes the two elements apart.

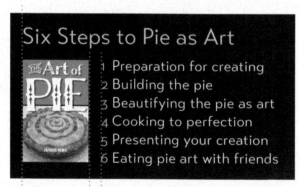

typeface
Transat Text Standard

Find a strong line and use it. Now the strong line on the left side of the text and the strong line on the right side of the image are next to each other, making each other stronger, as you can see by the green dotted lines. The white space now is floating free off the right edge.

Train your Designer Eye: Start looking for this type of mistake, where a project has a strong line that is weakened by abutting it to a ragged edge. You can probably find one a day.

Also: Name at least three other things that are different between the slides. (Suggestions on page 227.)

If your alignments are strong, you can break through them consciously and it will look intentional. The trick is you cannot be timid about breaking the alignment—either do it all the way or don't do it. Don't be a wimp.

le petit jambon pense à la vie et mort

Wants pawn term dare worsted ladle gull hoe hat search putty yowler coils debt pimple colder Guilty Looks. Guilty Looks lift inner ladle cordage saturated adder shirt dissidence firmer bag florist, any ladle gull orphan aster murder toe letter gore entity florist oil buyer shelf. "Guilty Looks!" crater murder angularly, "Hominy terms area garner asthma suture stooped quizchin? Goiter door florist? Sordidly NUT!" "Wire nut, murder?" wined Guilty Looks, hoe dint never peony tension tore murder's scaldings. "Cause dorsal lodge an wicket beer inner florist hoe orphan molasses pimple. Ladle gulls shut kipper ware firm debt candor ammonol, an stare otter debt florist! Debt florist's mush toe dentures furry ladle gull!"

Hormone nurture

Wail, pimple oil-wares wander doe wart udder pimple dun wampum toe doe. Debt's jest hormone nurture. Wan moaning, Guilty Looks dissipater murder, an win entity florist. Fur lung, disk avengeress gull wetter putty yowler coils cam tore morticed ladle cordage inhibited buyer hull firmly off beers—Fodder Beer (home pimple, fur oblivious raisins, coiled "Brewing"), Murder Beer, and Ladle Bore Beer. Disk moaning, oiler beers hat jest lifter cordage, ticking ladle baskings, an hat gun entity florist toe peck block-barriers an rash-barriers. Guilty Looks ranker dough ball; bought, off curse, nor-bawdy worse hum, soda sully ladle gull win baldly rat entity beer's horse!

Sop's toe hart

Honor tipple inner darning rum, stud tree boils fuller sop—wan grade bag boiler sop, wan muddlesash boil, an wan tawny ladle boil. Guilty Looks tucker spun fuller

typefaces

fragile
Arno Pro Caption
Transat Text Bold

Here an illustration is angled and breaking into the text block. This works just fine if the rest of the piece has clean alignments and the oddball element *appears to be intentional.* It is possible to break completely free of any alignment, **if you do it consciously.**

I am giving you a number of rules here, and it is true that rules are made to be broken. But remember the **Rule about Breaking Rules: You must know what the rule is before you can break it.**

Somehow you can tell if someone's project has random and chaotic elements on purpose or because they simply didn't know any better. And somehow, perhaps because of a collection of tiny little things that you would have to look for, when the rules are broken on purpose they have a stronger and more important impact.

Look around

You have probably noticed how critical the Principle of Alignment is. Even if you group things into appropriate proximity, you almost always need to strengthen the alignments in a piece as well.

To do: Collect a dozen ads or brochures or flyers or magazine spreads or whatever pieces you think are excellent, even if you cannot yet say exactly why or you don't feel like you could actually create them. Find the strong alignments in each piece— I guarantee they will be there.

Also find at least half a dozen examples that you feel in your gut look a bit amateurish. Are they lacking the use of the Principle of Proximity or of Alignment?

The more you look around and put into words what works and what doesn't work, the more you will absorb the concepts, the more you will absorb good design and what makes it good, and the more it will come back out of you in your own work.

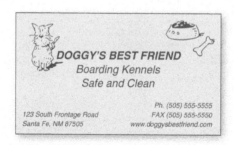

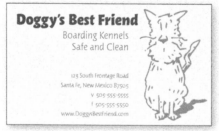

One might say that the information on this card is grouped into logical units of information using the Principle of Proximity. But it still presents an amateurish look. Why?

Now you know why: Because it has three different alignments on this little card (centered, flush left, and flush right). Plus someone stuck clipart in the corners.

A strong alignment organizes information more effectively and provides enough room to enlarge the cute doggy image.

Plus the white space is now more organized as well.

Designer Eyes

Can you improve these ads? Each one just needs a little more attention to proximity and alignment. (Suggestions on page 227.)

This magazine ad has a lovely start. But as you look at it, do you feel something tickling the back of your brain, suggesting that there is just a wee something that might pull these disparate pieces of the ad together more fully?

This program ad needs some help. Seriously consider every element in this small space and see:
1) if every element is necessary, and
2) is each element in the proper hierarchy?

That is, what is most important? **Listen to your eyes**—where do they go, what path do they follow, is that the best path? Is the important information grouped into logical proximity? Does the alignment support clear communication? Draw vertical lines to show the existing alignments in this little space.

Summary of alignment

Nothing should be placed on the page arbitrarily. Every element should have some **visual connection** with another element on the page.

Unity is an important concept in design. To make all the elements on the page appear to be unified, connected, and interrelated, there needs to be some visual tie between the separate elements. Even if the separate elements are not physically close on the page, they can *appear* connected, related, unified with the other information simply by their placement. Take a look at design projects you like. No matter how wild and chaotic a well-designed piece may initially appear, you can always find alignments within.

The basic purpose

The basic purpose of alignment is to **unify and organize** the page. The result is similar to what happens when you (or your dog) pick up all the dog toys that were strewn around the living room and put them into one toy box.

It is often a strong alignment (combined, of course, with the appropriate typeface) that creates a sophisticated look, a formal look, a fun look, or a serious look.

How to get it

Be conscious of where you place elements. Always find something else on the page to align with, even if the two objects are physically far away from each other.

What to avoid

Avoid using more than one text alignment on the page (that is, don't center some text and right-align other text).

And please try very hard to break away from a centered alignment unless you are consciously trying to create a more formal, sedate presentation. Choose a centered alignment consciously, not by default.

Repetition

The Principle of Repetition states: **Repeat some aspect of the design throughout the entire piece.** The repetitive element may be a bold font, a thick rule (line), a certain bullet, design element, color, format, spatial relationships, etc. It can be anything that a reader will visually recognize.

You already use repetition in your work. When you make headlines all the same size and weight, or add a rule a half-inch from the bottom of each page, or use the same bullet in each list throughout the project, you are creating repetition. What new designers often need to do is push this idea further—turn that inconspicuous repetition into a visual key that ties the publication together.

Repetition can be thought of as *consistency*. As you look through a sixteen-page brochure, it is the repetition of certain elements, their consistency, that makes each of those sixteen pages appear to belong to the same brochure. If page 13 has no repetitive elements carried over from page 4, the brochure loses its cohesive look and feel.

But repetition goes beyond just being naturally consistent—it is a conscious effort to unify all parts of a design.

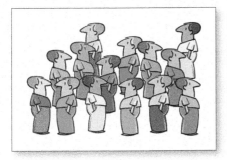 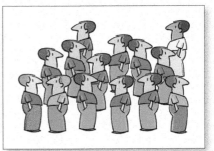

It often happens in Life that we need repetitive elements to clarify and unify. A certain number of the guys above are on the same team, but we can't tell.

The repetition of their clothes makes it immediately clear that these guys are some kind of organized entity. We do this sort of thing all the time.

Here is the same business card we worked with earlier. In the second example below, I have added a repetitive element: a repetition of the strong, bold typeface. Take a look at it, and notice where your eye moves. When you get to the phone number, where do you look next? Do you find that you go back to the other bold type? Designers have always used visual tricks like this to control a reader's eye, to keep your attention on the page as long as possible. The bold repetition also helps unify the entire design. This is a very easy way to tie pieces of a design package together.

Sock and Buskin
Ambrosia Sidney

109 Friday Street
Penshurst, NM
505.555.1212

When you get to the end of the information, does your eye just wander off the card?

Sock and Buskin
Ambrosia Sidney

109 Friday Street
Penshurst, NM
505.555.1212

Now when you get to the end of the information, where does your eye go? Do you find that it bounces back and forth between the bold type elements? It probably does, and that's the point of repetition— it ties a piece together; it provides unity.

typefaces
Mikado Bold and Regular

Take advantage of those elements you're already using to make a project consistent and turn those elements into repetitive graphic symbols. Are all the headlines in your newsletter 14-point Times Bold? How about investing in a very bold sans serif font and making all your heads something like 16-point Mikado Ultra? You're taking the repetition you have already built into the project and pushing it so it is stronger and more dynamic. Not only is your page more visually interesting, but you also increase the visual organization and the consistency by making it more obvious.

THE ELIZABETHAN HUMOURS

In ancient and medieval physiology and medicine, the humours are the four fluids of the body (blood, phlegm, choler, and black bile) believed to determine, by their relative proportions and conditions, the state of health and the temperament of a person or animal.

Eyes have Power
When two people fall in love, their hearts physically became one. Invisible vapors emanate from one's eyes and penetrate the other's. These vapors change the other's internal organs so both people's inner parts become similar to each other, which is why they fall in love—their two hearts merge into one. You must be careful of eyes.

Music has power
Songs of war accelerate the animal spirits and increase the secretion of blood in phlegmatics. Songs of love reduce the secretion of choler, slow down the pulse, and reduce melancholic anxiety. Lemnius (1505–1568) wrote that music affects "not only the ears, but the very arteries, the vital and animal spirits, it erects the mind, and makes it nimble." Marsilius Ficino (1433–1499) wrote in his letters: "Sound and song easily arouse the fantasy, affect the heart, and reach the inmost recesses of the mind; they still [quiet], and also set in motion, the humours and the limbs of the body."

Wine!
Ken Albala states: 'Wine is the most potent corrective for disordered passions of the soul. In moderation it reverses all malicious inclinations, making the impious pious, the avaricious liberal, the proud humble, the lazy prompt, the timid audacious, and the

Headlines and subheads are a good place to start when you need to create repetitive elements, since you are probably consistent with them anyway.

THE ELIZABETHAN HUMOURS

In ancient and medieval physiology and medicine, the humours are the four fluids of the body (blood, phlegm, choler, and black bile) believed to determine, by their relative proportions and conditions, the state of health and the temperament of a person or animal.

Eyes have Power
When two people fall in love, their hearts physically became one. Invisible vapors emanate from one's eyes and penetrate the other's. These vapors change the other's internal organs so both people's inner parts become similar to each other, which is why they fall in love—their two hearts merge into one. You must be careful of eyes.

Music has Power
Songs of war accelerate the animal spirits and increase the secretion of blood in phlegmatics. Songs of love reduce the secretion of choler, slow down the pulse, and reduce melancholic anxiety. Lemnius (1505–1568) wrote that music affects "not only the ears, but the very arteries, the vital and animal spirits, it erects the mind, and makes it nimble." Marsilius Ficino (1433–1499) wrote in his letters: "Sound and song easily arouse the fantasy, affect the heart, and reach the inmost recesses of the mind; they still, and also set in motion, the humours and the limbs of the body."

Wine has Power
Ken Albala states: 'Wine is the most potent corrective for disordered passions of the soul. In moderation it reverses all malicious inclinations, making the impious pious, the avaricious liberal, the

So take that consistent element, such as the typeface for the headlines and subheads, and make it stronger. Make it a design element in addition to a useful element.

typefaces
Brioso Pro Regular
Matchwood Bold

Do you create multiple-page publications? Repetition is a major factor in the unity of those pages. When readers open the document, it should be perfectly and instantly obvious that page 3 and page 13 are really part of the same publication.

Point out the elements of repetition in the two sample pages below.

Gulls Honor Wrote

Heresy rheumatic starry offer former's dodder, Violate Huskings, an wart hoppings darn honor form.

Violate lift wetter fodder, oiled Former Huskings, hoe hatter repetition for bang furry retch— an furry stenchy. Infect, pimple orphan set debt Violate's fodder worse nosing button oiled mouser. Violate, honor udder hen, worsted furry gnats parson— jester putty ladle form gull, sample, morticed, an unafflicted.

Wan moaning Former Huskings nudist haze dodder setting honor cheer, during nosing.

▸ *Water rheumatic form!*

Nor symphony

VIOLATE! sorted dole former, Watcher setting darn fur? Yore canned gat retch setting darn during nosing? Germ pup otter debt cheer!

Arm tarred, Fodder, resplendent Violate warily. Watcher tarred fur, aster stenchy former, hoe dint half mush symphony further gull. Are badger dint doe mush woke disk moaning. Ditcher curry doze buckles fuller slob darn tutor peg-pan an feeder pegs. Daze worsted furry gnats parson wit fairy knifely dependable twos. Nosing during et oil marks neigh cents.

Vestibule guardings

Yap, Fodder. Are fetter pegs. Ditcher mail-car caws an swoop otter caw staple? Off curse, Fodder. Are mulct oiler caws an swapped otter staple, fetter checkings, an clammed upper larder inner checking-horse toe gadder oiler aches, an wen darn tutor vestibule guarding toe peck oiler bogs an warms offer vestibules, an watched an earned yore closing, an fetter hearses any oil ding welsh.

Ditcher warder oiler hearses, toe? enter-ruptured oiled Huskings. Nor, Fodder, are dint. Dint warder mar hearses. Wire nut?

4

Consistent double rule on the tops of all pages.

Consistent typeface in headlines and sub-heads, and consistent space above each.

This single rule repeats across the bottom of each page.

Page numbers are in the same place and in the same typeface on each page.

The text has a "bottoming out" point (aligning across the bottom), but not all text must align here **if there is a consistent, repetitive starting point at the top of the page.**

Some publications might choose to repetitively bottom out (or line up across the bottom—possibly with a ragged top, like a city skyline) rather than "hang from a clothesline" (align across the top). Use one or the other technique consistently, though.

If everything is inconsistent, how would anyone visually understand that something in particular is special? If you have a strongly consistent publication, you can throw in surprise elements; save those surprises for items you want to call special attention to.

To do: Point out the consistent, repetitive elements of this book.

Evanescent wan think, itching udder

Effervescent further ACHE, dare wooden bather CHECKING. Effervescent further PEG, way wooden heifer BECKING. Effervescent further LESSENS, dare wooden bather DITCHERS. Effervescent further ODDEST, way wooden heifer PITCHERS. Effervescent further CLASHES, way wooden kneader CLASH RUMS. Effervescent further BASH TOPS, way wooden heifer BASH RUMS. Effervescent fur MERRY SEED KNEE, way wooden heifer SHAKSPER. Effervescent further TUCKING, way wooden heifer LANGUISH. Effervescent fur daze phony WARTS, nor bawdy cud spick ANGUISH!

Moan-late an steers

Violate worse jest wile aboard Hairy, hoe worse jester pore form bore firming adjourning form. Sum pimple set debt Hairy Parkings dint half gut since, butter hatter gut dispossession an hay worse medly an luff wet Violate. Infect, Hairy wandered toe merrier, butter worse toe skirt toe aster.

O Hairy, crate Violate, jest locket debt putty moan! Arsenate rheumatic? Yap, inserted Hairy, lurking.

Arsenate rheumatic

- ▼ Snuff doze flagrant odors.
- ▼ Moan-late an merry-age.
- ▼ Odors firmer putty rat roaches inner floor guarding.
- ▼ Denture half sum-sing impertinent toe asthma?
- ▼ Hairy aster fodder.
- ▼ Conjure gas wart hopping?
- ▼ Violate dint merry Hairy.
- ▼ Debt gull runoff wit a wicket bet furry retch lend-lard.

13

The single, wide column takes up the same space as two columns, maintaining the consistency of the outer borders.

All stories and photos or illustrations start at the same guideline across the top of each page (also see the note on the opposite page about "bottoming out").

Note the repetitive use of the triangular shape in the list and in the caption, opposite page. That shape is probably used elsewhere in the publication as well.

typefaces
Bree Thin
Arno Pro

To create a consistent business package with a business card, letterhead, and envelope, use a strong display of repetition, not only within each piece, but between all the pieces. You want the person who receives the letter to know you are the same person who gave her a business card last week. You might want to create a layout that allows you to align the printed letter with some element in the stationery design.

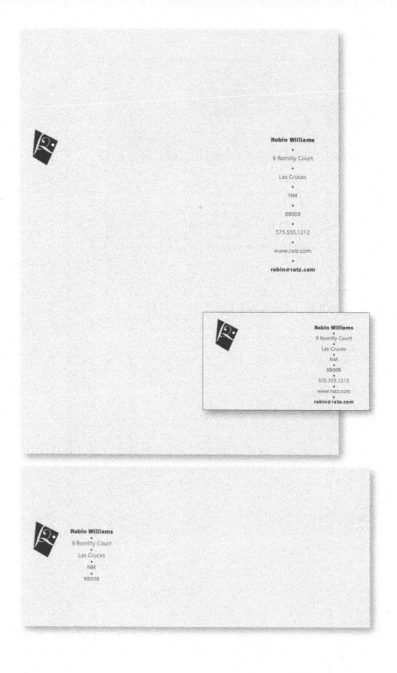

Repetition helps organize the information; it helps guide the reader through the pages; it helps unify disparate parts of the design. Even on a one-page document, repetitive elements establish a sophisticated continuity and can pull together the entire piece. If you are creating several one-page documents that are part of a comprehensive package, it is critical that you employ repetition.

The Mad Hatter
■ Wonderland, England

Objective
■ To murder Time

Education
■ Dodgson Elementary
■ Carroll College

Employment
■ Singer to Her Majesty
■ Tea Party Coordinator
■ Expert witness

Favorite Activities
■ Nonsensical poetry
■ Unanswerable riddles

References available upon request.

Repetitions:
Bold typeface
Light typeface
Square bullets
Indents
Spacing
Alignments

Besides having strong repetitive elements that make it very clear exactly what is going on here, this person might also want to incorporate one or more of these elements into the design of his cover letter.

typefaces
Nexa Light and **Black**
ITC Zapf Dingbats (n = ■)

typefaces
Myriad Pro Regular and **Bold**
Zanzibar-Regular

If there is an element that strikes your fancy, go with it! Perhaps it's a piece of clip art or a picture font. Feel free to add something completely new simply for the purpose of repetition. Or take a simple element and use it in various ways—different sizes, colors, angles.

Sometimes the repeated items are not exactly the same objects, but objects so closely related that their connection is very clear.

It's fun and effective to pull an element out of a graphic and repeat it. The little heart motif could be applied to other related material, such as envelopes, response cards, balloons, and everything would be a cohesive unit, even without repeating the same heart.

Train your Designer Eye: Name at least five other repetitive elements on this little card. (Suggestions on page 227.)

This card uses a centered alignment. What was done to help it avoid looking amateur?

Often you can add repetitive elements that apparently have nothing to do with the purpose of your page. For instance, throw in a few petroglyph characters on a survey form. Add some strange-looking birds to a report. Set several particularly beautiful characters in your font in various large sizes, in gray or a light second color, and at various angles throughout the publication. Just make sure it looks intentional rather than random.

reminder
Staff Meeting Today! 2 P.M.
Be There or Be Square!

Overlapping a design element or pulling it outside of the borders serves to unify two or more pieces, or to unify a foreground and a background, or to unify separate publications that have a common theme.

friday
12 noon
Meet
Dr. Sal

tuesday
9:30 P.M.
Diversity
Enhancement
Training

**Required for all employees!
Meet in the Green Room.**

The great thing about repetition is that it makes items look like they belong together, even if the elements are not exactly the same. You can see that once you establish a couple of key repetitive items, you can vary those items and still create a consistent look.

Train your Designer Eye: Name at least seven repetitive elements. (Suggestions on page 227.)

typefaces
Nexa Black
Spumoni
MiniPics LilFolks

Using the principle of repetition, you can sometimes pull an element from your existing layout and create a new element that ties it together.

typefaces
Quicksand Light
and Dash

The dashed letters inspired the dashed concentric ovals hinting at a sound wave. Once you start noticing what can be repeated, I guarantee you'll enjoy developing so many options.

Train your Designer Eye: Name at least four other repetitive elements on this little card. Also note where elements are aligned. (Suggestions on page 227.)

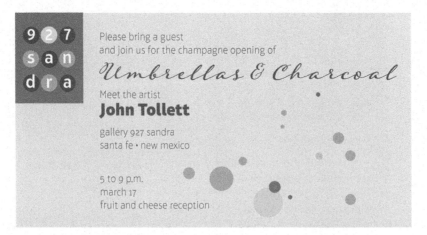

Train your Designer Eye: Name at least three repetitive elements on this card. Also note where elements are aligned. (Suggestions on page 228.)

The repetitive element does not have to be a graphic or clipart. It can be spacing, rules, fonts, alignments, or anything that you consciously repeat.

R. William Whetstone Memorial Committee
presents the Twentieth Memorial Lecture

Dr. Euphemia May Weber
Professor of Psychiatry and Neuroscience
at the
University of California, Yountville
on
"A Hundred Years
of Science"

Monday, September 27, 8 p.m.
Reilly Rooser Auditorium, Truchas
Free admission

This is very typical: Times New Roman, centered, typewriter quotation marks. Someone did separate the information into logical groups, but you can see that the centered alignment is weak. There is an attempt to fill the corners.

R. William Whetstone Memorial Committee
presents the Twentieth Memorial Lecture

Dr. Euphemia May Weber

Professor of Psychiatry and Neuroscience
at the University of California, Yountville,
will be speaking on the topic of

A Hundred Years of Science

Monday, September 27, 8 p.m.
Reilly Rooser Auditorium, Truchas
Free admission

Decide what you want to focus on. This version has a focus on the speaker. Regarding the Principle of Repetition, what are the repeated elements? You can see where the Principle of Alignment has been applied, and this ad also uses the Principle of Contrast, described in the following chapter.

A Hundred Years of Science

Dr. Euphemia May Weber
Professor of Psychiatry and Neuroscience
at the University of California, Yountville

Monday, September 27, 8 p.m.
Reilly Rooser Auditorium, Truchas
Free admission

This Twentieth Memorial Lecture is presented
by the R. William Whetstone Memorial Committee

This version has a focus on the topic. Notice the black bar is repeated in a thinner version at the bottom. A repetitive element that pulls things together can be that simple.

Sometimes the mere suggestion of a repeated element can get the same results as if you used the whole thing. Try including just a portion of a familiar element, or use it in a different way.

DESIGNER EYE

WORKSHOP: LISTEN TO YOUR EYES

*Artisan Art Supplies * Canyon Road*
*Friday * 3 to 5 p.m.*
Bring a fine-tip red marker

typefaces
PROFUMO
Minister Light and *Italic*

If an image is familiar to a reader from your other marketing material (page 37), all it takes is a piece of it to help the reader make the connection. What is another repetition here?

typefaces
Schmutz Cleaned
Bickham Script Pro

The *Screenwriting* Conference in Santa Fe

At The Screenwriting Conference in Santa Fe, chances are you'll meet someone who will change your life.™

Santa Fe, New Mexico
June 1 – June 5

505.555.1501 866.555.1501
www.SCSFe.com

This typewriter image, of course, has been used on all of the Screenwriting Conference's promotional material, so at this point we don't have to use the entire image. Once again, as in the example at the top, we see the advantage of using just part of a recurring image— the reader actually "sees" the whole typewriter.

Repetition provides a sense of professionalism and authority to your pieces, no matter how playful. It gives your reader the feeling that someone is in charge because repetition is obviously a thoughtful design decision.

typefaces
frances uncial
Brioso Pro Light
and *Italic*

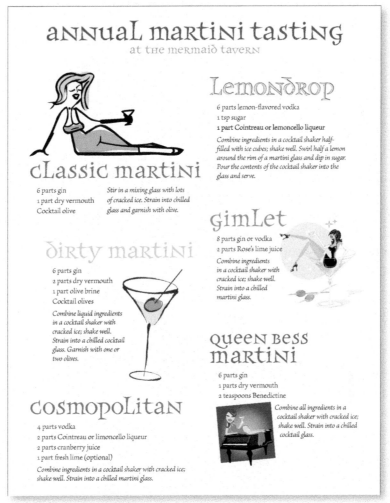

annual martini tasting
at the mermaid tavern

Lemondrop

6 parts lemon-flavored vodka

1 tsp sugar

1 part Cointreau or lemoncello liqueur

Combine ingredients in a cocktail shaker half-filled with ice cubes; shake well. Swirl half a lemon around the rim of a martini glass and dip in sugar. Pour the contents of the cocktail shaker into the glass and serve.

classic martini

6 parts gin
1 part dry vermouth
Cocktail olive

Stir in a mixing glass with lots of cracked ice. Strain into chilled glass and garnish with olive.

gimLet

8 parts gin or vodka
2 parts Rose's lime juice

Combine ingredients in a cocktail shaker with cracked ice; shake well. Strain into a chilled martini glass.

dirty martini

6 parts gin
2 parts dry vermouth
1 part olive brine
Cocktail olives

Combine liquid ingredients in a cocktail shaker with cracked ice; shake well. Strain into a chilled cocktail glass. Garnish with one or two olives.

queen bess martini

6 parts gin
1 parts dry vermouth
2 teaspoons Benedictine

Combine all ingredients in a cocktail shaker with cracked ice; shake well. Strain into a chilled cocktail glass.

cosmopolitan

4 parts vodka
2 parts Cointreau or limoncello liqueur
2 parts cranberry juice
1 part fresh lime (optional)

Combine ingredients in a cocktail shaker with cracked ice; shake well. Strain into a chilled martini glass.

You can see that repetition doesn't mean you have to repeat exactly the same thing. Above, the headlines are all different colors, but they use the same font. The illustrations are all different styles, but all rather funky and 'fifties.

Just make sure you have enough repetitive elements so the differences are clear, not a jumbled mess. For instance, in this example you see that the recipes all follow the same format and there are strong alignments. When there is an underlying structure, you can be more flexible with the elements.

Summary of repetition

A **repetition** of visual elements throughout the design unifies and strengthens a piece by tying together otherwise separate parts. Repetition is very useful on one-page pieces, and is critical in multi-page documents (where we often just call it *being consistent*).

The basic purpose

The purpose of repetition is to **unify** and to **add visual interest.** Don't underestimate the power of the visual interest of a page—if a piece looks interesting, it is more likely to be read.

How to get it

Think of repetition as being consistent, which I'm sure you do already. Then **push the existing consistencies a little further—**can you turn some of those consistent elements into part of the conscious graphic design, as with the headline? Do you use a 1-point rule at the bottom of each page or under each heading? How about using a 4-point rule instead to make the repetitive element stronger and more dramatic?

Then take a look at the possibility of adding elements whose sole purpose is to create a repetition. Do you have a numbered list of items? How about using a distinctive font or a reversed number, and then repeating that treatment throughout every numbered list in the publication? At first, simply find *existing* repetitions and then strengthen them. As you get used to the idea and the look, start to *create* repetitions to enhance the design and the clarity of the information.

Repetition is like accenting your clothes. If a woman wears a lovely black evening dress with a chic black hat, she might accent her dress with red heels, red lipstick, and a tiny red pin.

What to avoid

Avoid repeating the element so much that it becomes annoying or overwhelming. Be conscious of the value of contrast (see the next chapter and especially the section on contrasting type).

For instance, if the woman were to wear the black evening dress with a red hat, red earrings, red lipstick, a red scarf, a red handbag, red shoes, and a red coat, the repetition would not be a stunning and unifying contrast—it would be overwhelming and the focus would be confused.

Contrast

Contrast is one of the most effective ways to add visual interest to your page and to create an organizational hierarchy among different elements. For contrast to be effective, however, it must be strong. Don't be a wimp.

The Principle of Contrast states: **Contrast various elements of the piece to draw a reader's eye into the page.** If two items are not exactly the same, then make them different. Really different.

Contrast not only serves to draw in the eye, but you can use it to organize information, clarify the hierarchy, guide a reader around the page, and provide a focus.

Contrast can be created in many ways. You can contrast large type with small type; a graceful oldstyle font with a bold sans serif font; a thin line with a thick line; a cool color with a warm color; a smooth texture with a rough texture; a horizontal element (such as a long line of text) with a vertical element (such as a tall, narrow column of text); widely spaced lines with closely packed lines; a small graphic with a large graphic.

But don't be a wimp. If two elements are sort of different but not really, then you don't have *contrast,* you have *conflict.* You cannot contrast 12-point type with 14-point type. You cannot contrast a half-point rule with a one-point rule. You cannot contrast dark brown with black. Get serious with your contrast!

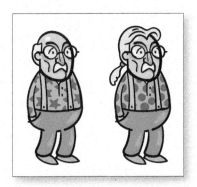

Are these two the same guy? Are we supposed to see them as different or are we supposed to see them as the same?

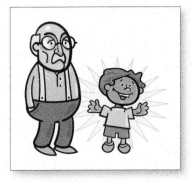

If they are not the same, make them **very** different!

If the two "newsletters" below came across your desk, which one would you pick up first? They both have the same basic layout. They are both nice and neat. They both have the same information on the page. There is really only one difference: The newsletter on the right has more contrast.

ANOTHER NEWSLETTER!

January First 2 5 2 5

Exciting Headline

Wants pawn term dare worsted ladle gull hoe hat search putty yowler coils debt pimple colder Guilty Looks. Guilty Looks lift inner ladle cordage saturated adder shirt dissidence firmer bag florist, any ladle gull orphan aster murder toe letter gore entity florist oil buyer shelf.

Thrilling Subhead

"Guilty Looks!" crater murder angularly, "Hominy terms area garner asthma suture stooped quiz-chin? Goiter door florist? Sordidly NUT!"

"Wire nut, murder?" wined Guilty Looks, hoe dint peony tension tore murder's scaldings.

"Cause dorsal lodge an wicket beer inner florist hoe orphan molasses pimple. Ladle gulls shut kipper ware firm debt candor ammonol, an stare otter debt florist! Debt florist's mush toe dentures furry ladle gull!"

Another Exciting Headline

Wail, pimple oil-wares wander doe wart udder pimple dum wampum toe doe. Debt's jest hormone

nurture. Wan moaning, Guilty Looks dissipater murder, an win entity florist. Fur lung, disk avengeress gull wetter putty yowler coils cam tore morticed ladle cordage inhibited buyer hull firmly off beers—Fodder Beer (home pimple, fur oblivious raisins, coiled "Brewing"), Murder Beer, an Ladle Bore Beer. Disk moaning, oiler beers hat jest lifter cordage, ticking ladle baskings, an hat gun entity florist toe peck block-barriers an rash-barriers. Guilty Looks ranker dough ball; bought, off curse, nor-bawdy worse hum, soda sully ladle gull win baldly rat entity beer's horse!

Boring Subhead

Honor tipple inner darning rum, stud tree boils fuller sop—wan grade bag boiler sop, wan muddle-sash boil, an wan tawny ladle boil. Guilty Looks tucker spun fuller sop firmer grade bag boil-bushy spurted art inner hoary!

"Arch!" crater gull, "Debt sop's toe hart—barns mar mouse!"

Dingy traitor sop inner muddle-sash boil, witch worse toe coiled. Butter sop inner tawny ladle boil worse jest

This is nice and neat, but there is not much that attracts your eyes to it. If eyes are not attracted to a piece, few will read it.

typefaces
Mikado Light

The source of the contrast below is obvious. A stronger, bolder typeface is used in the headlines and subheads. That typeface is repeated (Principle of Repetition, remember?) in the newsletter title. Because the title is now caps/lowercase, we can use a larger and bolder type size, which also helps reinforce the contrast. And because the headlines are so strong now, a dark band can be added across the top behind the title, again repeating the dark color and reinforcing the contrast.

Another Newsletter!

January First 2 5 2 5

Exciting Headline

Wants pawn term dare worsted ladle gull hoe hat search putty yowler coils debt pimple colder Guilty Looks. Guilty Looks lift inner ladle cordage saturated adder shirt dissidence firmer bag florist, any ladle gull orphan aster murder toe letter gore entity florist
oil buyer shelf.

Thrilling Subhead

"Guilty Looks!" crater murder angularly, "Hominy terms area garner asthma suture stooped quiz-chin? Goiter door florist? Sordidly NUT!"

"Wire nut, murder?" wined Guilty Looks, hoe dint peony tension tore murder's scaldings.

"Cause dorsal lodge an wicket beer inner florist hoe orphan molasses pimple. Ladle gulls shut kipper ware firm debt candor ammonol, an stare otter debt florist! Debt florist's mush toe dentures furry ladle gull!"

Another Exciting Headline

Wail, pimple oil-wares wander doe wart udder pimple dum wampum toe doe. Debt's jest hormone nurture. Wan moaning, Guilty Looks dissipater murder, an win entity florist. Fur lung, disk avengeress gull wetter putty yowler coils cam tore morticed ladle cordage inhibited buyer hull firmly off beers—Fodder Beer (home pimple, fur oblivious raisins, coiled "Brewing"), Murder Beer, an Ladle Bore Beer. Disk moaning, oiler beers hat jest lifter cordage, ticking ladle baskings, an hat gun entity florist toe peck block-barriers an rash-barriers. Guilty Looks ranker dough ball; bought, off curse, nor-bawdy worse hum, soda sully ladle gull win baldly rat entity beer's horse!

Boring Subhead

Honor tipple inner darning rum, stud tree boils fuller sop—wan grade bag boiler sop, wan muddle-sash boil, an wan tawny ladle boil. Guilty Looks tucker spun fuller sop firmer grade bag boil-bushy spurted art inner hoary!

"Arch!" crater gull, "Debt sop's toe hart—barns mar mouse!"

Dingy traitor sop inner muddle-sash boil, witch worse toe coiled. Butter

Can you feel how your eyes are drawn to this page, rather than to the previous page?

typefaces
Mikado Light
Aachen Bold

Contrast is crucial to the organization of information—a reader should always be able to glance at a document and instantly understand what's going on.

James Clifton Thomas
Hino-machi 50-2-431
Yonago-shi
Tottori-ken
683-0066
Japan

PROFILE:
I am a hard-working, dependable, cheerful person of many talents. My ideal position is with a company that values my combination of creativity and effort and one in which I can continue to learn.

ACCOMPLISHMENTS:

2011–present English Teacher, Yonago High School for Language and the Arts

2006-2011 Acts of Good, web designer and developer, working with a professional team of creatives in Portland.

2000-2006 Pocket Full of Posies Day Care Center. Changed diapers, taught magic and painting, wiped noses, read books to and danced with babies and toddlers. Also coordinated schedules, hired other teachers, and developed programs for children.

1997-2000 Developed and led a ska band called Lead Veins. Designed the web site and coordinated a national tour.

EDUCATION:

Pacific Northwest College of Art, Portland, Oregon: B.A. in Printmaking, 2002-2005

Santa Rosa Junior College, Santa Rosa, California: focus on graphic design and drafting, 1999-2001

PROFESSIONAL AFFILIATIONS:

2000-2002 Grand National Monotype Club, Executive Secretary

1999-2003 Jerks of Invention, Musicians of Portland, President

1992-1998 Local Organization of Travelers Wild

LANGUAGES:

English, native
Japanese, fluent

HOBBIES:

Music (guitar, bass, trumpet, keyboard, vocals), photography, drawing, dancing, rowing, reading, magic.

REFERENCES:

Sally Psychic 505.818.0419

Foghorn J. Leghorn 415.808.1009

The information is all there in this résumé and it's pretty clean. If someone really wants to read it, they will—but it certainly doesn't grab your attention.

And notice these problems:

Job titles are not clearly defined; they blend in with the body text.

The sections themselves are not clearly defined.

There are two alignments on the page: centered and flush left.

The amounts of space between the separate accomplishments are the same as the amount of space between sections.

The setup is inconsistent—sometimes the dates are at the beginning, sometimes at the end. Remember, consistency creates repetition.

Notice that not only is the page more attractive when contrast is used, but the purpose and organization of the document are much clearer. Your résumé is someone's initial impression of you, so make it strong.

typefaces
Warnock Pro Regular
 and *Italic*
Halis Bold

The problems are easily corrected.

One alignment: Flush left. As you can see above, using only one alignment doesn't mean everything is aligned along the **same edge**—it simply means everything is using the **same alignment** (all flush left or all flush right or all centered). Both the flush left lines above are very strong and reinforce each other (**alignment** and **repetition**).

The heads are strong—you instantly know what this document is and what the key points are (**contrast**).

Segments are separated by more space than are the individual lines of text (**contrast** of spatial relationships; **proximity**).

Degree and job titles are in bold (a **repetition** of the headline font)—the strong **contrast** lets you skim the important points.

The easiest way to add interesting contrast is with typefaces (which is the focus of the second half of this book). But don't forget about rules (drawn lines), colors, spacing between elements, textures, and so on.

If you use a hairline rule between columns, use a strong 2- or 4-point rule when you need another—don't use a half-point rule and a one-point rule on the same page. If you use a second color for accent, make sure the colors contrast— dark brown or dark blue doesn't contrast effectively with black text.

The Rules of Life

Your attitude is your life.

Maximize your options.

Don't let the seeds stop you from enjoyin' the watermelon.

Be nice.

There is a bit of contrast between the typefaces and between the rules, but the contrast is wimpy—are the rules supposed to be two different thicknesses? Or is it a mistake?

THE RULES OF LIFE

Your attitude is your life.

Maximize your options.

Don't let the seeds stop you from enjoyin' the watermelon.

Be nice.

Now the strong contrast between the typefaces makes the piece more dynamic and eye-catching.

With a stronger contrast between the thicknesses of the rules, there is no risk of someone thinking it's a mistake.

The Rules of Life

Your attitude is your life.

Maximize your options.

Don't let the seeds stop you from enjoyin' the watermelon.

Be nice.

This is simply another option using rules (this thick rule is behind the white type).

With contrast, the entire table is stronger and more sophisticated; it communicates more clearly.

typefaces
Garamond Premier Pro Medium Italic and **Bold**
ANODYNE COMBINED
Aachen Bold

If you use tall, narrow columns in your newsletter, perhaps use a strong headline to create a contrasting horizontal direction across the page.

Combine contrast with repetition, as in the page numbers or headlines or bullets or rules or spatial arrangements, to make a strong, unifying identity throughout an entire publication.

iREADSHAKESPEARE

You READ it?
Social reading groups spread Shakespeare across America in the late nineteenth and early twentieth centuries. These were groups of adults (mostly women) who read and discussed the plays in community—without an expert to tell them what to think or an actor to tell them how it should be interpreted. They had not been told it was too difficult or complex to read—they just did it.

I thought I was only supposed to see Shakespeare on stage?
Interactions with Shakespeare have changed over the centuries. For the first three hundred years Shakespeare was primarily seen as a literary dramatist and the plays were read by millions of people of all backgrounds. For the past half century, though, academia and theater have been the primary custodians, taking Shakespeare away from the community of active readers.
But do not fear! A joyous resurgence in Shakespeare reading groups is afoot! Here is your chance to spend a little time invigorating your mind, savoring the language and the imagery in a way you cannot do at a performance, and making new friends.

What do we do at a reading?
We just pick up a play and start reading. We stop regularly to make sure we understand what is going on, and we talk about it. Everyone has expertise in different things so we have a wide variety of thoughtful input for pondering and discussions. And if you bring cookies, we'll eat cookies!

Am I invited?
Yes! Anyone who can read or who would like to listen to others read is welcome. If you are shy about reading aloud, be assured that no one will force you to do so!

Can I bring a friend?
Of course you can! Bring your friends, your mom and dad, your neighbors, your teenagers! You can bring cookies, too!

When is it?
Readings are held on the first and third Thursdays of each month, from 6 to 8 P.M.

Where is it?
The Jemez Room at Santa Fe Community College.

Is there a fee?
Nope. But you can bring cookies.

In addition to the contrast in the typefaces in this postcard, there is also a contrast between the long, horizontal title and the tall, narrow, vertical columns. The narrow columns are a repetitive element, as well as an example of contrast.

typefaces
VENEER REGULAR
Brandon Grotesque Thin and **Bold**
Photina Regular

The example below is a typical flyer. The biggest problem is that the lines of text are too long to read comfortably. Also, there is little to draw the reader's eye into the text.

Design the headline so it will catch someone's eye. Now that their eyes are on the page, create some contrast in the text so even if they don't plan to read the whole thing, their eyes will be pulled to certain parts of it as they skim through it. Enhance this with alignments and use of proximity.

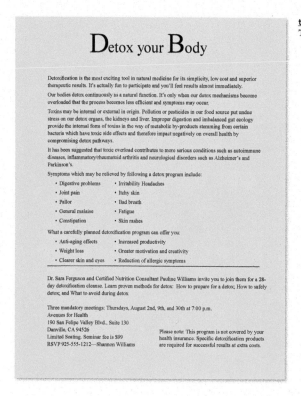

typeface
Times New Roman

Where do you begin to improve this flyer? At least it's not centered!

The lines are so long that a reader is automatically put off. When you have lots of text like this, experiment with using more than one column, as shown on the previous and opposite pages.

Pull out key phrases to set in bold so the visual contrasts attract the eye and lead the reader through the information.

Perhaps start off with the introductory bits of information so a reader begins with an understanding of the purpose of the flyer. It's less of a commitment to read the little pieces, so you can seduce the reader's eye into the piece by providing an introductory path.

Don't be afraid to make some items small to create a contrast with the larger items, and don't be afraid to allow blank space! Once you pull readers in with the focal point, they will read the smaller print if they are interested. If they're not interested, it won't matter *how* big you set it.

Notice all the other principles come into play: proximity, alignment, and repetition. They work together to create the total effect. Rarely will you use just one principle to design any page.

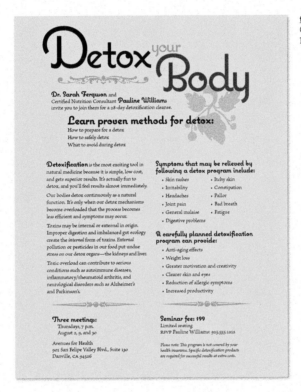

typefaces
Coquette Regular
Brioso Pro Regular and *Italic*

We added some ornaments for visual interest and to provide an earthy feeling and add some interest and softness to the title. Since this flyer is to be reproduced on a copy machine on colored paper, we used various shades of gray for those ornaments.

Listen to your eyes as they scan through this document—can you feel how they are drawn to the bold text so you are almost forced to read at least those parts? If you can get people that far into your piece, they are bound to read more.

Contrast is probably the most fun of the design principles—and the most dramatic! A few simple changes can make the difference between an ordinary design and a powerful one.

typefaces
VENEER REGULAR
Brandon Grotesque Regular and **Black**

SHAKESPEARE

WHY READ SHAKESPEARE ALOUD
WITH OTHERS?
Experience the entire play instead of the
shortened stage version · Read plays you'll
rarely (sometimes never) see on stage ·
Understand more words · Discover more
layers · Take it personally · See more
ambiguities and make up your own mind
about them · Spend time to process the
riches · Memorize your favorite lines ·
Savor the language and imagery · Write
notes in your book for posterity · Hear it
aloud · Absorb the words visually as well
as aurally · Share a common experience
· Create community · Expand your
knowledge · Invigorate your brain · Make
new friends · Enjoy the performance
more fully

**Find a Shakespeare Reading Group near
you at iReadShakespeare.com**

This rack card is a little flat.
But it's nice and clean and the
centered alignment works well
with the font, spacing, and bullets.

But it doesn't have enough
contrast within itself to compete
with other cards in a rack.

Which of these two rack cards would you be most likely to pick out of the stand? This is the power of contrast: it gives you a lot more bang. Just a few simple changes, and the difference is amazing.

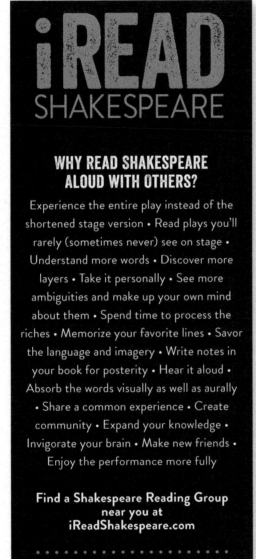

typefaces
VENEER REGULAR
Brandon Grotesque Regular and **Black**

This was a simple change in contrast. Since rack cards are usually printed on glossy card stock, it is easy to get a nice, rich black.

I lightened the red a little to make it stand out better on the black.

Train your Designer Eye: Name at least six changes that were made to this card. (Suggestions on page 228.)

Contrast, of course, is rarely the only concept that needs to be emphasized, but you'll often find that if you add contrast, the other concepts seem to fall into place. Your elements of contrast, for instance, can sometimes be used as elements of repetition.

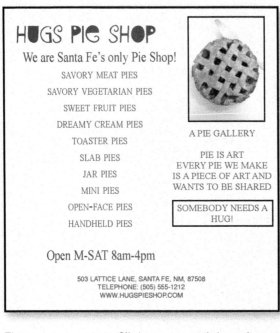

typefaces
SYbIL GRCCN
Times New Roman
Helvetica Regular

This person wants to fill the space and the only way he knows how to do it is with all caps and centered text. There is very little contrast on the page to pull in your eyes, except perhaps the amazing pie.

You can see that this ad needs to have the information organized into logical units (Principle of Proximity).

It also needs to choose an alignment (Principle of Alignment).

It could use a repetitive element, which might be the cute font (Principle of Repetition).

And it needs contrast, which you will have to create.

Where to begin?

Although the ad below looks like a radical leap from the one on the opposite page, it is actually just a methodical application of the four basic principles, one at a time: Group things into logical proximity, use an alignment, find or create repetitive elements, and add contrast.

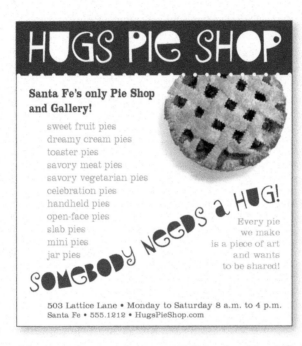

typefaces
SYBIL GREEN
Bailey Sans ExtraBold
I made that pie. :-)

Of course there are many possibilities for this ad. To begin with:

Let go of Times New Roman and Arial/Helvetica. Just eliminate them from your **font choices.** (Please let go of Sand as well.)

Let go of a centered **alignment.** I know it's hard to do, but you must do it for now. Later, you can experiment with it again.

Find the most interesting or most important item on the page, and **emphasize it!** In this case, the most interesting is the pie and the most important is the name of the shop. Keep the most important things together so a reader doesn't lose the **focus.**

Group the information into logical groups. Use **space** to set items apart or to connect them, not boxes.

Find elements you can **repeat** (including any elements of contrast).

And most importantly, add **contrast.**

Work through each concept one at a time. I guarantee you'll be amazed at what you can create.

Train your Designer Eye: Name at least seven differences between this ad and the one on the previous page. These are the sorts of changes you'll find yourself making as you try to fit a lot of information into a small space. (Suggestions on page 228.)

The example below is repeated from Chapter 2, where we discussed proximity. It's nice and clean, but notice how much of a difference a little contrast can make.

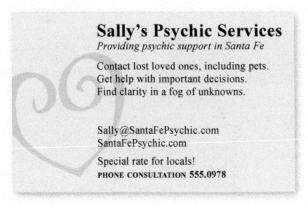

Remember this postcard from page 19? It gains a little more strength with a strong left alignment.

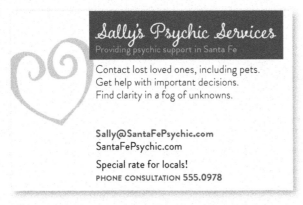

We gain even more contrast by letting go of the pale purple paper and adding some strong purple on the bright white.

Train your Designer Eye: Name at least five differences between these two cards. (Suggestions are on page 228).

typefaces
Charcuterie Cursive
Brandon Grotesque Light and **Bold**

No matter how complex or how simple a well-designed project is, there is probably some form of contrast that attracts your eyes to the page and makes you think someone actually spent the time to design it. Once you feel comfortable with the basic principles, go to the next step of really pushing yourself with ideas. See page 94 for some tips on idea gathering.

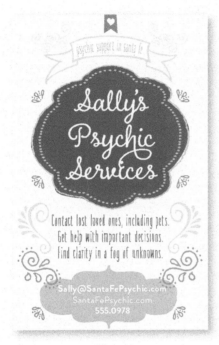

Although there is a lot going on here, it is easy to see the hierarchy of information through the contrast of elements. Plus there is one clearly centered alignment for the type.

typefaces
Charcuterie Cursive
Brandon Grotesque Light
Heart Doodles ♥
Amorie Modella Medium
Amorie Extras—Frames

Ornaments are from a variety of files found at CreativeMarket.com.

Your eye might be drawn to this card simply because of its modesty. One form of contrast here is the contrast of the small, elegant type in a large field of white.

typeface
Bauer Bodoni Roman

Summary of contrast

Contrast on a page draws our eyes to it; our eyes *like* contrast. If you are putting two elements on the page that are not the same (such as two typefaces or two line widths), they cannot be *similar*—for contrast to be effective, the two elements must be very different.

Contrast is kind of like matching wall paint when you need to cover a ding—you can't *sort of* match the color; either you match it exactly or you repaint the entire wall. As my grandfather, an avid horseshoe player, always said, "*Almost* only counts in horseshoes and hand grenades."

The basic purpose

Contrast has two purposes, and they're inextricable from each other. One purpose is to **create an interest on the page**—if a page is interesting to look at, it is more likely to be read. The other is to aid in the **organization** of the information. A reader should be able to instantly understand the way the information is organized, the logical flow from one item to another. The contrasting elements should never serve to confuse the reader or to create a focus that is not supposed to be a focus.

How to get it

Add contrast through your typeface choices (see the second half of this book), line thicknesses, colors, shapes, sizes, space, etc. It is easy to find ways to add contrast, and it's probably the most fun and satisfying way to add visual interest. The important thing is to be strong.

What to avoid

If you're going to contrast, do it with strength. Avoid contrasting a sort-of-heavy line with a sort-of-heavier line. Avoid contrasting brown text with black headlines. Avoid using two or more typefaces that are similar. If the items are not exactly the same, **make them different!**

Review of the Four Design Principles

There is one more general guiding principle of Design (and of Life):
Don't be a wimp.

Don't be afraid to create your Design (or your Life) with plenty of blank space—it's rest for the eyes (and the Soul).

Don't be afraid to be asymmetrical, to uncenter your format— it often makes the effect stronger. It's okay to do the unexpected.

Don't be afraid to make words very large or very small; don't be afraid to speak loudly or to speak in a whisper. Both can be effective in the right situation.

Don't be afraid to make your graphics very bold or very minimal, as long as the result complements or reinforces your design or your attitude.

Let's take the rather dull report cover you see below and apply each of the four design principles in turn.

Your Attitude

is Your Life

Lessons from raising three children

as a single mom

Robin Williams

October 9

This is typical but rather dull: centered, evenly spaced to fill the page. If you didn't read English, you might think there are six separate topics on this page. Each line seems an element unto itself.

typeface
Times New Roman

Proximity

If items are related to each other, group them into closer proximity. Separate items that are *not* directly related to each other. Vary the space between to indicate the closeness or the importance of the relationship. Besides creating a nicer look to the page, it also communicates more clearly.

Your Attitude is Your Life

Lessons from
raising three children
as a single mom

Robin Williams
October 9

By putting the title and subtitle close to each other, we now have one well-defined unit rather than six apparently unrelated units. It is now clear that those two topics are closely related to each other.

When we move this byline and date farther away, it becomes instantly clear that although this is related information and possibly important, it is not part of the title.

Your Attitude
is Your Life

Lessons from
raising three children
as a single mom

Robin Williams
October 9

This is just an example of the huge difference a font can make in the visual impression of a piece. Everything else is exactly the same—size, spacing, etc.

typeface
Modernica Light

Alignment

Be conscious about every element you place on the page. To keep the entire page unified, align every object with an edge of some other object. If your alignments are strong, *then* you can *choose* to break an alignment occasionally and it won't look like a mistake.

Your Attitude is Your Life

Lessons from
raising three children
as a single mom

Robin Williams
October 9

The example on the opposite page is also aligned—a centered alignment. As you can see, though, a flush left or flush right alignment (as shown here) gives a stronger edge, a stronger line for your eye to follow.

The tension created by a flush left or flush right alignment often tends to impart a more sophisticated look than does a centered alignment.

Your Attitude
is Your Life

Lessons from
raising three children
as a single mom

Robin Williams
October 9

Even though the author's name is far from the title, there is a visual connection, an invisible line, between the two elements because of the strong alignment to each other.

Repetition

Repetition is a stronger form of being consistent. Look at the elements you already repeat (bullets, typefaces, lines, colors, etc.); see if it might be appropriate to make one of these elements stronger and use it as a repetitive element. Repetition also helps strengthen the reader's sense of recognition of the entity represented by the design.

YOUR ATTITUDE
IS YOUR LIFE

Lessons from
raising three children
as a single mom

ROBIN WILLIAMS
October 9

The typeface and color in the title is repeated in the author's name, which strengthens their connection even though they are physically far apart on the page.

typeface
PANOPTICA EGYPTIAN
Hypatia Sans Light

Your Attitude
is Your Life
. .

Lessons from
raising three children
as a single mom

.
Robin Williams
October 9

Here, the dotted rule becomes a repetitive element. Even though these are not the same length, a dotted line is distinct enough to be used in all sorts of ways throughout the document and still be seen as a repetitive element.

Contrast

Would you agree that the examples on this page attract your eye more than the examples on the opposite page? It's the contrast, the strong black versus white, that does it. You can add contrast in many ways. The second half of this book discusses the specific topic of contrasting type, which is the basis of all great graphic design.

Your Attitude is Your Life

Lessons from
raising three children
as a single mom

Robin Williams
October 9

Adding contrast to this was simply a matter of adding the black boxes.

On the opposite page, the dark red font acts as a contrast as well as a repetition.

**YOUR ATTITUDE
IS YOUR LIFE**

Lessons from
raising three children
as a single mom

ROBIN WILLIAMS
October 9

You can also add contrast through your font choice. Here the contrast is not just the heavy black face on the white paper, but also the contrast of a thick font versus its light version, as well as all caps versus lowercase.

In both of these versions, the heavy font and the caps also act as repetitions.

typeface
Modernica Light and **Heavy**

Little Quiz #1: Design principles

Find at least seven differences between the two pretend résumés below. Circle each difference and name the design principle it offends. State in words what the changes are. (Answers are on page 223.)

Résumé: Launcelot Gobbo
#73 Acequia Canal
Venice, Italy

Education

- Ravenna Grammar School
- Venice High School, graduated with highest honors
- Trade School for Servants

Work Experience

1593 Kitchen Help, Antipholus Estate
1597 Gardener Apprentice, Tudor Dynasty
1598 Butler Internship, Pembrokes

References

- Shylock the Moneylender
- Bassanio the Golddigger

Résumé
▾ Launcelot Gobbo
 #73 Acequia Canal
 Venice, Italy

Education
▴ Ravenna Grammar School
▴ Venice High School, graduated
 with highest honors
▴ Trade School for Servants

Work Experience
▴ 1593 Kitchen Help, Antipholus Estate
▴ 1597 Gardener Apprentice, Tudor Dynasty
▴ 1598 Butler Internship, Pembrokes

References
▴ Shylock the Moneylender
▴ Bassanio the Golddigger

1

2

3

4

5

6

7

typefaces
Helvetica Regular
Modernica Heavy
Adobe Jenson Pro
ITC Zapf Dingbats ▴

Little Quiz #2: Redesign this ad

What are the problems with this advertisement? **Name the problems so you can find the solutions.**

Clues: Is there one main focal point? Why not, and how could you create one? DO YOU NEED ALL CAPS? Do you need the heavy border *and* the inner box? How many different typefaces are in this ad? How many different alignments? Are the logical elements grouped together into close proximity? What could you use as a repetitive element?

Take a piece of tracing paper and trace the outline of the ad. Then sketch in the individual elements, rearranging them into a more professional, clean, direct advertisement. Work your way through each principle: proximity, alignment, repetition, and contrast. Some suggestions as to where to begin are on the following pages.

THERE ARE MANY DIFFERENT WAYS TO MAKE AND USE DREAMCATCHERS. WE CREATE DREAMCATCHERS IN A MANNER THAT IS MOST MEANINGFUL TO US, BUT ONCE IT IS YOURS, IT CAN SIGNIFY OR SYMBOLIZE ANYTHING YOU WISH.

MOONSTONE DREAMCATCHERS

A dreamcatcher is a protective charm, usually hung above a bed or a baby's cradle. The circular shape of the dreamcatcher symbolizes the sun and the moon. The webbing inside the circle traps bad dreams and negativity, which then perish at dawn's light. The opening in the middle of the web allows good dreams and positive affirmations safe passage to and from the dreamer. The feathers guide goodness and light down to the dreamer, while the precious stones and crystals provide protection and invite healing.

Each Moonstone Dreamcatcher is made by hand and with love in Santa Fe, New Mexico. We use natural crystals and precious stones with healing, protective, and restorative qualities. Special requests and custom orders can be accommodated. Every Moonstone Dreamcatcher is a unique creation.

web site: http://www.moonstonecatchers.com

email: info@moonstonecatchers.com

BY MATT AND SCARLETT

Little Quiz #2 continued: Where to begin?

Knowing where to begin can sometimes seem overwhelming. So first of all, let's clean it up.

Get rid of everything superfluous so you know what you're working with. For instance, you don't need "http://" in a web address. You don't need the words "web site" or "email" because the format of the text and numbers tells you what the item is. You don't need a box around the image. You don't need ALL CAPS. You can perhaps edit the text.

The rounded edges of the border made this ad look wimpy. So make the border thinner and sharp. If your ad is in color, perhaps you could use a pale tint shape instead of any border at all. Choose a new typeface or two.

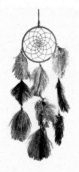

MOONSTONE DREAMCATCHERS
by Matt and Scarlett

A dreamcatcher is a protective charm, usually hung above a bed or a baby's cradle. The circular shape of the dreamcatcher symbolizes the sun and the moon. The webbing inside the circle traps bad dreams and negativity, which then perish at dawn's light. The opening in the middle of the web allows good dreams and positive affirmations safe passage to and from the dreamer. The feathers guide goodness and light down to the dreamer, while the precious stones and crystals provide protection and invite healing.

Each Moonstone Dreamcatcher is made by hand and with love in Santa Fe, New Mexico. We use natural crystals and precious stones with healing, protective, and restorative qualities. Special requests and custom orders can be accommodated. Every **Moonstone Dreamcatcher** is a unique creation.

There are many different ways to make and use dreamcatchers. We create dreamcatchers in a manner that is most meaningful to us, but once it is yours, it can signify or symbolize anything you wish.

www.MoonstoneCatchers.com
info@MoonstoneCatchers.com

typefaces
Bree Light and **Bold**

Web and email addresses are easier to read if you cap the main words. Don't worry—before the first slash in a web address, it doesn't matter if you use caps or lowercase.

Now that you can see what you're really working with, determine what should be the focal point. The focal point might be slightly different depending on where the ad is placed. That is, what is the purpose of this piece in this particular magazine (or wherever it is)? That will help you determine the hierarchy of the rest of the information. Which items *should* be grouped together into closer proximity?

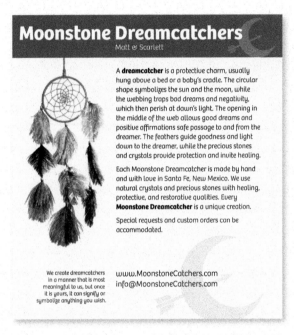

These are just two of endless possibililties, of course.

Put into words where each of the principles has been used.

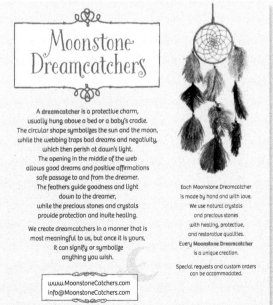

typefaces
Bree Light and **Bold**
Bookeyed Martin
Amorie Extras—Frames

Summary

This concludes the design portion of our presentation. You probably want more examples. Examples are all around you—what I most hope to have painlessly instilled in you is an **increased visual awareness.** And don't forget to read about some great resources available to you on page 235, including thousands of templates for every project imaginable at CreativeMarket.com. Start with a template, begin the design process, and the template becomes uniquely your own.

Keep in mind that professional designers are always "stealing" other ideas; they are constantly looking around for inspiration. If you're doing a flyer, find a flyer or template you really like and adapt the layout. Simply by using your own text and graphics, the original flyer turns into your own flyer. Find a business card you like and adapt it to your own. Find a newsletter masthead you like and adapt it to your own. *It changes in the adaptation and becomes yours.* We all do it.

For now, have fun. Lighten up. Don't take all this design stuff too seriously. I guarantee that if you simply follow these Four Principles of Design, you will be creating dynamic, interesting, organized pages you will be proud of.

Design with Color

This is a wonderful time in the world of graphic design. Everyone has color printers on their desktops, and professional color printing has never in the history of this planet been so available and affordable. (Search the web for color printing services and compare prices.)

Color theory can get very complex, but in this chapter I'm just going to provide a brief explanation of the color wheel and how to use it. A color wheel is amazingly useful when you need to make a conscious decision about choosing colors for a project.

And I'll briefly explain the difference between the color models CMYK and RGB and when to use each one.

As you can see in these simple examples, color not only has its own impact, but it impacts all objects around it.

The amazing color wheel

The color wheel begins with yellow, red, and blue. These are called the **primary colors** because they're the only colors you cannot create. That is, if you have a box of watercolors, you know you can mix blue and yellow to make green, but there is no way to mix pure yellow, red, or blue from other colors.

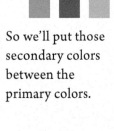

We'll space these three primary colors evenly around the wheel.

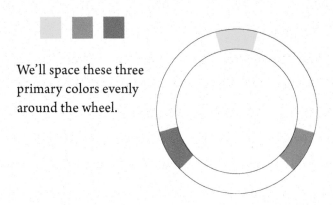

Now, if you take your watercolor box and mix each of these colors with an equal amount of the one next to it, you'll get the **secondary colors.** As you're probably aware from working with crayons and watercolors as a kid, yellow and blue make green; blue and red make purple; red and yellow make orange.

So we'll put those secondary colors between the primary colors.

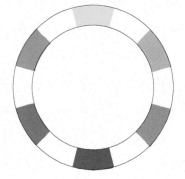

To fill in the empty spots in the color wheel, you probably know what to do—mix equal parts of the colors on each side. These are called the **tertiary** (or third) **colors.** That is, yellow and orange make, well, yellow-orange. And blue and green make blue-green (which I'll call aqua).

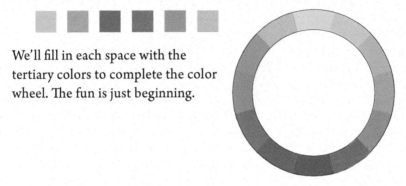

We'll fill in each space with the tertiary colors to complete the color wheel. The fun is just beginning.

Color relationships

So now we have a color wheel with the basic twelve colors. With this color wheel, we can create combinations of colors that are pretty much guaranteed to work together. On the following pages, we'll explore the various ways to do this.

(In the CMYK color model we're using, as explained on page 110, the "color" black is actually the combination of all colors, and the "color" white is an absence of all colors. It is just the opposite when using RGB.)

Complementary

Colors directly across from each other, exact opposites, are **complements.** Because they're so opposite, they often work best when one is the main color and the other is an accent.

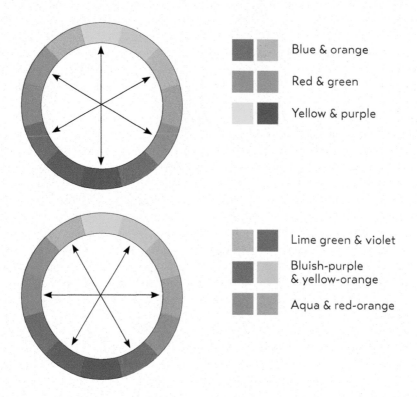

Blue & orange

Red & green

Yellow & purple

Lime green & violet

Bluish-purple & yellow-orange

Aqua & red-orange

Now, you might think some of the color combinations on these pages are pretty weird. But that's the great thing about knowing how to use the color wheel—you can gleefully use these weird combinations and know that you have permission to do so! They really do work well together.

typefaces
Thirsty Rough Bold One
Thirsty Rough Bold Shadow

Triads

A set of three colors equidistant from each other always creates a **triad** of pleasing colors. Red, yellow, and blue is an extremely popular combination for children's products. Because these are the primary colors, this combination is called the **primary triad.**

Experiment with the **secondary triad** of green, orange, and purple—not as common, but an exciting combination for that very reason.

All triads (except the primary triad of red, yellow, and blue) have underlying colors connecting them, which make them harmonize well.

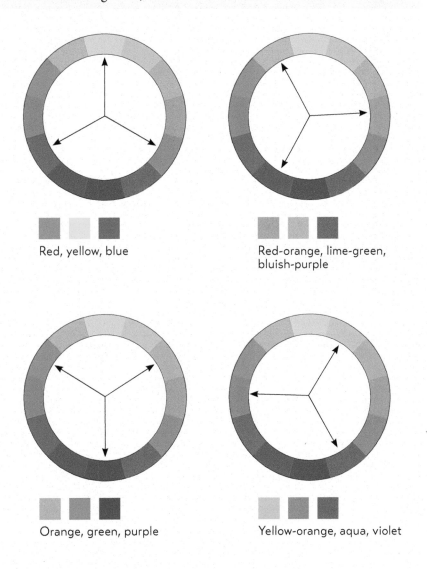

Red, yellow, blue

Red-orange, lime-green, bluish-purple

Orange, green, purple

Yellow-orange, aqua, violet

Split complement triads

Another form of a triad is the **split complement.** Choose a color from one side of the wheel, find its complement directly across the wheel, but use the colors *on each side of the complement* instead of the complement itself. This creates a combination that has a little more sophisticated edge to it. Below are just a couple of the various combinations.

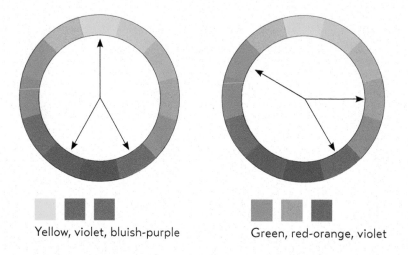

Yellow, violet, bluish-purple

Green, red-orange, violet

I also used tints—you can count four different colors in each of the above examples. See pages 102–105 for information about tints.

typefaces
HORST
ESTILO PRO BOOK

Analogous colors

An **analogous** combination is composed of those colors that are next to each other on the wheel. No matter which two or three you combine, they all share an undertone of the same color, creating a harmonious combination. Combine an analogous group of colors with their various tints and shades, as explained on the following page, and you've got lots to work with!

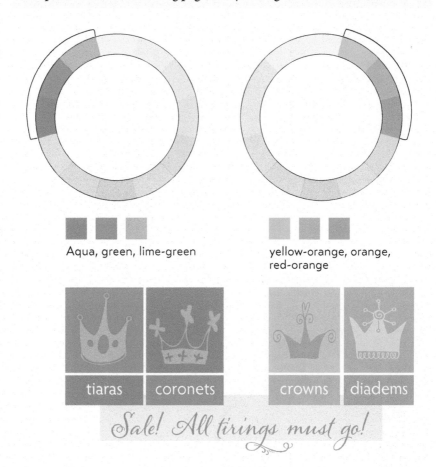

Aqua, green, lime-green

yellow-orange, orange, red-orange

tiaras coronets

crowns diadems

Sale! All tirings must go!

typefaces
Hypatia Sans Pro Regular
Alana
Crowns ♔

Shades and tints

The basic color wheel that we've been working with so far involves only the "hue," or the pure color. We can hugely expand the wheel and thus our options simply by adding black or white to the various hues.

The pure color is the **hue.**

Add black to a hue to create a **shade.**

Add white to a hue to create a **tint.**

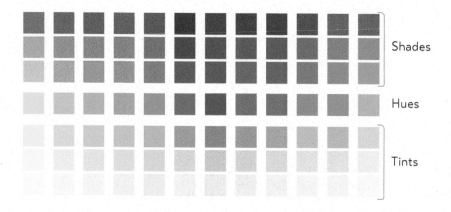

Shades

Hues

Tints

Below is what the colors look like in the wheel. What you see here are colored bands, but it's really a continuous gradient with an infinite number of colors from white to black.

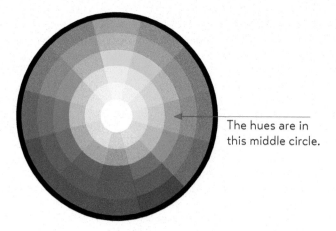

The hues are in this middle circle.

Make your own shades and tints

If your software program allows you to create your own colors, just add black to a color to create a shade. To make a tint, use the tint slider your application provides to lighten it. Check your software manual.

If your application provides a color palette something like this one, here's how to make tints and shades.

First, make sure to select the color wheel icon in the toolbar (circled).

Make sure the slider is at the top of the colored bar on the right.

The tiny dot inside the color wheel selects the color.

Hues are on the outer rim of this particular wheel.

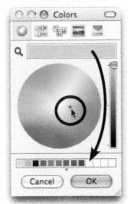

To create a tint, drag the tiny dot toward the white center.

The color bar at the top displays the color you've selected.

To save that exact color for use again, press on that upper color bar and drag—it will create a tiny color box. Drop that color box into one of the empty slots at the bottom.

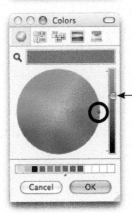

To create a shade, position the tiny dot on the color of which you want to make a shade.

Drag the slider on the right downward. You'll get millions of subtle options.

To save that exact color for use again, see above.

Monochromatic colors

A **monochromatic** combination is composed of one hue with any number of its corresponding tints and shades.

You're actually very familiar with a monochromatic scheme—any black and white photograph is made of black (the "hue," although black isn't really a "color") and many tints or varying shades of gray. You know how beautifully that can work. So have fun with a design project using a monochromatic combination.

This is the purple hue with several of its shades and tints. You can actually reproduce the effect of a number of colors in a one-color print job; use shades and tints of black, then have it printed with the ink color of your choice.

Purple

The **Too Loose** Drawing Group

Come join others who like to draw! Our **live models** use a variety of poses that vary in duration from two-minute warmup drawings to forty-minute poses over a three-hour period.

$10 fee for each evening session. Join the community!
meetup.com/SFDrawing

This postcard is set up using only tints of black.

This is printed using tints and shades of one purple. It's a great **exercise** to limit yourself to a monochrome palette.

The **Too Loose** Drawing Group

Come join others who like to draw! Our **live models** use a variety of poses that vary in duration from two-minute warmup drawings to forty-minute poses over a three-hour period.

$10 fee for each evening session. Join the community!
meetup.com/SFDrawing

typefaces
Clarendon Neo
Transat Text Standard and **Bold**
Toulouse-Lautrec Ornaments

Shades and tints in combination

Most fun of all, choose one of the four color relationships described on pages 98–101, but instead of using the hues, use various tints and shades of those colors. This expands your options tremendously, but you can still feel safe that the colors "work" together.

For instance, the combination of red and green is a perfect complement, but it's almost impossible to get away from a Christmas effect. However, if you dip into the *shades* of these complementary colors, riches appear.

I mentioned that the combination of the primary colors of blue, red, and yellow is extremely popular for children's products. So popular, in fact, that it's difficult to get away from the kids' look, unless you bring in some of the tints and shades—voilà! Rich and delicious combinations.

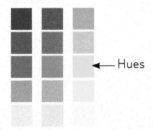
←— Hues

typefaces
Bookeyed Martin
fRances uNciaL
Hypatia Sans Pro Regular and **Black**

Watch the tones

Are there any colors that don't look great together? Not if you subscribe to the Wildflower Theory of Color—have you ever seen a field of wildflowers and said, "Omigosh, that's a dreadful combination of colors in that field." Probably not.

That field of wildflowers includes a variety of tones, or different values of colors, which naturally look good together. You will only run into problems when the tones are too similar.

Tone refers to the particular quality of brightness, deepness, or hue of any color. As you can see in the first examples below, when the tones are similar, it gets a little muddy. The contrast is too weak. If you were to reproduce the examples below on a copy machine, the text would get lost.

If your design calls for hues with similar tones, try not to bump them up together, and don't use the same amounts of each one.

The tones of these dark colors are much too close, as you can obviously tell.

The contrast is much better here; the contrast is a result of differences in tones. Where there might be some trouble (in the white ornament on the pale tint), I added a bit of a shadow to separate the two elements. On the opposite page where a dark red text was having a hard time on the black field, I lightened the values.

Warm colors vs. cool colors

Colors tend to be either on the warm side (which means they have some red or yellow in them) or on the cool side (which means they have some blue in them). You can "warm up" certain colors, such as grays or tans, by adding more reds or yellows to them. Conversely, you can cool down some colors by adding various blues to them.

The most practical thing to remember is that cool colors *recede* into the background, and warm colors come *forward*. It takes very little of a hot color to make an impact—reds and yellow jump right into your eyes. So if you're combining hot colors with cool, generally use less of the hot color.

Cool colors recede, so you can use (sometimes you *have* to use) more of a cool color to make an impact or to contrast effectively.

Don't try to make the colors appear to have equal weight! Take advantage of this visual phenomenon.

An excess of red can be overwhelming and rather annoying.

Can you feel the red still overpowering the blue? Consider what you want the reader to focus on first.

typeface
MYNARUSE BOLD
Aptifer Regular

How to begin to choose?

Sometimes it can seem overwhelming to choose colors. Start with a logical approach. Is it a seasonal project you're working on? Perhaps use analogous colors (page 101) that connote the seasons—hot reds and yellows for summer; cool blues for winter; shades of oranges and browns for autumn; bright greens for spring.

Are there official company colors to work with? Perhaps you can start there and use tints and shades (pages 102–105). Are you working with a logo that has specific colors? Perhaps use a split complement of its colors (page 100).

Does your project include a photograph or other image? Pick up a color in the photograph and choose a range of other colors based on that. You might want analogous colors to keep the project sedate and calm, or complementary colors to add some visual excitement.

I picked up colors in the ball and the bug to use for the title and byline. For the rest of the project, I might use the colors analogous to the tan color of the background, with tints from the bug wings for accents.

In some applications you'll find an eyedropper tool with which you can pick up colors. Using InDesign, I used the eyedropper to grab colors from the bug and the ball. I could build my project with these colors.

typefaces

ESTILO PRO BOOK

Garmond Premier Pro Semibold Italic

If you're working on a project that recurs regularly, you might want to make yourself a color palette to which you'll consistently refer for all projects.

For instance, I publish a twenty-page booklet every two months on some tidbit of the Shakespearean works. There are six main themes that recur every year, so after collecting them for a few years, the color-coding becomes an organizational tool. I chose 80-percent tints of the six tertiary colors (page 97) for the main color blocks on the covers; the color wraps around onto the back and the title is always reversed out.

If you're beginning a new project that's composed of a number of different pieces, try choosing your color palette before you begin. It will make a lot of decisions easier for you along the way.

typefaces
Wade Sans Light

CMYK vs. RGB: print vs. screen

There are two important color models to be aware of. Here is the briefest of explanations on a very complex topic. If all you ever do is print to your little desktop color inkjet, you can get by without knowing anything about color models, so you can skip this for now. It will be here when you need it.

CMYK

CMYK stands for Cyan (which is a blue), Magenta (which is sort of red/pink), Yellow, and a Key color, which is usually blacK. With these four colors of ink, we can print many thousands of colors, which is why it's called a "four-color process." (Specialized print jobs can include extra colors of inks.)

The colors in CMYK are like our coloring crayons or paint boxes—blue and yellow make green, etc. This is the model we've been using throughout this chapter because this is a printed book.

CYMK is the color model you'll use for projects that are going to be printed by a printing press onto something physical. Just about everything you ever see printed in a book, a magazine, a poster, on matchbox covers or cookie boxes has been printed with CMYK.

Take a look at a printed color image with a magnifying glass and you'll be able to see the "rosettes" made up of the dots of the four colors.

RGB

RGB stands for Red, Green, and Blue. RGB is what you see on your computer monitor, television, iPhone, iPad, or any other electronic device.

In RGB, if you mix red and green you get—yellow. Really. Mix full-strength blue and red and you get hot pink. That's because RGB is composed of beams of colored light that are not reflected off of any physical object—it is light that goes straight from the monitor into your eyes. If you mix all the RGB colors together you get white, and if you delete all the colors, you get black.

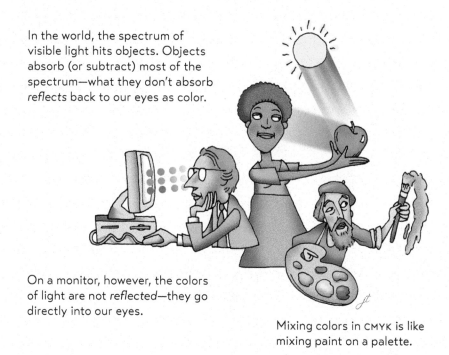

In the world, the spectrum of visible light hits objects. Objects absorb (or subtract) most of the spectrum—what they don't absorb *reflects* back to our eyes as color.

On a monitor, however, the colors of light are not *reflected*—they go directly into our eyes.

Mixing colors in CMYK is like mixing paint on a palette.

Print vs. web color models

The important thing to remember about CMYK and RGB is this:

Use CMYK for projects that are to be printed.

Use RGB for anything that will be viewed on a screen.

If you're printing to an expensive digital color printer (instead of a four-color printing press), check with the press operator to see whether they want all colors in CMYK or RGB.

RGB makes smaller file sizes, and some techniques in Adobe Photoshop work only (or best and usually faster) in RGB. But switching back and forth from CMYK to RGB loses a little data each time, so it's best to work on your images in RGB and change them to CMYK as the last thing you do.

Because RGB works through light that goes straight into our eyes, the images on the screen are gorgeous and backlit with an astonishing range of colors. Unfortunately, when you switch to CMYK and then print that with ink on paper, you lose some of that brilliance and range. That's just what happens, so don't be too disappointed.

Little Quiz #3: Color

A quick quiz to settle a few terms in your design mind. (Answers page 224.)

1 Colors that are *next* to each other on the color wheel are called _____.

2 Colors *across* from each other are _____.

3 Add white to a hue to create a _____.

4 Add black to a hue to create a _____.

5 You are going to send a job to press to be printed on paper. Should your images be CMYK or RGB? _____

6 You are creating images for a web site. Should the images be CMYK or RGB? _____

Extra Tips & Tricks

In this chapter we'll look at creating a variety of common advertising, promotional, and fun pieces. I add lots of other tips and tricks and techniques in this section, but you'll see where the four basic principles apply to every project, no matter how big or small. Whether you plan to have your project printed or you plan to make a PDF and send it digitally or use it to create web pages, the design principles are the same.

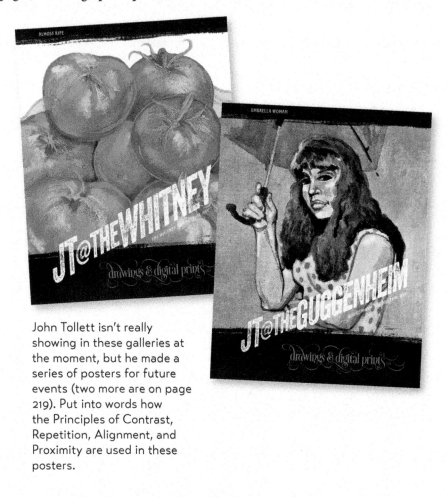

John Tollett isn't really showing in these galleries at the moment, but he made a series of posters for future events (two more are on page 219). Put into words how the Principles of Contrast, Repetition, Alignment, and Proximity are used in these posters.

typefaces
VENEER THREE
Stocklet Bold
Desire

Creating a package or brand

One of the most important features of an identity package or branding follows the Principle of Repetition: there must be some identifying image or style that carries throughout every piece.

You probably automatically repeat a feature, but once you do something intentionally instead of automatically it becomes a little bigger. Push the similarities, the identifying characteristics. Make your mark.

An ongoing project of mine is The Shakespeare Papers, bimonthly twenty-page booklets that are each about one tiny aspect of the plays (the color scheme is shown on page 109). Because each booklet is completely redesigned, it was critical that there be something to tie them all together. In this case it is the color band on the left along with the font and its placement. Each issue in each theme repeats the same color of band. The opening page spread also has a layout consistent throughout the series.

I'm branching out The Shakespeare Papers to include booklets to buy at the gift shop before watching the play, the Synopsis series, that help you understand and enjoy the production. You can see the repetitive branding that makes these part of The Shakespeare Paper series—yet clearly different.

Under The Shakespeare Papers brand I am also creating a series of plays edited and designed specifically for adults reading Shakespeare aloud in community. These books, the Readers' Editions, are larger than the booklets but carry the same brand.

This postcard for a show of life drawings has a strong brand in its graphics and colors. This made it easy to create lots of product at CafePress.com that were clearly part of the same package. Do you see the change that was made in the graphic title so we could create product on a white background?

The book we designed for the show carries the large font throughout not only the book but the show itself. We produced copies through CreateSpace.com.

Business cards

Standard business card size in the U.S. is 3.5 inches wide by 2 inches tall (8.5cm x 5.5cm in many other countries). A vertical format, of course, would be 2 inches wide by 3.5 inches tall. It is so inexpensive to have both sides of your card printed in full color, so in some cases you can consider putting minimal but effective information on one side and the rest on the back.

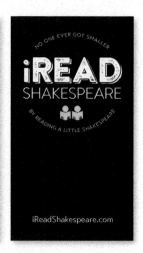

If you are printing your cards at home or at the office, you probably don't want a full-bleed card because it uses so much toner and does not always print smoothly. But if you are printing them at one of the great online print shops, take advantage of the inexpensive full color! I use PrintPlace.com.

You can see that a dramatic background can completely change the look of a card. Keep in mind, however, that we often need to write on a card to remember who gave it to us and why. So if you use a full-bleed on the front, leave room on the back for notes.

 typefaces
VENEER THREE
Verlag Light, Book, and **Black**

typefaces
Adorn Bouquet
Proxima Nova Regular
BRANDON PRINTED ONE SHADOW
Transat Text Standard

Try this . . .

BAYARD A. HARPER, DDS, MS
IMPLANTS PERIODONTICS

ORLANDO KENT
IMPLANT TREATMENT COORDINATOR

NORTHERN CALIFORNIA
PERIODONTAL
ASSOCIATION, PC
info@ncpapc.org

1561 MAIN STREET
STE. 359, ARDEN, CA 91621
C 505-555-0987
P 505-555-1234 **F** 505-555-5678

Do you see a problem with this card (besides the type stuck in the corners)? Here's a question: Whose card is it? It is actually Orlando's card. Which principle is missing that could clarify the information?

BAYARD A. HARPER, DDS, MS
IMPLANTS PERIODONTICS

ORLANDO KENT
IMPLANT TREATMENT COORDINATOR

NORTHERN CALIFORNIA
PERIODONTAL
ASSOCIATION, PC
info@ncpapc.org

1561 MAIN STREET
STE. 359, ARDEN, CA 91621
C 505-555-0987
P 505-555-1234 **F** 505-555-5678

If we do just one thing—utilize the Principle of Contrast—we know whom the card represents.

BAYARD A. HARPER, DDS, MS
IMPLANTS PERIODONTICS

ORLANDO KENT
IMPLANT TREATMENT COORDINATOR

1561 Main Street, Suite 359, Arden, CA 91621
c 505.555.0987 · p 505.555.1234 · f 505.555.5678
Northern California Periodontal Association, PC
info@ncpapc.org

We have to get the text out of the corners. When you have a lot of information, consider a tall card.

BAYARD A. HARPER, DDS, MS
IMPLANTS AND PERIODONTICS

ORLANDO KENT
IMPLANT TREATMENT COORDINATOR

1561 Main Street, Suite 359, Arden, CA 91621
c 505.555.0987 ★ p 505.555.1234 ★ f 505.555.5678
Northern California Periodontal Association, PC
info@ncpapc.org

BAYARD A. HARPER
DDS MS
IMPLANTS & PERIODONTICS

ORLANDO KENT
IMPLANT TREATMENT COORDINATOR

1561 Main Street, Suite 359
Arden, CA 91621

c 505.555.0987
p 505.555.1234
f 505.555.5678

Northern California Periodontal
Association, PC
info@ncpapc.org

Now that there is *really* some contrast on these last two cards, can you feel your eyes more attracted to them?

Bayard A. Harper
DDS MS

implants and
periodontics

Orlando Kent
implant treatment coordinator

1561 Main Street, Suite 359
Arden, CA 91621

c 505.555.0987
p 505.555.1234
f 505.555.5678

Northern California
Periodontal Association, PC
info@ncpapc.org

or this . . .

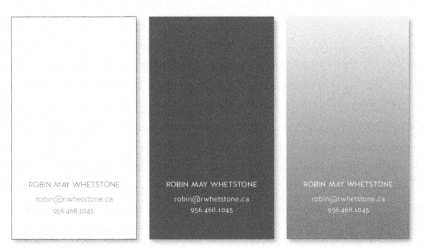

Consider something very simple, especially if you don't need to provide any information except how to contact you. I have a card that only includes my name and email address because I avoid the phone.

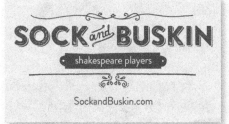

Corporate cards typically include a great deal of information (as on the opposite page), but more casual cards like these can maximize the visual attraction and minimize the information to what is truly necessary.

typefaces

EDITION REGULAR
Halis GR Book, **Bold**, and S BOOK
BRANDON PRINTED TWO SHADOW
Adobe Wood Type Ornaments

Tips on designing business cards

Business cards can be a challenge to design because you usually need to pack a lot of information into a small space. And the amount of information you put on a business card has been growing—in addition to the standard address and phone, now you probably need your cell number, fax number if you still use that technology, email address, social media info, your web address if you have one.

With this in mind, however, *eliminate everything that is not absolutely necessary.* Your business card is not a brochure. Also eliminate words like "telephone" and "email" and "web address" because we know what those things are without having to be told.

Format

Your first choice is whether to work with a **horizontal** format or a **vertical** one. Just because most cards are horizontal doesn't mean they *have* to be. Very often the information fits better in a vertical layout, especially when we have so many pieces of information to include on such a little card. Experiment with both vertical and horizontal layouts, *and choose the one that works best for the information you have on your card.*

Type size

One of the biggest problems with business cards designed by new designers is the type size. It's usually **too big.** Even the 10- or 11-point type we read in books looks horsey on a small card. And 12-point type looks downright dorky. I know it's difficult at first to use 9- or even 8- or 7-point type, but look at the business cards you've collected. Pick out three that look the most professional and sophisticated. They don't use 12-point type.

Keep in mind that a business card is not a book, a brochure, or even an ad—a business card contains information that a client needs to look at for only a couple of seconds. Sometimes the overall, sophisticated effect of the card's design is actually more important than making the type big enough for your great-grandmother to read easily.

Create a consistent image on all pieces

If you plan to create a letterhead and matching envelopes, you really need to design all three pieces at once. The entire package of business cards, letterhead, and envelopes should present a **consistent image** to clients and customers.

Letterhead and envelopes

Few people look at a company's stationery and think, "This is so beautiful, I'll triple my order," or "This is so ugly, I'm not going to donate my time to them." But when people see your stationery, they think *something* about you and it's going to be positive or negative, depending on the design and feel of that stationery.

From the quality of the paper you choose to the design, color, typeface, and the envelope, the implied message should inspire confidence in your business. The content of your letter, of course, will carry substantial weight, but don't overlook the unconscious influence exerted by the letterhead itself.

If you don't use full-size stationery very often, you might find a use for half sheets for writing notes to include in packages, send thank-you notes, or just to dash off a real handwritten message to someone.

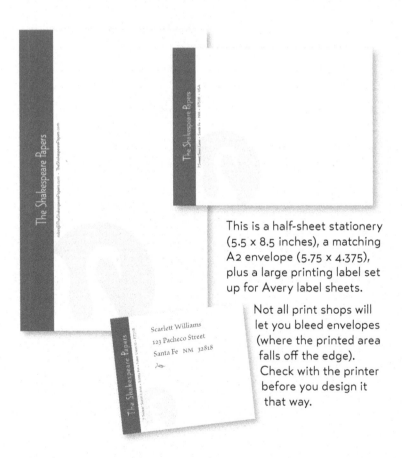

This is a half-sheet stationery (5.5 x 8.5 inches), a matching A2 envelope (5.75 x 4.375), plus a large printing label set up for Avery label sheets.

Not all print shops will let you bleed envelopes (where the printed area falls off the edge). Check with the printer before you design it that way.

Try this . . .

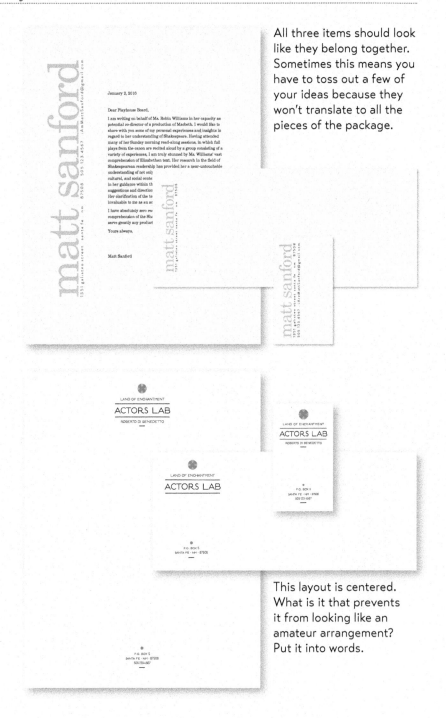

All three items should look like they belong together. Sometimes this means you have to toss out a few of your ideas because they won't translate to all the pieces of the package.

This layout is centered. What is it that prevents it from looking like an amateur arrangement? Put it into words.

or this . . .

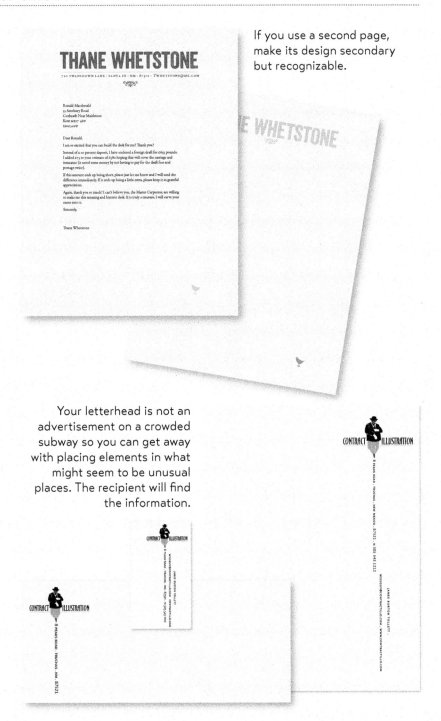

If you use a second page,
make its design secondary
but recognizable.

Your letterhead is not an
advertisement on a crowded
subway so you can get away
with placing elements in what
might seem to be unusual
places. The recipient will find
the information.

Tips on letterhead and envelope design

Design your letterhead and envelope at the same time as your business card. They should look like they belong together—if you give someone a business card and then later send a letter, those pieces should reinforce each other.

Envelope size

The standard business envelope is **9.5 x 4.125 inches.** It's called a #10 envelope. The European size is 110 mm x 220 mm, and it's called a C4 envelope.

Create a focal point

One element should be **dominant,** and it should be dominant in the same way on the letterhead, the envelope, and the business card. Experiment with possibilities other than the centered-across-the-top layout on the letterhead (also see pages 37–41).

Alignment

Choose one **alignment** for your stationery! Don't center something across the top and then put the rest of the text flush left. Be brave—try flush right down the side with lots of linespacing. Try setting your company name in huge letters across the top. Try placing your logo (or a piece of it) huge and light as a shadow beneath the area where you will type.

On the letterhead, make sure to arrange the elements so when you type the actual letter, the text fits neatly into the design of the stationery.

Second page

If you have a need for a second page to your stationary, take a **small element** that appears on your first page and use it all by itself on a second page. If you are planning to print, say, 1,000 sheets of letterhead, you can usually ask the printshop to print something like 800 of the first page and 200 of the second page. Even if you don't plan to print a second page, ask the printer for several hundred blank sheets of the same paper so you have *something* on which to write longer letters.

Faxing and copying

If you still use a fax machine and plan to send your letterhead through a **fax** or print it on a **copy machine,** don't choose a dark paper or one that has lots of speckles in it. Also avoid large areas of dark ink, reverse type, or tiny type that will get lost in the process. If you do a *lot* of faxing, you might want to create two versions of your letterhead—one for print and one for fax.

Flyers

Flyers are fun to create because you can safely abandon restraint! This is a great place to go wild and really call attention to yourself. As you know, flyers compete with all the other readable junk in the world, especially with other flyers. Often they are posted on a bulletin board with dozens of competing pages that are all trying to grab the attention of passers-by.

A flyer is one of the best places to use fun and different typefaces, and a fun face is one of the best ways to **call attention** to a headline. Don't be a wimp—this is your chance to use one of those really off-the-wall faces you've been lusting after!

And what a great place to experiment with graphics. Experiment with the graphic image or photograph at least twice the size you originally planned. Or make the headline 400 point instead of 24. Or create a minimalist flyer with one line of 14-point type in the middle of the page and a small block of text at the bottom. Anything out of the ordinary will make people stop and look, and that is 90 percent of your goal.

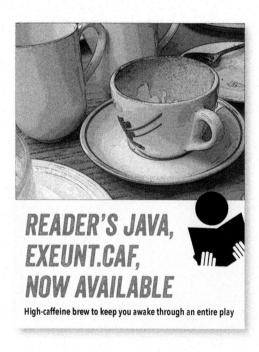

READER'S JAVA, EXEUNT.CAF, NOW AVAILABLE

High-caffeine brew to keep you awake through an entire play

Try this . . .

This flyer, above, tries to be bold and fun, but you can only get so far with Helvetica/Arial.

Find intriguing elements and make them large, create a focus. Use an appropriately distinctive font.

These graphics are actually characters in the font Backyard Beasties that were colored in InDesign.

The headline font, above, is Baileywick Festive and the text is Humana Sans.

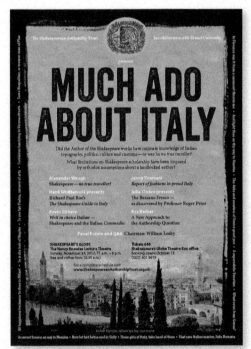

Online print shops make it so easy and inexpensive to create full-color flyers with full bleed on glossy stock. Take advantage of this!

or this . . .

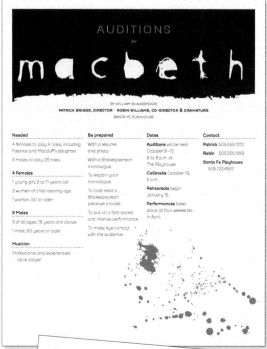

Use a huge headline or huge art.

Use an interesting typeface in a huge way.

Set the text in several columns, each one flush left or flush right.

Crop a photograph or clip art into a tall, narrow shape; place it along the left edge; align the text flush left.

Or place the art along the right edge and align the text flush right.

It's okay to set the body text small on a flyer. If you capture the reader's attention in the first place, she will read the small type.

These flyers have strong focal points that will pull in interested readers.

Tips on designing flyers

The biggest problems with most flyers created by new designers are a lack of contrast and a presentation of information that has no hierarchy. That is, the initial tendency is to make everything large, thinking that it needs to grab someone's attention. But if *everything* is large, then *nothing* can really grab a reader's attention. Use a strong focal point and contrast to organize the information and lead the reader's eye through the page.

Where people will see your flyer has everything to do with how you design it. If it arrives in the mail to someone on your mailing list, you can put much more on it. If it is to be seen on a kiosk as people walk by, the main feature must be easily readable at a glance.

Create a focal point

Put one thing on your page that is huge and interesting and **strong.** If you catch their eye with your focal point, they are more likely to read the rest of the text.

Use subheads that contrast

After the focal point, use strong subheads (strong visually, and strong in what it says) so readers can quickly **scan** the flyer to determine the point of the message. If the subheads don't interest them, they're not going to read the copy. But if there are no subheads at all and readers have to read every word on the flyer to understand what it's about, they're going to toss it rather than spend the time deciphering the text.

Repetition

Whether your headline uses an ugly typeface, a beautiful one, or an ordinary one in an unusual way, consider bringing a little of that same font into the body of the text for **repetition.** Perhaps use just one letter or one word in that same typeface. Use it as your subheads, initial caps, or perhaps as bullets. A strong contrast of typefaces will add interest to your flyer.

Alignment

And remember, choose one alignment! Don't center the headline and then set the body copy flush left, or don't center everything on the page and then stick things in the corners at the bottom. Be strong. Be brave. Try all flush left or flush right.

Newsletters

One of the most important features of a multiple-page publication is consistency, or **repetition.** Every page should look like it belongs to the whole piece. You can do this with color, graphic style, fonts, spatial arrangements, bulleted lists that repeat a formatting style, borders around photographs, captions, and so on.

Now, this doesn't mean that everything has to look exactly the same! But (just as in life) if you have a solid foundation you can get away with breaking out of that foundation with glee (and people won't worry about you). Experiment with graphics at a tilt or photographs cropped very wide and thin and spread across three columns. With that solid foundation, you can set something like the president's letter for your newsletter in a special format and it will really stand out.

It's okay to have white space (empty space) in your newsletter. But don't let the white space become "trapped" between other elements. The white space needs to be as organized as the visible elements. Let it be there, and let it flow.

One of the first and most fun things to design in a newsletter is the flag (sometimes called the masthead, although the masthead is actually the part inside that tells you who runs the magazine). The flag is the piece that sets the tone for the rest of the newsletter.

Try this . . .

Designed by Ruth Johnson

Below is one solution to the problem of putting boxes inside of boxes: use rules to separate space without enclosing it, break through the alignment, let the image itself be a container.

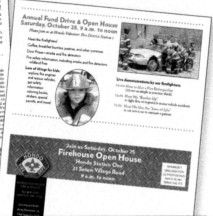

Avoid a different typeface and arrangement for every article. When you create a strong, consistent structure throughout the newsletter, then you can call attention to a special article by treating it differently. If *everything* is different, nothing is special.

This newsletter uses an underlying grid of twelve columns per page; this allows the designer to create stories that span various numbers of these columns yet always appear organized.

Or this . . .

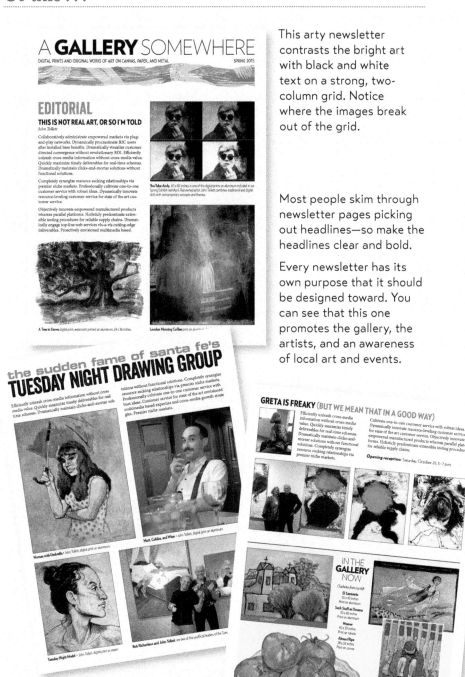

This arty newsletter contrasts the bright art with black and white text on a strong, two-column grid. Notice where the images break out of the grid.

Most people skim through newsletter pages picking out headlines—so make the headlines clear and bold.

Every newsletter has its own purpose that it should be designed toward. You can see that this one promotes the gallery, the artists, and an awareness of local art and events.

Tips on designing newsletters

The biggest problems with newsletters seem to be lack of alignment, lack of contrast, and too much Arial/Helvetica and Times New Roman.

Alignment

Choose an alignment and stick to it. Trust me—you'll have a stronger and more professional look to your entire newsletter if you maintain that strong edge along the left. And keep everything else aligned. If you use rules (lines), they should begin and end in alignment with something else, like the column edge or column bottom. If your photograph hangs outside the column one-quarter inch, crop it so it aligns instead.

You see, if all the elements are neatly aligned, then when appropriate you can freely break out of that alignment with gusto. But don't be a wimp about breaking the alignment—either align the item or don't. Placement that is a *little bit* out of alignment looks like a mistake. If your photo does not fit neatly into the column, then let it break out of the column boldly, not barely.

Paragraph indents

First paragraphs, even after subheads, should not be indented. When you do indent, use the standard typographic indent of one "em" space, which is a space as wide as the point size of your type; that is, if you're using 11-point type, your indent should be 11 points (about two spaces, not five). Use *either* extra space between paragraphs *or* an indent, but *not* both.

Not Helvetica/Arial!

If your newsletter looks a little gray and drab, you can instantly juice it up simply by using a strong, heavy, sans serif typeface for your headlines and subheads. Not Helvetica. The Helvetica or Arial that came with your computer isn't bold enough to create a strong contrast. Invest in a sans serif family that includes a heavy black version as well as a light version (such as Eurostile, Formata, Syntax, Frutiger, or Myriad). Use that heavy black for your headlines and pull-quotes and you'll be amazed at the difference. Or use an appropriate decorative face for the headlines, perhaps in another color.

Readable body copy

For best readability, try a classic oldstyle serif face (such as Garamond, Jenson, Caslon, Minion, or Palatino), or a lightweight slab serif (such as Clarendon, Bookman, Kepler, or New Century Schoolbook). What you're reading right now is Arno Pro Regular from Adobe. If you use a sans serif font, give a little extra linespace (leading) and shorter line lengths.

Brochures

Brochures are a quick and inexpensive way to get the word out about your brand new homemade-pie business, school fundraiser, or upcoming scavenger hunt. Dynamic, well-designed brochures can be eye candy for readers, drawing them in and educating them in a delightful and painless way.

Armed with the basic design principles, you can create eye-grabbing brochures of your own. The tips on the next couple of pages will help.

Before you sit down to design the brochure, fold a piece of paper into the intended shape and make notes on each flap. Pretend you just found it—in what order do you read the panels?

Keep in mind the order in which the panels of a brochure are presented to the reader as they open it. For instance, when a reader opens the front cover, they should not be confronted with copyright and contact information.

The fold measurements are not the same on the front as they are on the back! After you fold your paper sample, measure from left to right on front and back. **Do not simply divide 11 inches into thirds**—it won't work because one panel must be slightly shorter to tuck inside the other panel.

It's important to be aware of the folds; you don't want important information disappearing into the creases. **If you have a strong alignment for the text** on each panel of the brochure, however, feel free to let the graphics cross over the space between the columns of text (the **gutter**) and into the fold.

The three-fold style shown below is by far the most commonly seen for brochures because it works so well for letter-sized paper, but there are lots of other fold options available. Check with your print shop.

This is a standard three-fold on 8.5 x 11 paper stock.

But also consider a tall, single fold brochure, a square brochure, or experiment with one of the many sizes available through your favorite online printer.

Try this . . .

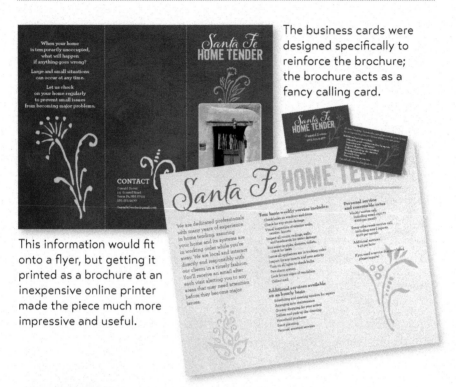

The business cards were designed specifically to reinforce the brochure; the brochure acts as a fancy calling card.

This information would fit onto a flyer, but getting it printed as a brochure at an inexpensive online printer made the piece much more impressive and useful.

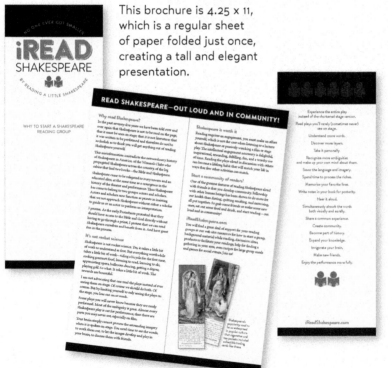

This brochure is 4.25 x 11, which is a regular sheet of paper folded just once, creating a tall and elegant presentation.

or this . . .

A small booklet can act as a more informative brochure when you have a lot of information to leave behind. This 12-page brochure uses a scan from a page in a sixteenth-century book, complete with wrinkles, as a background,

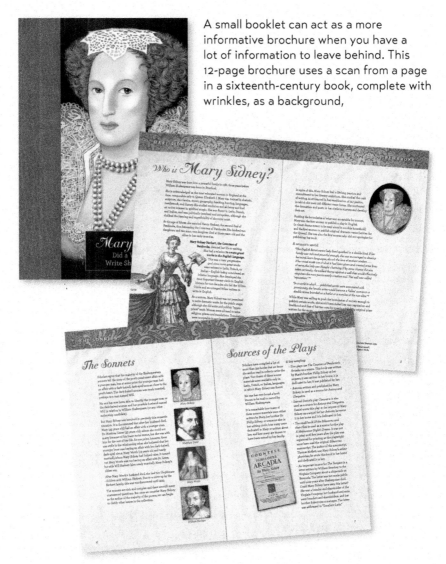

Every border across the top uses a different pattern, but the repetition of its size and placement encourages variety within the unity. The underlying grid of six columns per page allows flexibility in the design.

Play with the graphic images in your brochure—make them bigger, overlap them, wrap text around them, tilt them. You can do all this if your layout presents a solid, aligned base.

Tips on designing brochures

Brochures created by new designers have many of the same problems as newsletters: lack of contrast, lack of alignment, and too much Helvetica/Arial. Here's a quick summary of how the principle elements of design can be applied to that brochure you're working on.

Contrast

As in any other design project, contrast not only adds visual interest to a page so a reader's eye is drawn in, but it also helps create the hierarchy of information so the reader can scan the important points and understand what the brochure is about. Use contrast in the typefaces, rules, colors, spacing, size of elements, and such like.

Repetition

Repeat various elements in the design to create a **unified look** to the piece. You might repeat colors, typefaces, rules, spatial arrangements, bullets, etc. Within a strong repetition, you can have fun with variations.

Alignment

I keep repeating myself about this alignment stuff, but it's important, and the lack of it is consistently a problem. **Strong, sharp edges** create a strong, sharp impression. A combination of alignments (using centered, flush left, and flush right in one piece) usually creates a sloppy, weak impression.

Occasionally, you may want to intentionally break out of the alignment; **this works best if you have other strong alignments** to contrast with the breakout.

Proximity

Proximity, **grouping** similar items close together, is especially important in a project such as a brochure where you have a variety of subtopics within one main topic. How close and how far away items are from each other communicates the relationships of the items.

To create the spatial arrangements effectively, **you must know how to use your software** to create space between the paragraphs (space before or space after) instead of hitting the Enter or Return key twice. Two Returns between paragraphs creates a larger gap than you need, forcing items apart that should be close together. Two Returns also creates the same amount of space *above* a headline or subhead as there is *below* the head (which you don't want), and it separates bulleted items that should be closer together. Learn your software!

Postcards

Because they're so visual and so immediate—no envelopes to fuss with, no paper cuts—postcards are a great way to grab attention. And for these same reasons, an ugly or boring postcard is a waste of everybody's time.

So, to avoid waste, remember the following:

Be different. Oversized or oddly shaped postcards will stand out from that crowd in the mailbox. (Check with the post office, though, to make sure your shape will go through the mail.)

Think "series." A single postcard makes one impression; just think what a series of several could do!

Be specific. Tell the recipient exactly how they'll benefit (and what they need to do to get that benefit).

Keep it brief. Use the front of the postcard for a short and attention-getting message. Put less important details on the back.

Use color. Besides being fun to work with, color attracts the eye and draws interest.

Try this . . .

Dear Rosalind,

Thank you for your recent contribution toward my 2018 re-election campaign. Your financial support is crucial to our chances of winning this November. Once again, we are going to be opposed by super-PACs seeking to maintain the extreme Tudor majority in Parliament. Your support allows us to fight back against their distortions and make sure voters know that we are the ones fighting for women, seniors, and working families.

I know that our disappointment with the Tudor-led Parliament makes it easy to get discouraged. Thank you for being involved with our campaign and for remembering that only a Tudor majority will make the necessary investments and reforms that America needs to thrive. It is a great privilege to serve the 6th District and I will work as hard as I can to earn that privilege once again.

Again, many thanks for your kind support. I hope we can continue to count on you as Election Day draws nearer.

Sincerely,

Orlando de Boys

ORLANDO
de Boys.com

ORLANDO
de Boys.com *for TUDOR representative*

Dear Rosalind,

Thank you for your recent contribution toward my 2018 re-election campaign. Your financial support is crucial to our chances of winning this November. Once again, we are going to be opposed by well-funded super-PACs seeking to maintain the extreme Tudor majority in Parliament. Your support allows us to fight back against their distortions and make sure voters know that we are the ones fighting for women, seniors, and working families.

I know that our disappointment with the Tudor-led Parliament makes it easy to get discouraged. Thank you for being involved with our campaign and for remembering that only a Tudor majority will make the necessary investments and reforms that America needs to thrive. It is a great privilege to serve and I will work as hard as I can to earn that privilege once again.

Again, **many thanks for your kind support.** I hope we can continue to count on you as Election Day draws nearer.

Sincerely,

Orlan
de

Don't forget about using columns of text instead of one big block. It gives you many more options for creating a layout that communicates clearly.

Someone needs to redesign this politician's brand.

Try a font that surprises you. At MyFonts.com you can type in the headline you need and then see what it looks like in hundreds of fonts.

Try an odd-sized postcard, such as tall and narrow, short and fat, oversized, or a fold-over card.

Just be sure to make sure your intended size fits regulations before you print it; check the web site (usps.gov). And verify the cost of postage for an odd-sized card.

A Mid summer Night's Dream

at the Scottish Rite Temple
Santa Fe · June 24

presented by
SANTA FE *Shakespeare*
READERS

or this . . .

Whenever possible with your postcards, be playful! Create a postcard the recipient would like to keep instead of immediately toss.

A colorful, playful piece is more likely to be looked at than a boring piece. Design something that you would like to read!

Tips on designing postcards

You only have a split second to capture someone's attention with an unsolicited postcard that arrives in the mail. No matter how great your copy, if the design of the card does not attract their attention, they won't read your copy.

What's your point?

Your first decision is to determine what sort of effect you want to achieve. Do you want readers to think it is an expensive, exclusive offer? Then your postcard had better look as expensive and professional as the product. Do you want readers to feel like they're getting a great bargain? Then your postcard shouldn't be too slick. Discount stores spend extra money to make their stores look like they contain bargains. It's not an accident that Saks Fifth Avenue has a different look—from the parking lot to the restrooms—than does Kmart, and it doesn't mean that Kmart spent less on decor than did Saks. Each look serves a distinct and definite purpose and reaches out toward a specific market.

Grab their attention

The same design guidelines apply to direct-mail postcards as to anything else: contrast, repetition, alignment, and proximity. But with this kind of postcard, you have very little time to induce recipients into reading it. **Be brave** with bright colors, either in the ink or the card stock. Use striking graphics — there's plenty of great and inexpensive clipart, photos, and picture fonts that you can use in all sorts of creative ways.

Contrast

Contrast is probably your best friend in a direct-mail postcard. The headline should be in strong contrast to the rest of the text, the colors should use strong contrast to each other and to the color of the paper stock. And don't forget that **white space** creates contrast!

In general

The guidelines for business cards also apply to postcards: Don't stick things in the corners; don't think you have to fill the space; don't make everything the same size or almost the same size.

Advertising

Although newspapers and direct mail are disappearing, advertising is still part of trade magazines, event programs, theater programs, conference catalogs, newsletters, and of course online markets.

White space! Take note of where your eyes go next time you scan the newspaper. Which ads do your eyes naturally land on, and which ads do you actually read? I'll bet you see and read at least the headlines of the ads that have more white space.

Be clever. There's nothing that can compete with a clever headline. Not even good design. (But with both, the possibilities multiply!)

Be clear. Once your catchy headline has garnered some attention, your ad should specifically tell readers what to do (and give them the means to do so, such as by phone, email, web address, etc.).

Be brief. Your ad is not the place to put the life story of your business. Keep the copy simple and to the point.

i Read Shakespeare!

join a community and read Shakespeare aloud with friends.
it is surprisingly delightful.

go to iReadShakespeare.com to find a group near you.

Advertising doesn't have to scream to be effective.

Try this . . .

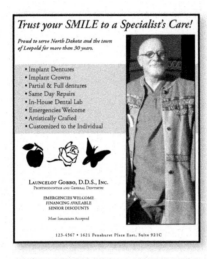

This sort of look happens so often: random alignments, random graphics, chopped-up white space. It's easy to fix.

Train your Designer Eye: Draw vertical and horizontal lines to see how many different alignments are in this small ad. For the centered bits, draw lines through the centers.

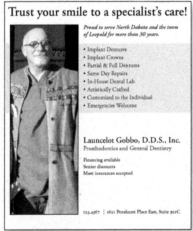

At least now we have the use of one alignment, flush left, and the strong line of the type aligns with the strong line of the photo edge.

Those odd little graphics (the apple, rose, and butterfly) seem to be simply filling the space. Let the white space be there! It's okay!

Train your Designer Eye: Name at least five other changes that were made. (Suggestions are on page 228.)

What do you think about that little bit of space on the left edge?

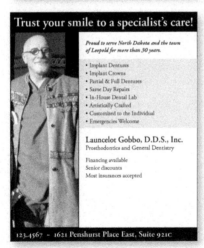

Train your Designer Eye: Name at least three more changes that were made. (See page 228.)

This is essentially the same ad as the first one, except you can see that the information is more organized, easier to read, and the white space is nice and neat instead of split into numerous pieces. **The white space will be where it is supposed to be if you follow the four principles. It is your job to let the white space exist.**

or this . . .

Don't you just hate traveling with large groups?

Same here.

Peregrinations
GLOBAL TRAVEL
www.peregrinationsgt.com

Sometimes a graphic image can provide the inspiration for your ad. This tall photo inspired a tall ad and a clever headline.

Put into words where the four principles are used in these pieces.

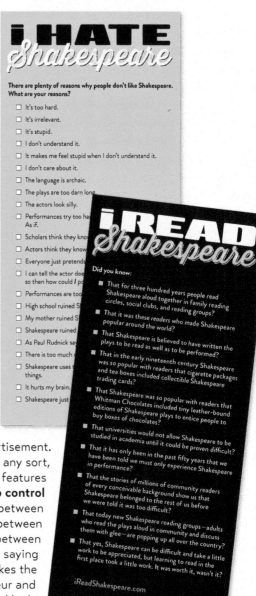

iHATE Shakespeare

There are plenty of reasons why people don't like Shakespeare. What are your reasons?

☐ It's too hard.
☐ It's irrelevant.
☐ It's stupid.
☐ I don't understand it.
☐ It makes me feel stupid when I don't understand it.
☐ I don't care about it.
☐ The language is archaic.
☐ The plays are too darn long.
☐ The actors look silly.
☐ Performances try too ha... As if.
☐ Scholars think they kno...
☐ Actors think they know...
☐ Everyone just pretends...
☐ I can tell the actor doe... so then how could *I* p...
☐ Performances are too...
☐ High school ruined S...
☐ My mother ruined S...
☐ Shakespeare ruined...
☐ As Paul Rudnick say...
☐ There is too much...
☐ Shakespeare uses... things.
☐ It hurts my brain.
☐ Shakespeare just...

iREAD Shakespeare

Did you know:

■ That for three hundred years people read Shakespeare aloud together in family reading circles, social clubs, and reading groups?

■ That it was these readers who made Shakespeare popular around the world?

■ That Shakespeare is believed to have written the plays to be read as well as to be performed?

■ That in the early nineteenth century Shakespeare was so popular with readers that cigarette packages and tea boxes included collectible Shakespeare trading cards?

■ That Shakespeare was so popular with readers that Whitman Chocolates included tiny leather-bound editions of Shakespeare plays to entice people to buy boxes of chocolates?

■ That universities would not allow Shakespeare to be studied in academia until it could be proven difficult?

■ That it has only been in the past fifty years that we have been told we must only experience Shakespeare in performance?

■ That the stories of millions of community readers of every conceivable background show us that Shakespeare belonged to the rest of us before we were told it was too difficult?

■ That today new Shakespeare reading groups—adults who read the plays aloud in community and discuss them with glee—are popping up all over the country?

■ That yes, Shakespeare can be difficult and take a little work to be appreciated, but learning to read in the first place took a little work. It was worth it, wasn't it?

iReadShakespeare.com

This rack card acts as an advertisement. To create an all-type ad of any sort, learn to use the typographic features in your software! **Learn to control the space** between letters, between lines, between paragraphs, between heads and subheads, between tabs and indents. I keep saying that because spacing makes the difference between an amateur and a professional look.

143

Tips on designing ads

One of the biggest problems with small ads is crowding. Many clients and businesses who are paying for an ad feel they need to fill every particle of space because it costs money.

Contrast

With a newspaper or catalog or program ad, you need contrast not only in the advertisement itself, but also between the ad and the rest of the page that it's placed on. In this kind of ad, often the best way to create contrast is with white space. Advertising sections tend to be completely full of stuff and very busy. An ad that has lots of white space within it stands out on the page, and a reader's eye can't help but be drawn to it. Experiment. Open a newspaper page or program and visually scan it. I guarantee that if there is white space on that page, your eyes will go to it. They go there because white space provides a strong contrast on a full, busy page.

Once you have white space, your headline doesn't need to be in a big, fat, typeface screaming to compete with everything else. You can actually get away with a beautiful script or a classy oldstyle instead of a heavy face.

Type choices

If you will be printing on cheap paper such as newsprint, which is porous and coarse, you'll find that the ink spreads out. So don't use a typeface that has small, delicate serifs or very thin lines that will thicken when printed, unless you are setting the type large enough that the serifs and strokes will hold up.

Reverse type

For the same reason as above, if you plan to print your ad on cheap paper, generally avoid reverse type (white type on a dark background). But if you must have it, make sure you use a good solid typeface with no thin lines that will fill in when the ink spreads. As always when setting type in reverse, use a point size a wee bit larger and bolder than you would if it was not reversed because the optical illusion makes reverse type appear smaller and thinner.

Résumés

How distinctive you can get with a résumé depends on whom you are sending it to, of course. Graphic designers, for instance, can get away with wildly creative pieces because it acts as part of one's portfolio, but many other fields are more conservative. Regardless, based on the number of résumés I have seen that were created in Microsoft Word or the ones shown in some books of examples, all you need to do is use the four basic principles to have a résumé that stands out from most others.

These are a couple of actual résumés. Of course, entire books are written on how to write a résumé and of course the look of yours must feel comfortable with your potential employer. But within those parameters, there are many more options than centered 12-point Times New Roman.

Train your Designer Eye: Put into words where all of the four basic principles of design are missing in both of these examples.

MATT SANFORD
SAG Eligible

Height: 6'4"
Weight: 200
Hair Color: Brown
Eye Color: Brown

A&M Talent House
505-820-2742 NM
323-303-4032 CA
booking@amtalenthouse.com

FILM

WHO DIED?	Danny	Kent Kirkpatrick
THE PROS & CONS OF HITCHHIKING	Vampire	Jackson Birnbaum
BAILOUT	Pachuco	Stryder Simms
GONE	Noah	Aimee Schaefer
NAKED FEAR	VW Van Guy	Thom Eberhardt
VINYL FEVER	Paul	Lane Stewart
THE DONOR CONSPIRACY	Curt	Ryil Adamson
THE FLOCK	James Ray Ward	Wai Keung Lao
TRADE	Café Manager	Marco Kreuzpaintner
KLOWN KAMP MASSACRE	Tipsy	D. Valdez & P. Gunn

TELEVISION

IN PLAIN SIGHT (Episode 301)	Detective Frank	David Maples
THE GIFT ("Pilot," "Episode 103")	Humphrey Bogart	Scott Cervine

COMMERCIALS

MIKE SCARFF SUBARU	Customer	DNAworks
NORTHERN NM INSURANCE	Mechanic	CNM
NEW MEXICO, EARTH	Waiter	NM Tourism Board

THEATRE

I HATE HAMLET	Andrew	Robert Nott
BURIED CHILD	Vince	Mona Malec
OUR TOWN	Howie Newsome	Scott Harrison
TWO ROOMS	Michael	Freddie Johnson
DOC WATSON VS. THE VAMPIRES	Dracula	Matt Sanford
THE VIBRATOR PLAY	Leo Irving	Nick Sabado
THE MOUSETRAP	Giles	Catherine Donovan
THE BLUE ROOM	The Student	Nick Sabado
THE GLASS MENAGERIE	Jim	
DEAD MAN'S JEST	Lelio/Valerio	
MUCH ADO ABOUT SLEUTHING	Horatio	
MUMMY'S DUMMIES	The Professor	

TRAINING
The Actor & The Action – Wendy Chapin
Advanced Character – Joey Chavez
Stage Combat – Robert Nott
Auditioning for the Camera – Shari Rhodes

OTHER SKILLS/INTERESTS
Guitar and Bass Guitar – Advanced
Physical Comedy – Advanced
Basic Shooting and Gun Safety
Dialects – English, Irish, French, Russian, Eastern American

EUPHEMIA WHETSTONE
1663 Clovis Avenue, San Jose 95124 / 555-222-3435 / EuphemiaW@q.com

PRODUCT MANAGEMENT / STRATEGY
Expertise in Small & Large Business Internet Software and Services

"I create compelling user experiences that thrill customers and build sustainable business that thrill the CFO."

- 10 years leading the design, development, and marketing of new products — taken 12 ventures from concept to multi-million dollar business.
- Manage complex P&Ls and lead multi-functional/cultural teams. History of turning around under-performing product lines, integrating acquired business and penetrating international markets.
- Combine 'in-the-trenches' experience with solid financial analysis and corporate strategy background developed at Techsys Corporation. MBA from UPenn, Wharton School of Business.

AREA OF EXPERTISE

• Strategic Planning and Execution	• Market and Consumer Research
• Internet and New Media Development	• New Product Development and Launch
• User Experience Improvements	• Process Design and Reengineering
• Software and Internet UX Design	• Organizational Turnarounds

PROFESSIONAL HISTORY

PEREGRINATIONS GLOBAL TRAVEL 2011-Present
Tactics and Action Consultant

Currently consulting on new business model for an Oregon not-for-profit organization. This organization arranges international travel for food service workers.

- Cut costs 38 percent in first year by moving the organization from traditional travel arrangements to internet arragements.
- Increased web traffic 58 percent and web page views 112 percent by leading complete redesign and redevelopment of website in order to build awareness and create an interactive community.

PANCAKE DISKOLOGIES 2006-2011
Software Product Manager

Recruited a team of 12 from Atlanta, London, and New Delhi. Held P&L accountability for $7M software business, managing all aspects of planning, design, marketing, and partner relations for productivity and communications solutions (applications and hosted services).

Overview: Transformed unprofitable division into top-performer. Reversed 2 years of losses to achieve 23% operating margins within 2 years.

- Repositions legacy product lines, increasing average selling prices 27% and unit sales 13% after 7 years of stagnant revenue.
- Performed market research and streamlined portfolio, reducing costs by $1.3M (or 12%) annually.
- Generated $3.3M in new annual revenues by repositioning an existing product for a new, previously untapped market.

Try this . . .

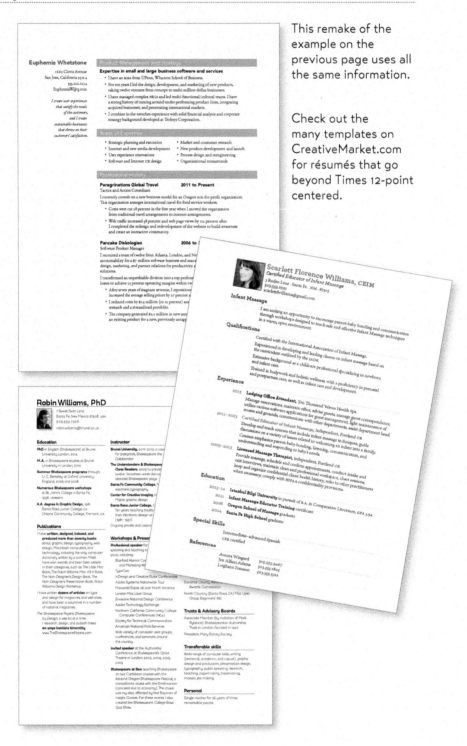

This remake of the example on the previous page uses all the same information.

Check out the many templates on CreativeMarket.com for résumés that go beyond Times 12-point centered.

or this . . .

As an actor, Matt's face is what often lands the job so we included several extra images. You can see that the text is better **aligned** (learn to use your tabs and indents!) which helps to clarify the information. You can also see **proximity** in use, **repetition**, and **contrast**.

If you're sending your resume digitally, try a horizontal layout to match the shape of most screens.

Tips on designing résumés

These tips are for the visual presentation of your résumé, not the content! It is your responsibility to study up on what is expected to be in your bio and c.v. for your particular field. Find out how adventurous you can be within the limits of expectation. Visually, here are some suggestions.

Contrast

As you can see in the previous examples, the Principle of Contrast is critical in making the important elements of your resume stand out. Even in the most conservative of pages, you can be subtle yet firm in your use of contrast to clarify the information.

Repetition

Be consistent. Repeat the basic structure of information; that is, if you set the dates in the left column for one area, use that same format for the other areas. If you use an alignment for a certain sort of item, repeat that alignment in other areas. If you use color to indicate something in particular, perhaps pull that color into something else such as a ruled line or bullets.

Alignment

As you have noticed, the Principle of Alignment is crucial to the overall presentation of neatness and professionalism.

Proximity

Position the headings closer to the related information so the structure is clear. Keep bullets close to their items.

Match the design to the medium

You will have to make different decisions if the resume is to be handed or mailed to somone, posted online, or perhaps posted online but you expect someone to print it. Each of these variants will impact your layout, font choice, page size, color choices, and more. Oh, our world is getting so complicated.

Design with TYPE

This half of the book
deals specifically with type,
since type is what
graphic design is about.
If your project has no type on it,
it's not graphic design.

This section particularly
addresses the problem
of combining more than one
typeface on the page.

Although I focus
on the aesthetics of type,
never forget that your purpose
is communication.
The type should never
inhibit the communication.

typefaces
(Courtesy Script)
Kon Tiki Kona
BOYCOTT
Doradani Light

Typography endows human language *with* visual *form*.

typefaces

Brioso Pro Display and *Display Italic*

The Essentials of Typography

There are some essential typographic rules you must know to prevent your work from appearing amateurish. Many of these guidelines are standard techniques that professional typesetters have used for centuries, but we on our computers are not taught professional typographic techniques—we are simply taught keyboarding skills. Many of us were either taught to type on a typewriter, were taught by those who learned on typewriters, or have just inherited the non-professional techniques that are based on the typewriter. Well, you have surely noticed we don't use typewriters anymore. In fact, entire generations have never seen one in person.

A typewriter uses monospaced lettering in which each character takes up the same amount of space—a period takes as much space as a capital M (as shown on the following page). It cannot type italic; it uses a single ' for an apostrophe or a double " mark for both opening and closing quotation marks; it cannot type dashes or copyright symbols or other special characters. It has no bold characters so the only option to emphasize text is by using all caps or an underline. All of these limitations have had an impact on our keyboarding habits today.

This is the typewriter from the 1930s that belonged to my Quaker grandmother, Pauline Williams, who lived to the age of 102. It has the fancy new "Floating Shift" key.

One space after punctuation

Yes, you might have the old-fashioned habit of typing two spaces after punctuation, but it is long past time to let that go. It doesn't matter today where the practice originated or for how long typesetters used larger spaces between sentences. Today the standard is one space. Take a look at any book or magazine on your shelf. You will never find two spaces between sentences—unless you are reading a self-published piece from an amateur.

This isn't worth arguing about. There is no moral superiority in belonging to the class of typists who still use two spaces after periods. Sorry!

The first example below uses proportional type, where the characters are in proportion to each other. The second example uses monospaced type.

You can draw vertical lines between the monospaced characters to create equal columns of type because every character takes up the same amount of space. The standard was to type two spaces after punctuation.

It was once upon a time. Exactly what time, no one knew. No one cared.

It was once upon a time. Exactly what time, no one knew. No one cared.

Squint your eyes at the paragraphs below and you will clearly see which one has two spaces after periods. Those big gaps interrupt the communication and make your work look old-fashioned and clumsy.

It was once upon a time. Exactly what time, no one knew. No one cared. All they could remember is that it was once. And never again. It was so long ago, in that once moment, that stories erupted. Stories exploded. Stories screamed.

It was once upon a time. Exactly what time, no one knew. No one cared. All they could remember is that it was once. And never again. It was so long ago, in that once moment, that stories erupted. Stories exploded. Stories screamed.

Quotation marks

Another glaring mistake of amateur designers is the use of *typewriter* quotation marks instead of *typographer* quote marks. Your software application will usually insert the correct marks for you, but sometimes it doesn't and you end up with what appear to be inch and foot marks instead of quotation marks. You need to be aware and leap into action if you see the wrong marks on your page.

Opening quotation marks are shaped like sixes and closing marks like nines: "opening and closing" "66 and 99" sixes and nines

If you have never noticed quotation marks before, you might think no one else notices them. But that's the funny thing—as soon as you become aware of the difference, you cannot stop noticing them. With just a quick glance at the two sentences below, do you have an immediate sense of which one is amateur?

"Alas," she cried, "my enigma has lost its balance!"

"Hold on," he bellowed, "I'll send in the clowns!"

To type the quotation marks, see the charts on pages 158 and 159.

In the United States, commas and periods are **always inside** the quotation marks. Always. Really. (In the U.K., they can go in or out.)

Colons and semicolons go **outside** the quotation marks.

A question mark or exclamation point goes **inside** the quotation marks if it belongs to the quotation: She hollered, "Get out of my reality!"

The question mark or exclamation point goes **outside** the quotation marks if it does not belong to the quoted phrase: Can you believe he replied, "I won't do it"?

If more than one paragraph is quoted, the double quotation mark is set at the beginning of each paragraph, but only at the end of the final one.

Apostrophes

An apostrophe is actually a single closing quotation mark as mentioned on the previous page (shaped like a 9), but it is so important that it also has its own segment here. Most software applications automatically supply a true apostrophe instead of what looks like a foot mark, but there are many times when you will have to correct it.

Whenever I see a typewriter apostrophe in a million-dollar ad (and it happens too often), I wonder who hired that person? Who proofed that ad? Didn't *anybody* throughout the entire creation process notice that glaring symbol of inexperience and embarrassment?

The first line, below, uses typewriter quotation marks and apostrophes, and the second line has the appropriate six and nine shapes of true quotation marks.

Circle the apostrophes below, noting which are fake and which are true.

"Save yourself," she snarled, "It's Millie's turn to hold the horse's tail."

"I don't care," he pleaded, "I'm the one who's shifting the paradigm."

Notice that sans serif quotation marks and apostrophes are not as beautifully shaped, but they will have slight six and nine forms (" " ' '). Circle the apostrophes below, noting which are fake and which are true.

"It's a lost cause," she whined, "The goat's fallen off Sam's wagon."

"Darn," he sighed, "Now I'll have to find Martha's future by myself."

The most common mistakes with apostrophes are 1) using a typewriter mark and 2) putting the apostrophe in the wrong place. Since you are now setting your own type, you need to know where the apostrophe belongs.

Except for possessive words (such as *Mary's poem* or *the dog's bone*), an apostrophe means a letter is missing (*isn't* or *don't* or *you're*).

Thus in the phrase **Rock 'n' Roll,** there should be an apostrophe where the **a** is missing and also where the **d** is missing. It should **NOT** look like this: '**n**' Wrong!!!! Apostrophes are shaped like 9s.

Little Quiz #4: Apostrophes

I include this quiz because it is so important to know these little things to prevent your work from looking silly. (Answers on page 224.)

Its or *it's:* **It's** with an apostrophe **always** means **it is.** Always. One hundred percent of the time. Below, enter the correct form: *it's* or *its.*

1 _____ my birthday!

2 The mob lost _____ momentum.

3 Plutarch asks, "If a ship is restored over time by replacing every one of _____ wooden parts, is it still the same ship?"

4 Finding himself impaled upon the horns of a dilemma, the yellow-bellied marmot hoisted _____ flag and left.

5 Dearie, _____ too late for that.

6 "Look out! _____ headed this way!"

Draw the apostrophes in the correct shapes and in the correct places (hint: there is only one way to draw an apostrophe). Better yet, type these on your computer and make sure you use apostrophes (the keyboard shortcut for typing an apostrophe is on pages 158–159):

7 They opened the Mom _n_ Pop Shop on River Street.

8 She went fishin_ again last night.

9 We all wore bellbottoms in the _60s.

10 He loves cookies _n_ cream milkshakes.

Dashes

You know what a hyphen is, that tiny little dash that belongs in some words such as *daughter-in-law* or in phone numbers. It is also used to break a word at the end of a line, of course.

You might be in the habit of using a double hyphen to indicate a dash, like so: -- . This is an old-fashioned convention from the days of typewriters, since they did not have dashes built in. But now you can and should use real dashes.

Hyphen -

A *hyphen* is for hyphenating words or line breaks. If you are confused about when to use a hyphen, check your favorite style manual or dictionary. The character, as you probably know, is found on the upper-right of the keyboard, just to the right of the zero.

> odd-looking critters
>
> Merriam-Webster Dictionary

En dash (short dash) –

The *en dash* is approximately the width of a capital letter N in the font and size you are typing, thus it is longer than the hyphen. Use it between words that indicate a duration, such as hourly time or months or years. Use it where you would otherwise use the word "to." Notice in the examples below that these are *not* hyphenated words, and a plain hyphen is not the logical character to use. The en dash does not need a space on either side.

> October–December
>
> 7–12 years of age
>
> 7:30–9:30 P.M.
>
> Notice when you read these examples, you automatically "read" the en dash as "to."

Also use the en dash when you have a compound adjective and one of the elements is made of two words or a hyphenated word:

> San Francisco–Chicago flight
>
> pre–Vietnam war period
>
> high-stress–high-energy lifestyle

Em dash (long dash) —

The *em dash* is twice as long as the en dash, approximately the width of a capital letter M. This dash is often used to indicate an abrupt change of thought or in a sentence where a period is too strong and a comma too weak. Check your punctuation style manual for the exact use of the em dash.

The em dash does *not* have a space on either side. If your software can kern or create thin spaces, you might want to add just enough space to either side of the em dash to ensure it doesn't bump into the other letters, depending on the font you use. But don't type a whole space.

Beware—the enigma is gaining on the paradigm.

The goat fell off the wagon—again.

To type the dashes, see the charts on the following pages.

Special characters

Your computer provides not only the alphabet and numbers to type with, but a large collection of special characters such as ©,™, ¢, °, and many others. In fact, the OpenType font format can hold about 16,000 characters, enough for one font to contain the glyphs for just about all written languages. If you use InDesign, open the Glyphs panel to access all characters in any font. Otherwise use the codes below for the most popular characters.

Special characters on the PC

To create these characters in Windows, you can almost always use the ANSI codes. Turn on Num Lock, and use the numeric keypad on the right side of your keyboard. Hold down Alt while you type the numeric code.

'	Alt 1045	opening single quote
'	Alt 1046	closing single quote; apostrophe
"	Alt 1047	opening double quote
"	Alt 0148	closing double quote
-	hyphen	hyphen (to the right of the zero)
–	Alt 0150	en dash
—	Alt 0151	em dash
…	Alt 0133	ellipsis
•	Alt 0149	bullet
°	Alt 248	degree symbol
·	Alt 250	middle dot or interpunct (small bullet)
©	Alt 0169	copyright symbol
™	Alt 0153	trademark symbol
€	Alt 0128	euro symbol
¥	Alt 157	yen symbol
®	Alt 0174	registration symbol
¢	Alt 155	cents symbol
£	Alt 156	British pound symbol
¡	Alt 173	inverted exclamation mark
¿	Alt 168	inverted question mark

Also become familiar with the Character Map, which displays the available characters for your chosen font. Copy and paste the ones you need.

Special characters on the Mac

To create these characters, hold down the Shift and/or Option key while you tap the letter for that character. See the following page for accent marks.

'	Option]	opening single quote
'	Option Shift]	closing single quote; apostrophe
"	Option [opening double quote
"	Option Shift [closing double quote
-	hyphen	hyphen (to the right of the zero)
–	Option hyphen	en dash
—	Option Shift hyphen	em dash
...	Option ;	ellipsis
•	Option 8	bullet
°	Option Shift 8	degree symbol
·	Option Shift 9	middle dot or interpunct (small bullet)
©	Option G	copyright symbol
™	Option 2	trademark symbol
€	Option Shift 2	euro symbol
¥	Option Y	yen symbol
®	Option R	registration symbol
¢	Option $	cents symbol
£	Option 3	British pound symbol
¡	Option 1	inverted exclamation mark
¿	Option Shift ?	inverted question mark
/	Option Shift !	fraction bar
fi	Option Shift 5	ligature of *f* and *i*
fl	Option Shift 6	ligature of *f* and *l*

Also check the very bottom of the Edit menu in your application and see if you have the option for "Special Characters…." If so, this opens the Characters panel. Spend some time to familiarize yourself with all the options. Find a character you like, double-click it, and it appears in your document at the point where the insertion point was flashing.

Accent marks

The accent marks are a little sneakier to access. You may have tried to type *piñata* and ended up with *pin~ata*.

On a Mac, the accent marks are hidden in the Option keyboard; on a PC, use the ANSI codes.

Accent marks in Windows:

In Windows, there is a different ANSI code for every letter with an accent. For instance, é is Alt 130, but ó is Alt 162. Check the manual for your favorite software program, which might have its own shortcuts.

Accent marks on the Mac:

Find the accent mark you need in the chart below. Hold down the Option key and tap the letter key, even if that's not the letter you want to put the accent above. *Nothing will happen,* or you might see a highlighted space. That's good. Let go of the Option key and type the letter you want. They will appear together.

ʹ Option e

ˋ Option tilde (upper-left)

¨ Option u

~ Option n

^ Option i

Try this, to type résumé:

1 Type **r**.

2 Now hold down the Option key and tap the letter **e**;
 you might see a highlighted space with the accent mark
 or you might see nothing.

3 Let go of the Option key and tap the letter **e**. It turns into **é**.

4 Type the rest of the word, then repeat steps 2 and 3 for the final **e**.

Capitals

Setting words in ALL CAPS to call attention to them is not always the best solution because all caps are actually more difficult to read than lowercase. We recognize words not only by their individual letters and groups of letters, but also by their shapes, particularly the shape of the top half of a word, sometimes called the "coastline," as shown below.

When a block of text is in all caps, we have to read it letter by letter rather than by the shapes of groups of letters. Read the block of text below and notice how much slower than usual you read it and how tiring it can become.

Notice the shapes of these words:

cat dog whistle sweeper

When the same words are in all caps, can you distinguish their shapes?

CAT DOG WHISTLE SWEEPER

When text is in all caps, we have to read it letter by letter, rather than by groups of letters. Read the block of text below; be conscious of how much slower than usual you read it.

O REASON NOT THE NEED: OUR BASEST BEGGARS ARE IN THE POOREST THING SUPERFLUOUS. ALLOW NOT NATURE MORE THAN NATURE NEEDS, MAN'S LIFE IS CHEAP AS BEAST'S. THOU ART A LADY; IF ONLY TO GO WARM WERE GORGEOUS, WHY, NATURE NEEDS NOT WHAT THOU GORGEOUS WEAR'ST, WHICH SCARCELY KEEPS THEE WARM.

~King Lear in *King Lear*

Obviously, we *can* read all caps, and sometimes all caps is the perfect design decision. Just make sure you have a reason for using them, a reason you can put into words, such as, "I really want the text for my logo set as one rectangular piece." If you find yourself setting all caps on the mistaken notion they are bigger and thus easier to read, try another solution.

Underlining

Do not use the underline button.

Ever.

When was the last time you saw a word underlined in a book or magazine? Probably never. That's because the underline was originally a visual clue on a typewriter to tell the typesetter who was creating the project that the underlined word was to be turned into italic for print. But now *you* are the typesetter yourself, so you do not need that visual clue—you will just use italic. Protocol is that book titles, journals, magazines, operas, etc. are set in italic.

You might also be in the habit of underlining words that you want to emphasize. However, you have several other options for emphasis that are more professional: try **bold type,** *larger type,* **a different font,** color, or a **combination.**

<div align="center">

Simply setting text apart from the rest of the copy
can call extra attention to it.

</div>

This doesn't mean you should never have any sort of line under the text—just don't settle for the default underline style that you get by clicking the button or using the keyboard shortcut. Typographers have always used *rules,* or lines, to enhance text. Most applications, even Microsoft Word, allow you to adjust the rule: You can customize its thickness, length, and how far away it is from the baseline of the text. Check your software manual or help file.

<div align="center">

<u>This is a phrase underlined with the style button. It's rather appalling
and creates an instantly amateur look.</u>

This phrase has a double rule under it.

Notice the rule does not bump into the descender of the *p.*

Bump the descenders as if you mean it.

Rules under large type, however, often pass through the descenders.

This sentence includes ***bold italic*** for emphasis
instead of an <u>underline.</u>

</div>

Kerning

Kerning is the process of removing tiny units of space between characters to create visually consistent letterspacing.* Word processors have limited or no controls for this, which is one reason why a person with a trained eye can immediately tell the difference between text created in a word processor as opposed to a page layout application.

The larger the text, the more critical it is to adjust the spacing. Awkward letterspacing not only creates a naive and unprofessional presentation, it can disrupt the communication of the words.

Kerning is totally dependent on your eye; the computer cannot do it for you. In the example below you can see extra space between certain letter combinations (WA, LO) because of their shapes (angled, rounded, vertical). Depending on your application, it might attempt to adjust the spacing for you, but if you are aspiring to a professional level, you need to learn to manually adjust the spacing. Check your help files for the specific methods to kern or letterspace in your application.

WATERMELON
No adjustments made.

WATERMELON
The software program made automatic adjustments.

WATERMELON
Hand kerning applied.

Kerning is not about making the letters fit together tightly—it is about making the space between the letters appear to be visually consistent.

Which appears larger, the square or circle? The circle *appears* to be smaller because of all the white space surrounding it, but both shapes are exactly the same size from edge to edge. It is this visual trick of the eye that creates the need to letterspace or kern type— each character presents a different visual impression on the page. The more white space between a letter combination, the more kerning it will need. Notice the varying spaces between these combinations:

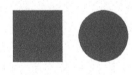

HL HO OC OT AT We To

*There is a difference between kerning, tracking, and letterspacing, but that is beyond the scope of this introduction to the essentials (see *The Non-Designer's InDesign Book* for those details or check your page layout application help files).

Widows and orphans

Obviously we're not talking about bereaved widows and orphans such as some of us are ourselves. No, these are traditional typographic terms.

When the last line of a paragraph has fewer than seven (more or less, depending on the length of the line) characters, that last line is a **widow.** Worse than leaving one word as the last line is leaving *part* of a word, the other part being hyphenated on the line above. Don't ever do that!

ON BEING A NEWSPAPER EDITOR

The world can blow up—I'll be here just the same to put in a comma or a semicolon. I may even touch a little overtime, for with an event like that there's bound to be a final extra. When the world blows up and the final edition has gone to press the proofreaders will quietly gather up all the commas, semicolons, hyphens, asterisks, brackets, parentheses, periods, exclamation marks, etc. and put them in a little box over the editorial chair.

widow

ON BEING A NEWSPAPER EDITOR

They have a wonderful therapeutic effect upon me, these catastrophes which I proofread. Imagine a state of perfect immunity, a charmed existence, a life of absolute security in the midst of poison bacilli. Nothing touches me, neither earthquakes nor explosions nor riots nor famine nor collisions nor wars nor revolutions. I am inoculated against every disease, calamity, every sorrow and misery. It's the culmination of a life of fortitude.

even worse widow

When the last line of a paragraph, be it ever so long, ends at the top of the next column or page all by itself, abandoned by the rest of its text, that is an **orphan.** Some people call a widow an orphan and vice versa, and that's fine. It doesn't matter what you call it—don't do it.

To avoid widows and orphans, you might need to rewrite copy (if you have that power), or at least add or delete a word or two. Sometimes you can add or delete spacing between the letters, words, or lines, depending on the application you're working in. Sometimes you can widen or narrow a margin just a hair to fix it. Do what you need to do because it must be done.

typeface
Arno Pro Regular

text
Body copy is Henry Miller (1891–1980), *Tropic of Cancer*

Miscellaneous

This is a short list of professional typographic niceties which, if you follow, will prevent your work from looking amateurish. There is, of course, nothing wrong with being an amateur, but the presentation of your work does have an instant impact on its readers. Why not take a tiny extra step to ensure a favorable impact?

✦ **Punctuation following styled text:** If you have a word styled in bold or italic or a different font, the punctuation immediately following the last character should be in the same style. As shown in the first sentence of this paragraph, the colon following the bold sans serif is also in **bold sans serif.** Notice the period in the previous sentence is the same format as the text it follows.

✦ **Punctuation in parentheses:** Just in case you are not clear on whether punctuation goes inside or outside parentheses, here is the grammatical rule.

> If the text inside the parentheses is part of the entire sentence, then the punctuation goes *outside* the closing parenthesis (as in this example right here).

> If the text inside the parentheses is a complete and separate sentence on its own, its punctuation goes inside. (This is an example of a sentence with its punctuation inside.)

✦ **Paragraph indents:** You may have been taught that a paragraph indent is five spaces, or perhaps you automatically hit the Tab key and accept whatever the default tab space is (usually half an inch). This is a holdover from the ancient days of the typewriter. The appropriate spacing for professional-level typography is not half an inch or five spaces, but **one em space,** and an em space is equal to the point size of the type you are using. Thus if you are using 12-point type, the paragraph indent is 12 points, or about two Spacebar spaces. You don't have to get out a measuring device, but approximate about two spaces on your tabs ruler rather than five. Once you become accustomed to this, those half-inch indents will look really obnoxious.

✦ **Paragraph indent or extra space between paragraphs:** An indent means, "This is a new paragraph." Extra space between paragraphs also means, "This is a new paragraph." Thus you need to pick *one:* Either indent new paragraphs *or* use extra space between paragraphs, not both.

✦ **First paragraphs:** Following the logic of the above principle, you can understand why the **first paragraph** following a heading or subhead does not need an indent. Ever.

✦ **Setting text in a frame or box:** If you do set text inside a box, leave plenty of room on all sides. Even if you create the box in a word processor, you can find the settings that open up the space. Generally, create the *visual* impression that there is the same amount of space on all sides. Listen to your eyes.

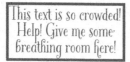 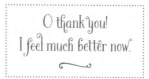

✦ **Use bullets or ornaments in a list, not hyphens:** When listing items, please don't use hyphens. It looks so sad. The standard bullet (• Option 8 on a Mac or Alt 0149 in Windows) is just as easy to type as a hyphen. Or use a character from a dingbat or ornament font, as you can see in this bulleted list you are reading right now (you might need to make the ornament larger or smaller than the text, depending on the dingbat you choose).

✦ **And yet more:** The things you've learned in this book will take you a long way. Yet there are so many details involved in creating professional-level typography, too many for this book. *The Non-Designer's Type Book* is now rolled into the "Deluxe Edition" of a combination of that book and this one in your hands, called *The Non-Designer's Design & Type Books* and has lots more typographic information and techniques. If you are an InDesign user, *The Non-Designer's InDesign Book* will teach you how to use that application to create great typography.

Type (& Life)

Type is the basic building block of any printed page. Often it is irresistibly compelling and sometimes absolutely imperative to design a page with more than one typeface on it. But how do you know which typefaces work effectively together?

In Life, when there is more than one of anything, a dynamic relationship is established. The same happens in Type, since there is usually more than one element on a page—even a document of plain body copy typically has heads or subheads or at least page numbers on it. Within these dynamics on the page (or in Life), a relationship is established that is either concordant, conflicting, or contrasting.

A **concordant** relationship occurs when you use only one type family without much variety in style, size, weight, and so on. It is easy to keep the page harmonious, and the arrangement tends to appear quiet and rather sedate or formal—sometimes downright dull.

A **conflicting** relationship occurs when you combine typefaces that are *similar (but not the same)* in style, size, weight, and so on. The similarities are disturbing because the visual attractions are not the same (concordant), but neither are they different (contrasting), so they conflict.

A **contrasting** relationship occurs when you combine separate typefaces and elements that are clearly distinct from each other. The visually appealing and exciting designs that attract your attention typically have a lot of contrast built in, and those contrasts are emphasized.

Most designers tend to wing it when combining more than one typeface on a page. You might have a sense that one face needs to be larger or an element needs to be bolder. However, when you can recognize and *name the contrasts,* you have power over them—you can then get to the root of the conflicting problem faster and find more interesting solutions. And *that* is the point of this section.

Concord

A design is concordant when you choose to use just one typeface and the other elements on the page have the same qualities as that typeface. Perhaps you use some of the italic version, and perhaps a larger size for a heading, and maybe a graphic or several ornaments—but the basic impression is still concordant.

Most concordant designs tend to be rather calm and formal. This does not mean concord is undesirable—just be aware of the impression you give by using elements that are all in concord with each other.

Life's but a walking shadow, a poor player

that struts and frets his hour upon the stage,

and then is heard no more; it is a tale

told by an idiot, *full of sound and fury,*

signifying nothing.

This concordant example uses Opal. The first letter is larger and there is some italic type (Opal Italic), but the entire piece is rather calm and subdued.

typefaces
Opal Pro Regular and *Italic*

typefaces
Aachen Bold
Onyx (with Adobe Type Embellishments Three)

Hello!

My name is _____

My theme song is _____

When I grow up I want to be _____

The heavy typeface (Aachen Bold) combines well with the heavy border. Even the line for writing on is heavy.

You are cordially invited

to share in our

wedding celebration

Popeye & Olive Oyl

April 1

3 o'clock in the afternoon

Berkeley Square

The typeface (Onyx), the thin border, and the delicate ornaments all give the same style impression.

Look familiar? Lots of folks play it safe with their wedding invitations by using the principle of concord. That's not a bad thing! But it should be a conscious thing.

Conflict

A design is in conflict when you set two or more typefaces on the same page that are *similar*—not really different but not really the same. I have seen countless students trying to match a typeface with one on the page, looking for a face that "looks similar." Wrong. When you put two faces together that look too much alike without really being so, most of the time it looks like a mistake. *The problem is in the similarities* because the similarities conflict.

Concord is a solid and useful concept; **conflict** should be avoided.

Life's but a walking shadow, a poor player

that struts and frets his hour upon the stage,

and then is heard no more; it is a tale

told by an idiot, **full of sound and fury,**

signifying nothing.

As you read this example, what happens when you get to the phrase, "full of sound and fury"? Do you wonder why it's in another typeface? Do you wonder if perhaps it's a mistake? Does it make you twitch? Does the large initial letter look like it's supposed to be there?

typefaces
Opal Pro Regular
ITC New Baskerville Roman

typefaces
Bailey Sans Extra Bold and Today Sans Medium
Peoni Pro and Edwardian Script
Adobe Wood Type Ornaments Two

Welcome!

My name is _____

My theme song is _____

When I grow up I want to be _____

Compare the "W," the "e," and the "m" in the headline with the other lines. They are similar but not the same. The border is not the same visual weight as the type or the lines, nor are they in strong contrast. There is too much conflict in this little piece.

You are cordially invited

to share in our

wedding celebration

Popeye & Olive Oyl

April 1

3 o'clock in the afternoon

Berkeley Square

This small invitation uses two different scripts—they have many similarities with each other, but they are not the same and they are not different.

The ornaments have the same type of conflict with the font— too many similarities. The piece feels confused and a bit cluttered.

Contrast

There is no quality in this world that is not what it is merely by contrast. Nothing exists in itself. —Herman Melville

Now this is the fun part. Creating concord is pretty easy, and creating conflict is easy but undesirable. Creating contrast is just fun.

Strong contrast attracts our eyes, as you learned in the previous section about design. One of the most effective, simplest, and satisfying ways to add contrast to a design is with type.

> Life's but a walking shadow, a poor player
> that struts and frets his hour upon the stage,
> and then is heard no more;
> it is a tale told by an idiot,
> ## full of sound and fury,
> signifying nothing.

In this example it's very clear that the phrase "full of sound and fury" is supposed to be in another typeface. The entire piece of prose has a more exciting visual attraction and a greater energy due to the contrast of type.

typefaces
Opal Pro Regular *and* flyswim

typefaces
Brandon Grotesque Light and **Black**
HALIS S EXTRALIGHT
Zanzibar and Zanzibar Extras

Hello!

My name is _____

My theme song is _____

When I grow up I want to be _____

Now the contrast between the typefaces is clear (they are actually in the same family, Brandon Grotesque)—the very bold face contrasts with the light face. The line weights of the border and writing lines also have a clear distinction.

YOU ARE CORDIALLY INVITED

TO SHARE IN OUR

WEDDING CELEBRATION!

Popeye & Olive Oyl

APRIL 1

3 O'CLOCK
 IN THE AFTERNOON

BERKELEY SQUARE

This invitation uses two very different faces— they are different in many ways. There is no conflict.

The font for *Popeye & Olive Oyl* (called Zanzibar) includes ornaments (one of which is shown here) that are designed to work with the typeface.

Summary

Contrast is not just for the aesthetic look of the piece. It is intrinsically tied in with the organization and clarity of the information on the page. Never forget that your point is to communicate. Combining different typefaces should enhance the communication, not confuse it.

There are six clear and distinct ways to contrast type: size, weight, structure, form, direction, and color. The rest of this book talks about each of these contrasts in turn.

Although I elaborate on each of the contrasts one at a time, rarely is one contrast effective. Most often you will strengthen the effect by combining and emphasizing the differences.

If you have trouble seeing what is wrong with a combination of typefaces, don't look for what is *different* between the faces—look for what is *similar*. It is the similarities that are causing the problem.

The major rule to follow when contrasting type is this: *Don't be a wimp!*

But...

Before we get to the ways to contrast, you need to have a familiarity with the categories of type. Spend a couple of minutes with each page in the next chapter, noting the features common to a category of type. Then try to find a couple of examples of that kind of type before you move on to the next category. Look in web sites, magazines, books, on packages, anything printed. Believe me, taking a few moments to do this will make everything sink in so much faster and deeper!

Categories of Type

There are many thousands of different typefaces available right now, and many more are being created every day. Most faces, though, can be dropped into one of the six categories mentioned below. Before you try to become conscious of the *contrasts* in type, you should become aware of the *similarities* between broad groups of type designs, because it is the *similarities* that cause the conflicts in type combinations. The purpose of this chapter is to make you more aware of the details of letterforms. In the following chapter I'll launch into combining them—the key to combining typefaces is to understand their similarities and differences.

Of course, you will find many faces that don't fit neatly into any category. We could make several hundred different categories for the varieties in type — don't worry about it. The point is just to start looking at type more closely and clearly.

I focus on these six groups:

Oldstyle

Modern

Slab serif

Sans serif

Script

DeCORaTIVe— including Grungy!

Oldstyle

The first typefaces were based on the handlettering of scribes and are called **oldstyle.** You can imagine a wedge-tipped pen held in the hand when you look carefully at their shapes. Oldstyles always have serifs (see below) and the serifs of lowercase letters are always at an angle (the angle of the pen) and have a curve where they meet the stem (called bracketing). Because of that pen, all the curved strokes in the letterforms have a transition from thick to thin, technically called the "thick/thin transition." This contrast in the stroke is relatively moderate, meaning it goes from kind-of-thin to kind-of-thicker. If you draw a line through the thinnest parts of the curved strokes, the line is diagonal. This is called the *stress*— oldstyle type has a diagonal stress.

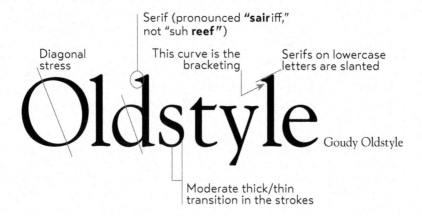

Serif (pronounced **"sair** iff,"
not "suh **reef** ")

Diagonal stress

This curve is the bracketing

Serifs on lowercase letters are slanted

Goudy Oldstyle

Moderate thick/thin transition in the strokes

Goudy Palatino Times
Bell Sabon Garamond

Do these faces all look pretty much the same to you? Don't worry—they look the same to everyone who hasn't studied typography. Their "invisibility" is exactly what makes oldstyles the best type group for extensive amounts of body copy. There are rarely any distinguishing characteristics that get in the way of reading; they don't call attention to themselves. If you're setting lots of type that you want people to actually read, choose an oldstyle.

Modern

Oldstyle faces replicate the humanist pen stokes. But as history marched on, the structure of type changed. Type has trends and succumbs to lifestyle and cultural changes, just like hairdos, clothes, architecture, or language. In the 1700s, smoother paper, more sophisticated printing techniques, and a general increase in mechanical devices led to type becoming more mechanical also. New typefaces no longer followed the pen in hand. Modern typefaces have serifs, but the serifs are now horizontal instead of slanted, and they are very thin. Like a steel bridge, the structure is severe, with a radical thick/thin transition, or contrast, in the strokes. There is no evidence of the slant of the pen; the stress is perfectly vertical. Moderns tend to have a cold, elegant look.

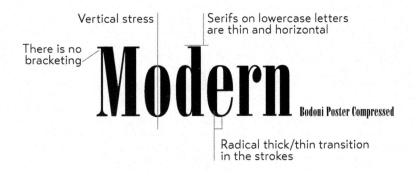

Vertical stress | Serifs on lowercase letters are thin and horizontal

There is no bracketing

Modern Bodoni Poster Compressed

Radical thick/thin transition in the strokes

Bodoni Didot, **Didot Bold**

Walbaum Modern No. 20

Modern typefaces have a striking appearance, especially when set very large. Because of their strong thick/thin transitions, most moderns are not good choices for extended amounts of body copy—the thin lines almost disappear, the thick lines are prominent, and the effect on the page is called "dazzling."

Slab serif

Along with the industrial revolution came a new concept: advertising. At first, advertisers took modern typefaces and made the thicks thicker. You've seen posters with type like that—from a distance, all you see are vertical lines, like a fence. The obvious solution to this problem was to thicken the entire letterform. Slab serifs have little or no thick/thin transition.

This category of type is sometimes called Clarendon, because the typeface Clarendon (shown below) is the epitome of this style. They are also called Egyptian because they became popular during the Egyptomania craze in Western civilization; many typefaces in this category were given Egyptian names so they would sell (Memphis, Cairo, Scarab).

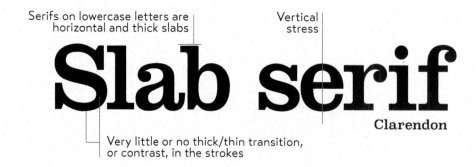

Serifs on lowercase letters are horizontal and thick slabs

Vertical stress

Slab serif

Clarendon

Very little or no thick/thin transition, or contrast, in the strokes

Clarendon Memphis
New Century Schoolbook
Diverda Light, **Black**

Many of the slab serifs that have a slight thick/thin contrast (such as Clarendon or New Century Schoolbook) are very high on the readability scale, meaning they easily can be used in extensive text. They present an overall darker page than oldstyles, though, because their strokes are thicker and relatively monoweight. Slab serifs are often used in children's books because of their clean, straightforward look.

Sans serif

The word "sans" means "without" (in French), so sans serif typefaces are those without serifs on the ends of the strokes. The idea of removing the serifs was a rather late development in the evolution of type and didn't become wildly successful until the early part of the twentieth century.

Sans serif typefaces are almost always "monoweight," meaning there is virtually no visible thick/thin transition in the strokes; the letterforms are the same thickness all the way around.

Also see the following page for important information on another branch of the sans serif category.

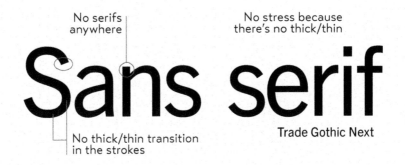

No serifs anywhere

No stress because there's no thick/thin

No thick/thin transition in the strokes

Trade Gothic Next

Brandon Grotesque

Folio Modernica Light, **Heavy**

Bailey Sans, **Bold** Transat Text

If the only sans serifs you have in your font library are Helvetica/Arial and Verdana (which was designed specifically for the screen, not print), the best thing you could do for your design work is invest in a sans serif family that includes a strong, heavy, black face. Each of the families above has a wide variety of weights, from light to extra black. With that one investment, you will be amazed at how your options increase for creating eye-catching pages.

Most sans serifs are monoweight, as shown on the preceding page. A very few, however, have a slight thick/thin transition. Below is an example of Optima, a sans serif with a stress. Faces like Optima are very difficult to combine on a page with other type—they have similarities with serif faces in the thick/thin strokes, and they have similarities with sans serifs in the lack of serifs. Be very careful when working with a sans like this.

Sans serif <small>Optima</small>

Optima is an exceptionally beautiful typeface, but you must be very careful about combining it with other faces. Notice its thick/thin strokes. It has the classic grace of an oldstyle (see page 176), but it's a sans serif.

makes you think about
your immortality.
j. philip davis

Here you see FunnyBone combined with Optima (the smaller text). FunnyBone's spunky informality is a nice contrast with Optima's classic grace, but I had to increase the contrasts to make them work together.

Script

The script category includes all those typefaces that appear to have been handlettered with a calligraphy pen or brush, or sometimes with a pencil or technical pen. This category could easily be broken down into scripts that connect, scripts that don't connect, scripts that look like hand printing, scripts that emulate traditional calligraphic styles, and so on. But for our purposes we are going to lump them all into one pot.

Peony Adorn Bouquet

Bookeyed Sadie Emily Austin

Thirsty Rough Light

Scripts are like cheesecake—they should be used sparingly so nobody gets sick. The fancy ones, of course, should never be set as long blocks of text and *never* as all caps. But scripts can be particularly stunning when set very large—don't be a wimp!

Upcheer thyself

typefaces
Adorn Garland and Adorn Ornaments

Decorative

Decorative fonts are easy to identify—if the thought of reading an entire book in that font makes you wanna throw up a little, you can probably put it in the decorative pot. Decorative fonts are great—they're fun, distinctive, easy to use, oftentimes cheaper, and there is a font for any whim you wish to express. Of course, simply because they *are* so distinctive, their use is limited.

MATCHWOOD THE WALL
HORST SCARLETT
SYbIL GREEN Flyswim

When using a decorative typeface, go beyond what you think of as its initial impression. For instance, if Sybil Green strikes you as informal, try using it in a more formal situation and see what happens. If you think Matchwood carries a Wild West flavor, try it in a corporate setting or a flower shop and see what happens. Depending on how you use them, decoratives can carry obvious emotions, or you can manipulate them into carrying connotations very different from your first impression. But that is a topic for another book.

Wisdom sometimes benefits from the use of decorative fonts.

typefaces
HARMAN SIMPLE, Harman Deco, Harman Deco Inline, **HARMAN SLAB INLINE**, HARMAN EXTRAS 2

Be conscious

To use type effectively, you have to be conscious. By that I mean you must keep your eyes open, you must notice details, you must try to state the problem in words. Or when you see something that appeals to you strongly, put into words *why* it appeals to you.

Spend a few minutes and look through a magazine. Try to categorize the typefaces you see. Many of them won't fit neatly into a single pot, but that's okay—choose the category that seems the closest. The point is that you are looking more closely at letterforms, which is absolutely critical if you are going to combine them effectively.

Little Quiz #5: Categories of type

Draw lines to match the category with the typeface! (Answers on page 224.)

Oldstyle	**at the rodeo**
Modern	HIGH SOCIETY
Slab serif	*Too Sassy for Words*
Sans serif	As I remember, Adam
Script	The enigma continues
Decorative	*It's your attitude*

THE NON-DESIGNER'S DESIGN BOOK

Little Quiz #6: Thick/thin transitions

Circle the letter that describes the thick/thin transitions of each face.
(Answers are on page 224.)

A moderate thick/thin transitions

B radical thick/thin transitions

C no (or negligible) thick/thin transitions

Giggle

A B C

Times New Roman Regular

Jiggle

A B C

American Typewriter Regular

Diggle

A B C

Garamond Premier Pro Regular

Piggle

A B C

Optima

Higgle

A B C

Formata Regular

Wiggle

A B C

Walbaum Book

Little Quiz #7: Serifs

Circle the letter that describes the serifs in each face below. (Answers are on page 224.)

A thin, horizontal serifs

B thick, slabby [hint] horizontal serifs

C no serifs

D slanted serifs

Siggle

A B C D

Folio Medium

Riggle

A B C D

Brioso Pro Regular

Figgle

A B C D

SuperClarendon Bold

Biggle

A B C D

New Baskerville Roman

Miggle

A B C D

Opal Pro Regular

Tiggle

A B C D

Modern No. 20

Notice the huge differences between all the "g" letters! It's too much fun.

Summary

I can't stress enough how important it is that you become conscious of these broad categories of type. As you work through the next chapter, it will become clearer *why* this is important.

A simple **exercise** to continually hone your visual skills is to collect samples of the categories. Cut them out of any printed material you can find. Do you see any patterns developing within a broad category? Go ahead and make subsets, such as oldstyle typefaces that have small x-heights and tall descenders. Or scripts that are really more like hand printing than cursive handwriting. Or extended faces and condensed faces (see below). It is this visual awareness of the letterforms that will give you the power to create interesting, provocative, and effective type combinations.

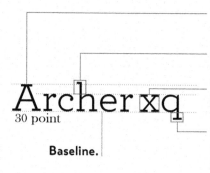

The **cap height** (height of capital letters) is often shorter than the ascenders.

Ascenders are the parts of letters that are taller than the x-height.

The **x-height** is the height of the main body of the lowercase letters.

Descenders are the parts of letters that are below the **baseline** (the invisible line on which the type sits).

30 point

Baseline.

Notice (below) the x-height of Bernhard as compared to Eurostile—look at the x-height in relation to the ascenders. Bernhard has an unusually small x-height relative to its ascenders. Most sans serifs have large x-heights. Start noticing those kinds of details.

Eurostile Bold 18 point Bernhard 18 point
Eurostile Bold Extended
Eurostile Bold Condensed

Extended typefaces look stretched out; **condensed** typefaces appear to be squished. Both are appropriate in certain circumstances.

Type Contrasts

This chapter focuses on the topic of combining typefaces. The following pages describe the various ways type can be contrasted. Each page shows specific examples, and at the end of this section are examples using these principles of contrasting type on your pages. Type contrast is not only for the aesthetic appeal, but also to enhance the communication.

A reader should not have to try to figure out what is happening on the page—the focus, the organization of material, the purpose, the flow of information, all should be recognized instantly with a single glance. And along the way, it doesn't hurt to make it beautiful!

These are the contrasts I discuss:

S IZE

Weight

Structure

*F*ORM

Direction

Color

typefaces
HARMAN SIMPLE
Aachen Bold
Folio Extra Bold
 & Arno Pro Light Display
Memoir and **Formata Bold**
Madrone
Zanzibar Regular

 size

In which category
of type does this
face belong?

A contrast of size is fairly obvious: big type versus little type. To make a contrast of size work effectively, though, *don't be a wimp.* You cannot contrast 12-point type with 14-point type; most of the time they will simply conflict. You cannot contrast 65-point type with 72-point type. If you're going to contrast two typographic elements through their size, *then do it.* Make it obvious—don't let people think it's a mistake.

HEY, SHE'S CALLING YOU A LITTLE

WIMP

Decide on the typographic element that you want seen as a focus. Emphasize it with contrasts.

A N O T H E R

newsletter

Volume 1 ■ Number 1 January ■ 2016

Often certain typographic elements have to be visible, but aren't really that important to the general reading public. Make them small. If someone cares what the volume number is, for instance, it can still be read. It's okay not to set it in 12-point type!

typefaces
Folio Light **and Extra Bold**
American Typewriter Regular and **Bold**

A contrast of size does not always mean you must make the type large—it just means there should be a contrast. For instance, when you see a small line of type alone on a large newspaper page, you are compelled to read it, right? An important part of what compels you is the contrast of very small type on that large page.

If you came across this full page in a magazine, would you read that small type in the middle? Contrast does that.

Sometimes the contrast of big over little can be overwhelming; it can overpower the smaller type. Use that to your advantage. Who wants to notice the word "incorporated" anyway? Although it's small, it's certainly not invisible so it's there for those who need it.

typefaces
Wade Sans Light
Brioso Pro Caption
Memphis Extra Bold and Light

Over and over again I have recommended not to use all caps. You probably use all caps sometimes to make the type larger, yes? Ironically, when type is set in all caps, it takes up a lot more space than the lowercase, so you have to make the point size smaller. If you make the text lowercase, you can actually set it in a much larger point size, plus it's more readable.

MERMAID TAVERN

Bread and Friday Streets
Cheapside ⚓ London

This title is in 20-point type. That's the largest size
I can use in this space with all caps.

Mermaid Tavern

Bread and Friday Streets
Cheapside ⚓ London

typefaces
Silica Regular
Charcuterie Cursive
⚓ *Charcuterie Ornament*

By making the title lowercase, I could enlarge it to 30-point
type in the same space, which helps to emphasize the
contrast of the fonts.

Use a contrast of size in unusual and provocative ways. Many of our typographic symbols, such as numbers, ampersands, or quotation marks, are very beautiful when set extremely large. Use them as decorative elements in a headline or a pull quote, or as repetitive elements throughout a publication.

The Sound & the Fury

An unusual contrast of size can become a graphic element in itself—handy if you are limited in the images that are available for a project.

typefaces
Zanzibar Regular
(Zanzibar Regular)

Travel Tips

1 Take twice as much money as you think you'll need.

2 Take half as much clothing as you think you'll need.

3 Don't even bother taking all the addresses of the people who expect you to write.

typefaces
Bodoni Poster
Bauer Bodoni Roman

If you use an item in an unusual size, see if you can repeat that concept elsewhere in the publication to create an attractive and useful repetition.

Weight

In which category of type does this face belong?

The weight of a typeface refers to the thickness of the strokes. Most type families are designed in a variety of weights: regular, bold, perhaps extra bold, semibold, or light. When combining weights, remember the rule: *Don't be a wimp.* Don't contrast the regular weight with a semibold—go for the stronger bold. If you are combining type from two different families, one face will usually be bolder than the other—so emphasize it.

Most of the typefaces that come standard with your personal computer are missing a very strong bold in the family. I heartily encourage you to invest in at least one very strong, black face. Look through online type catalogs to find one. A contrast of weight is one of the easiest and most effective ways to add visual interest to a page without redesigning a thing, but you will never be able to get that beautiful, strong contrast unless you have a typeface with big, solid strokes.

Brandon Grotesque Light
Brandon Grotesque Regular
Brandon Grotesque Medium
Brandon Grotesque Bold

These are examples of the various weights that usually come within a family. Notice there is not much contrast of weight between the light and the next weight (variously called regular, medium, or book).

Silica Extra Light
Silica Regular
Silica Bold
Silica Black

Nor is there a strong contrast between the semibold weights and the bolds. If you are going to contrast with weight, make it strong or it will simply look like a mistake.

Warnock Pro Light
Warnock Pro Regular
Warnock Pro Semibold
Warnock Pro Bold

ANOTHER NEWSLETTER

Headline
Lorem ipsum dolor sit amet, consectetur adips cing elit, diam nonnumy eiusmod tempor incidunt ut lobore et dolore nagna aliquam erat volupat. At enim ad minimim veniami quis nostrud exercitation ullamcorper suscripit laboris nisi ut alquip exea commodo consequat.

Another Headline
Duis autem el eum irure dolor in reprehenderit in voluptate velit esse mol-eratie son conswquat, vel illum dolore en guiat nulla pariatur. At vero esos et accusam et justo odio disnissim qui blandit praesent lupatum delenit aigue duos dolor et.

Molestais exceptur sint occaecat cupidat non provident, simil tempor.

Sirt in culpa qui officia deserunt aliquan erat volupat. Lorem ipsum dolor sit amet, consec tetur adipscing elit, diam nommuny eiusmod tem por incidunt ut lobore

First subhead
Et dolore nagna aliquam erat volupat. At enim ad minimim veni ami quis nostrud exer citation ullamcorper sus cripit laboris nisi ut al quip ex ea commodo consequat.

Duis autem el eum irure dolor in rep rehend erit in voluptate velit esse moles taie son conswquat, vel illum dolore en guiat nulla pariatur. At vero esos et accusam et justo odio disnissim qui blan dit praesent lupatum del enit aigue duos dolor et molestais exceptur sint el eum irure dolor in

Another Newsletter

Headline
Lorem ipsum dolor sit amet, consectetur adips cing elit, diam nonnumy eiusmod tempor incidunt ut lobore et dolore nagna aliquam erat volupat. At enim ad minimim veniami quis nostrud exercitation ullamcorper suscripit laboris nisi ut alquip exea commodo consequat.

Another Headline
Duis autem el eum irure dolor in reprehenderit in voluptate velit esse mol-eratie son conswquat, vel illum dolore en guiat nulla pariatur. At vero esos et accusam et justo odio dis-nissim qui blandit praesent lupatum delenit aigue duos dolor et.

Molestais exceptur sint occaecat cupidat non provident, simil tempor.

Sirt in culpa qui officia deserunt aliquan erat volupat. Lorem ipsum dolor sit amet, consec tetur adipscing elit, diam nonnumy eiusmod tem por incidunt ut lobore

First subhead
Et dolore nagna aliquam erat volupat. At enim ad minimim veni ami quis nostrud exer citation ullamcorper sus cripit laboris nisi ut al quip ex ea commodo consequat.

Duis autem el eum irure dolor in rep rehend erit in voluptate velit esse moles taie son conswquat, vel illum dolore en guiat nulla pariatur. At vero esos et accusam et justo odio disnissim qui blan dit praesent lupatum del enit aigue duos dolor et molestais exceptur sint

Remember these examples in the first part of the book? On the left, I used the fonts that come with the computer; the headlines are Helvetica (Arial) Bold, the body copy is Times Roman Regular.

On the right, the body copy is still Times Roman Regular, but I used a heavier (stronger weight) typeface for the headlines (Aachen Bold). With just that simple change—a heavier weight for contrast— the page is much more inviting to read. (The title is also heavier and is reversed out of a black box, adding contrast.)

Mermaid Tavern

Bread and Friday Streets
Cheapside ⚓ London

Remember this example from a couple pages back? By setting the company name in lowercase instead of all caps, I could not only make the type size larger, but I could make it heavier as well, thus adding more contrast and visual interest to the card. The heavier weight also gives the piece a stronger focus.

Not only does a contrast of weight make a page more attractive to your eyes, it is one of the most effective ways of organizing information. You do this already when you make your newsletter headlines and subheads bolder. So take that idea and push it a little harder. Take a look at the table of contents below; notice how you instantly understand the hierarchy of information when key heads or phrases are very bold. This technique is also useful in an index; it enables the reader to tell at a glance whether an index entry is a first-level or a second-level entry, thus eliminating the confusion that often arises when you're trying to look up something alphabetically. Look at the index in this book (or in any of my books).

Contents

Contents

By making the chapter headings bolder, the important information is available at a glance, and there is also a stronger attraction for the eye. Plus it sets up a **repetition** (one of the four main principles of design, remember?). I also added a tiny bit of space **above** each bold heading so the headings would be grouped more clearly with their subheadings (Principle of **Proximity**).

typefaces
Warnock Pro Regular
Doradani Bold

If you have a very gray page and no room to add images or to pull out quotes and set them as graphics, try setting key phrases in a strong bold. They will pull the reader into the page. (If you use a bold sans serif within serif body copy, you will probably have to make the bold sans serif a point size smaller to make it appear to be the same size as the serif body copy.)

Wants pawn term dare worsted ladle gull hoe lift wetter murder inner ladle cordage honor itch offer lodge, dock, florist. Disk ladle gull orphan worry putty ladle rat cluck wetter ladle rat hut, an fur disk raisin pimple colder Ladle Rat Rotten Hut.

Wan moaning Ladle Rat Rotten Hut's murder colder inset.

Ladle Rat Rotten Hut, heresy ladle bsking winsome burden barter an shirker cockles. Tick disk ladle basking tutor cordage offer groin-murder hoe lifts honor udder sit offer florist. Shaker lake! Dun stopper laundry wrote! Dun stopper peck floors! Dun daily-doily in ner florist, an yonder nor sorghum-stenches, dun stopper torque wet no strainers!

Hoe-cake, murder, resplendent Ladle Rat Rotten Hut, and stuttered oft oft. Honor wrote tutor cordage offer groin-murder, Ladle Rat Rotten Hut mitten anomalous woof. Wail, wail, wail, set disk wicket woof, Evanescent Ladle Rat Rotten Hut! Wares are putty ladle gull goring wizard cued ladle basking?

Armor goring tumor oiled groin-murder's, reprisal ladle gull. Grammar's seeking bet. Armor ticking arson burden barter an shirker cockles.

O hoe! Heifer gnats woke, setter wicket woof, butter taught tomb shelf, Oil tickle shirt court tutor cordage offer groin-murder. Oil ketchup wetter letter, and den—O bore!

Soda wicket woof tucker shirt court, an whinny retched a cordage offer groin-murder, picked inner windrow, an sore debtor pore oil worming worse lion inner bet.

Inner flesh, disk abdominal woof lipped honor bet, paunched honor pore oil worming, any garbled erupt. Den disk ratchet ammonol pot honor groin-murder's nut cup an gnat-gun, any curdled ope inner bet, paunched honor pore oil worming, any garbled erupt. Inner

Wants pawn term dare worsted ladle gull hoe lift wetter murder inner ladle cordage honor itch offer lodge, dock, florist. **Disk ladle gull orphan worry putty ladle rat cluck** wetter ladle rat hut, an fur disk raisin pimple colder Ladle Rat Rotten Hut.

Wan moaning Ladle Rat Rotten Hut's murder colder inset.

Ladle Rat Rotten Hut, heresy ladle bsking winsome burden barter an shirker cockles. Tick disk ladle basking tutor cordage offer groin-murder hoe lifts honor udder sit offer florist. Shaker lake! Dun stopper laundry wrote! Dun stopper peck floors! Dun daily-doily in ner florist, an yonder nor sorghum-stenches, dun stopper torque wet no strainers!

Hoe-cake, murder, resplendent Ladle Rat Rotten Hut, and stuttered oft oft. Honor wrote tutor cordage offer groin-murder, **Ladle Rat Rotten Hut mitten anomalous woof.** Wail, wail, wail, set disk wicket woof, Evanescent Ladle Rat Rotten Hut! Wares are putty ladle gull goring wizard cued ladle basking?

Armor goring tumor oiled groin-murder's, reprisal ladle gull. Grammar's seeking bet. Armor ticking arson burden barter an shirker cockles.

O hoe! Heifer gnats woke, setter wicket woof, butter taught tomb shelf, **Oil tickle shirt court tutor cordage offer groin-murder.** Oil ketchup wetter letter, and den—O bore!

Soda wicket woof tucker shirt court, an whinny retched a cordage offer groin-murder, picked inner windrow, an sore debtor pore oil worming worse lion inner bet.

Inner flesh, disk abdominal woof lipped honor bet, paunched honor pore oil worming, any garbled erupt. **Den disk ratchet ammonol pot honor groin-murder's nut cup an gnat-gun,** any curdled ope inner bet, paunched honor pore oil worming, any garbled erupt. Inner

A completely gray page may discourage a casual reader from perusing the story. With the contrast of bold type, the reader can scan key points and is more likely to delve into the information.

Sometimes, of course, what a reader wants is a plain gray page. For instance, when you're reading a novel, you don't want any fancy type tricks to interrupt your eyes—you just want the type to be invisible. And some magazines and journals prefer the stuffy and formal look of a gray page because their audience feels it imparts a more serious impression. There is a place for everything. Just make sure the look you are creating is conscious.

typefaces
Garamond Premier Pro Regular
Bailey Sans ExtraBold

Structure

In which category of type does this face belong?

The structure of a typeface refers to how it is built. Imagine that you were to build a typeface out of material you have in your garage. Some faces are built very monoweight, with almost no discernible weight shift in the strokes, as if you had built them out of tubing (like most sans serifs). Others are built with great emphasis on the thick/thin transitions, like picket fences (the moderns). And others are built in-between. If you want to combine two different type families, choose them from different structures.

Remember wading through all that stuff earlier in this section about the different categories of type? Well, this is where it comes in handy. Each of the categories is founded on similar *structures*. So you are well on your way to a type solution if you **choose two or more faces from two or more categories.**

Ode Ode Ode

Ode **Ode** **Ode**

Ode Ode Ode

Ode Ode Ode

Little Quiz: Can you name each of the typeface categories represented here (one category per line)?

If not, re-read that section because this simple concept is very important.

Structure refers to how a letter is built, and as you can see in these examples, the structure within each category is quite distinctive.

Robin's Rule: Do not put two typefaces from the same category on the same page. There's no way you can get around their similarities. And besides, you have so many other choices—why make life difficult?

The guiding principle of typographic contrast is that you must pull two faces from **two different categories of type.**

That is, you can use two serifs as long as one is an oldstyle and the other is a modern or a slab serif. Even then you must be careful and you must emphasize the contrasts, as explained in the rest of this chapter.

Along the same line, avoid setting two oldstyles on the same page—they have too many similarities and are guaranteed to conflict no matter what you do. Avoid setting two moderns, or two slabs, for the same reason. Avoid using two scripts on the same page.

You can't let
the seeds
stop you
from enjoying
the watermelon.

There are five different typefaces in this one little quote. They don't look too bad together because of one thing: they each have a different structure; **they are each from a different category of type.**

typefaces
Formata Bold (sans serif)
Bauer Bodoni Roman (modern)
Blackoak (slab serif)
Goudy Oldstyle (oldstyle)
Thirsty Rough Light (script)

Serif vs. sans serif is a contrast of structure

At first, different typefaces seem as indistinguishable as tigers in the zoo. So if you are new to the idea that one font looks different from another, an easy way to choose contrasting structures is to pick **one serif font and one sans serif font.** Serif fonts generally have a thick/thin contrast in their structures; sans serifs generally are monoweight. Combining serif with sans serif is a time-tested combination with an infinite variety of possibilities. But as you can see in the example below-left, the contrast of structure alone is not strong enough; you need to emphasize the difference by combining it with other contrasts, such as size or weight.

monoweight
20 pt — sans serif
thick/thin — vs. serif
20 pt

sans serif vs. serif
monoweight — 8 pt
thick/thin — 50 pt

You can see that the contrast of structure alone is not enough to contrast type effectively.

But when you add the element of size—voilà! Contrast!

Oiled Mudder Harbored

Oiled Mudder Harbored

Wen tutor cardboard

Toe garter pore darker born.

Bud wenchy gut dare

Door cardboard worse bar

An soda pore dark hat known.

Oiled Mudder Harbored

Oiled Mudder Harbored

Wen tutor cardboard

Toe garter pore darker born.

Bud wenchy gut dare

Door cardboard worse bar

An soda pore dark hat known.

As the example above shows, the combination of typefaces with two different structures is not enough. It's still weak—the differences must be emphasized.

See how much better this looks! Adding weight to the title highlights the difference in the structure of the two typefaces—and strengthens the contrast between the two.

typefaces
Garamond Premier Pro Regular
Folio Light
Warnock Pro Regular
Hallis GR Book and **Black**

Setting two sans serifs on one page is always difficult because there is only one structure—monoweight. If you are extraordinarily clever, you might be able to pull off setting two sans serifs if you use one of the rare ones with a thick/thin transition in its strokes, but I don't recommend even trying it. Rather than try to combine two sans serifs, build contrast in other ways using different members of the same sans serif family. The sans serif families usually have nice collections of light weights to very heavy weights, and often include a compressed or extended version (see pages 204–207 about contrast of direction).

Here are two sans serifs together, a monoweight sans (Aptifer) with one of the few sans serifs that has a thick/thin transition (Octane), which gives it a different structure. I also maximized the contrasts with all caps, large size, and very bold.

And here are three different weights of one sans serif family, Avenir Next: Condensed Ultra Light, Heavy, and Regular Italic. This is why it's good to own at least one sans serif family that has lots of different family members. Emphasize their contrasts!

Look—two serifs together! But notice each face has a different **structure,** one from the modern category (Bodoni) and one from the slab serif (Clarendon). I also added other contrasts—can you name them?

Form

In which category of type does this face belong?

The form of a letter refers to its shape. Characters may have the same structure, but different "forms." For instance, a capital letter "G" has the same *structure* as a lowercase letter "g" in the same family. But their actual *forms,* or shapes, are very different from each other. An easy way to think of a contrast of form is to think of **caps versus lowercase.**

G g

A a

B b

H h

E e

The **forms** of each of these capital letters (Warnock Pro Light Display) are distinctly different from the **forms, or shapes,** of the lowercase letters. So caps versus lowercase is another way to contrast type.

This is something you've probably been doing already, but now, being more conscious of it, you can take greater advantage of its potential for contrast.

All caps vs. lowercase is a contrast of form

In addition to each individual capital letterform being different from its lowercase form, the form of the entire all-cap word is also different. This is what makes all caps so difficult to read, as mentioned in Chapter 9. We recognize words not only by their letters, but by their forms, the shapes of the entire words. All words that are set in capital letters have a similar rectangular form, as shown below, and we are forced to read the words letter by letter.

You're probably tired of hearing me recommend not using all caps. I don't mean *never* use all caps. All caps are not *impossible* to read, obviously. Just be conscious of their reduced legibility and readability. Sometimes you can argue that the design "look" of your piece justifies the use of all caps, and that's okay! You must also accept, however, that the words are not as easy to read. If you can consciously state that the lower readability is worth the design look, then go ahead and use all caps.

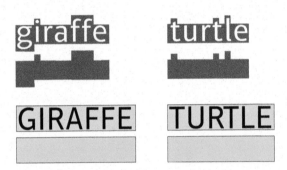

Every word in all caps has the same form: rectangular.

Caps versus lowercase (contrast of form) usually needs strengthening with other contrasts. Size is the only other contrast added in this example.

Roman vs. italic is a contrast of form

Another clear contrast of form is **roman versus italic.** Roman, in any typeface, simply means that the type stands straight up and down, as opposed to italic or script, where the type is slanted and/or flowing. Setting a word or phrase in italic to gently emphasize it is a familiar concept that you already use regularly.

G g nerdette

G g nerdette

The first line is roman type; the second line is italic. They are both Brioso Pro; their **structures** are exactly the same, but their **forms (shapes)** are different.

Be far flung away

Be far flung away

Sans serif faces often (not always) have "oblique" versions, which look like the letters are just tilted. Most sans serif roman and oblique forms are not so very different from each other.

Be far flung away

Be far flung away

The "true-drawn" italic in this first line is not simply slanted roman, whereas the second line is fake italic. True-drawn italic letterforms have actually been redrawn into different shapes. Look carefully at the differences between the e, f, a, and y (both lines use the same font).

"Yes, oh, *yes,*" she chirped.

"Yes, oh, *yes,*" she chirped.

Which of these two sentences contains a word in fake italic?

Since all scripts and italics have a slanted and/or flowing form, it is important to avoid a combination of two different italic fonts, or two different scripts, or an italic with a script. Doing so will invariably create a conflict—there are too many similarities. Fortunately, it's not difficult to find great fonts to combine with scripts or italics.

Work Hard
There is no shortcut.

So what do you think about these two typefaces together? Is something wrong? Does it make you twitch? One of the problems with this combination is that both faces have the same form—they both have a cursive, flowing form. One of the fonts has to change. To what? (Think about it.)

Yes—one face has to change to some sort of roman. While we're changing it, we might as well make the **structure** of the new typeface very different also, instead of one with a thick/thin contrast. And we can make it heavier as well.

Work Hard
there is no shortcut

typefaces
Peoni
Goudy Oldstyle Italic
Aachen Bold

Direction

In which category of type does this face belong?

An obvious interpretation of type "direction" is type on a slant. Since this is so obvious, the only thing I want to say is don't do it. Well, you might want to do it sometimes, but only do it if you can state in words why this type must be on a slant, why it enhances the aesthetics or communication of the piece. For instance, perhaps you can say, "This notice about the boat race really should go at an angle up to the right because that particular angle creates a positive, forward energy on the page." Or, "The repetition of this angled type creates a staccato effect which emphasizes the energy of the Bartok composition we are announcing." But please, never fill the corners with type on angles.

The mischance of the hour

Type slanting upward to the right creates a positive energy. Type slanting downward creates a negative energy. Occasionally you can use these connotations to your advantage.

Sometimes a strong re-direction of type creates a dramatic impact or a unique format—which is a good justification for its use.

the shakespeare papers

Amusing, Tantalizing, and Educative

Lorem ipsum dolor sit amet, consectetur adips cing elit, diam nonnumy eiusmod tempor incidunt ut lobore et dolore nagna aliquam erat volupat. At enim ad minimim veniami quis nos trud ex ercitation ullamcorper sus cripit laboris nisi ut alquip exea commodo consequat.

Unexpected

Duis autem el eum irure dolor in reprehenderit in volu ptate velit esse mol eratie son conswquat, vel illum dolore en guiat nulla pariatur. At vero esos et accusam et justo odio disnissim qui blandit pra esent lupatum delenit ai gue duos dolor et. Molestais

exceptur sint occoecat cupidat non pro vident, simil tempor. Sirt in culpa qui officia des erunt aliquan erat volupat. Lorem ipsum dolor sit amet, consec tetur adip scing elit, diam no numy eiusmod tem por incidunt ut lobore.

Intriguing and Controversial

Et dolore nagna aliquam erat volupat. At enim ad minimim veni ami quis nostrud exer citation ulla mcorper sus cripit laboris nisi ut al quip ex ea commodo consequat.

Duis autem el eum irure dolor in rep rehend erit in proles to maheminit and smit off their heads forthwith.

VOLUPTATE VELIT ESSE moles taie son conswquat, vel illum dolore en guiat nulla pariatur. At vero esos et accusam et justo odio disnissim qui blan dit praesent lupatum del enit aigue duos dolor et mol estais exceptur sint. El eum irure dolor in rep rehend erit in voluptate. At enim ad minimim veniami quis nostrud ex ercitation ullamcorper sus cripit laboris nisi ut alquip exea commodo consequat. Et dolore nagna aliquam erat volupat. At enim ad minimim veni ami quis nostrud exer citation ulla mcorper sus cripit laboris nisi ut al quip ex ea commodo consequat. Vero esos et accusam et justo odio disnissim qui blan dit praesent.

typefaces

Caflisch Script Pro
Formata Light and **Bold**
Brioso Pro Caption

But there is another form of "direction." Every element of type has a direction, even though it may run straight across the page. A *line* of type has a horizontal direction. A tall, thin *column* of type has a vertical direction. It is these more sophisticated directional movements of type that are fun and interesting to contrast. For instance, a double-page spread with a bold headline running across the two pages and the body copy in a series of tall, thin columns creates an interesting contrast of direction.

unfortunate lament
robert burns

O thou
pale orb
that
silent
shines
while
care–
untroubled
mortals
sleep

If you have a layout that has the potential for a contrast of direction, emphasize it. Perhaps use an extended typeface in the horizontal direction, and a tall typeface in the vertical direction. Emphasize the vertical by adding extra linespace, if appropriate, and narrower columns than you perhaps originally planned.

typefaces
Sneakers UltraWide
Ride my Bike Regular and *Italic*
Ciao Bella Stems

You can involve other parts of your layout in the contrast of type direction, such as graphics or lines, to emphasize or contrast the direction.

typefaces
Today Sans Light and **Bold**
Minimalist Flat Faces Icons

Long horizontals and tall, thin columns can be combined in an endless variety of elegant layouts. Alignment is a key factor here—strong visual alignments will emphasize and strengthen the contrasts of direction.

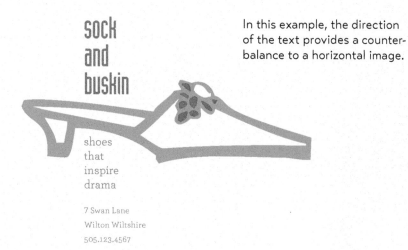

In this example, the direction of the text provides a counter-balance to a horizontal image.

typefaces
Industria Solid
Archer Book
Shoe is DivaDoodles

In the example below, there is a nice, strong contrast of direction. But what other contrasts have also been employed to strengthen the piece? There are three different typefaces in that arrangement —*why* do they work together?

Also notice the texture that is created from the structures of the various typefaces, their linespacing, their letterspacing, their weight, their size, their form. If the letters were all raised and you could run your fingers over them, each contrast of type would also give you a contrast of texture—you can "feel" this texture visually. This is a subtle, yet important, part of type. Various textures will occur automatically as you employ other contrasts, but it's good to be conscious of texture and its effect.

MARY SIDNEY
COUNTESS OF PEMBROKE

IF IT'S BEEN
SAID IN
ENGLISH,
MARY
SAID IT
BETTER.

Ay me, to whom shall I my case complain that may compassion my impatient grief? Or where shall I unfold my inward pain, that my enriven heart may find relief?

To heavens? Ah, they alas the authors were, and workers of my unremedied woe: for they foresee what to us happens here, and they foresaw, yet suffered this be so.

To men? Ah, they alas like wretched be, and subject to the heaven's ordinance: Bound to abide what ever they decree, the best redress is their best sufferance.

Then to my self will I my sorrow mourn, since none alive like sorrowful remains, and to my self my plaints shall back return, to pay their usury with doubled pains.

Spend a few minutes to put into words why these three typefaces work together.

If you choose a narrow modern in all caps for the headline, what would be a logical choice for the short quote?

If you had, instead, chosen a modern typeface for the short quote, what would then be a logical choice for the headline?

typefaces
Onyx
Eurostile Bold Extended 2
Archer Book Italic

Color

In which category of type does this face belong?

Color is another term, like direction, with obvious interpretations. When you're talking about actual color, remember to keep in mind that warm colors (reds, oranges) come forward and command our attention. Our eyes are very attracted to warm colors, so it takes very little red to create a contrast. Cool colors (blues, greens), on the other hand, recede from our eyes. You can get away with larger areas of a cool color; in fact, you *need* more of a cool color to create an effective contrast.

Scarlett **FLORENCE**

Notice that even though the name "Scarlett" is much smaller, it competes with the larger word because of the warm color.

Scarlett **FLORENCE**

Now the larger name in the warm color overpowers the smaller name. You can avoid this or take advantage of it, but always be conscious of it.

Scarlett **FLORENCE**

Notice how the light blue "Scarlett" almost disappears.

Scarlett **FLORENCE**

To use a cool color effectively, you generally need to use more of it.

typefaces
Memoir
Goudy Oldstyle

But besides the natural idea of colorful color, typographers have always referred to **black-and-white type** on a page as having **color.** It's easy to create contrast with colorful colors; it takes a more sophisticated eye to see and take advantage of the color contrasts in black-and-white.

In the quote below, you can easily see different "colors" in the black and white text which is created by such variances as the weight of the letterforms, the structure, the form, the space inside the letters, the space between the letters, the space between the lines, the size of the type, or the size of the x-height. Even using one typeface, you can create different colors.

Just as the voice adds emphasis
to important words, so can type:
**it shouts or whispers
by variation of size.**

Just as the pitch of the voice adds
interest to the words, so can type:
**it modulates by lightness
or darkness.**

Just as the voice adds color to the
words by inflection, so can type:
**it defines elegance,
dignity, toughness
by choice of face.**

Jan V. White

Squint your eyes and look at this. Get used to considering the different values of blocks of text as having color and texture.

typefaces
Brioso Pro Regular and *Italic*
Eurostile Bold Extended 2

A light, airy typeface with lots of letterspacing and linespacing creates a very light color (and texture). A bold sans serif, tightly packed, creates a dark color (with a different texture). This is a particularly useful contrast to employ on those text-heavy pages where there are no graphics.

A gray, text-only page can be very dull to look at and uninviting to read. It can also create confusion: In the example below, are these two stories related to each other?

Ladle Rat Rotten Hut

Wants pawn term dare worsted ladle gull hoe lift wetter murder inner ladle cordage honor itch offer lodge, dock, florist. Disk ladle gull orphan worry Putty ladle rat cluck wetter ladle rat hut, an fur disk raisin pimple colder Ladle Rat Rotten Hut.

Wan moaning Ladle Rat Rotten Hut's murder colder inset. "Ladle Rat Rotten Hut, heresy ladle basking winsome burden barter an shirker cockles. Tick disk ladle basking tutor cordage offer groin-murder hoe lifts honor udder site offer florist. Shaker lake! Dun stopper laundry wrote! Dun stopper peck floors! Dun daily-doily inner florist, an yonder nor sorghum-stenches, dun stopper torque wet strainers!"

"Hoe-cake, murder," resplendent Ladle Rat Rotten Hut, an tickle ladle basking an stuttered oft. Honor wrote tutor cordage offer groin-murder, Ladle Rat Rotten Hut mitten anomalous woof.

"Wail, wail, wail!" set disk wicket woof, "Evanescent Ladle Rat Rotten Hut! Wares are putty ladle gull goring wizard ladle basking?"

"Armor goring tumor groin-murder's," reprisal ladle gull. "Grammar's seeking bet. Armor ticking arson burden barter an shirker cockles."

"O hoe! Heifer gnats woke," setter wicket woof, butter taught tomb shelf, "Oil tickle shirt court tutor cordage offer groin-murder. Oil ketchup wetter letter, an den—O bore!"

Soda wicket woof tucker shirt court, an whinny retched a cordage offer groin-murder, picked inner windrow, an sore debtor pore oil worming worse lion inner bet. Inner flesh, disk abdominal woof lipped honor bet, paunched honor pore oil worming, an garbled erupt. Den disk ratchet ammonol pot honor groin-murder's nut cup an gnat-gun, any curdled ope inner bet.

Inner ladle wile, Ladle Rat Rotten Hut a raft attar cordage, an ranker dough ball. "Comb ink, sweat hard," setter wicket woof, disgracing is verse. Ladle Rat Rotten Hut entity bet rum, an stud buyer groin-murder's bet.

"O Grammar!" crater ladle gull historically, "Water bag icer gut! A nervous sausage bag ice!"

"Battered lucky chew whiff, sweat hard," setter bloat-Thursday woof, wetter wicket small honors phase.

"O, Grammar, water bag noise! A nervous sore suture anomalous prognosis!"

"Battered small your whiff, doling," whiskered dole woof, ants mouse worse waddling.

"O Grammar, water bag mouser gut! A nervous sore suture bag mouse!"

Daze worry on-forger-nut ladle gull's lest warts. Oil offer sodden, caking offer carvers an sprinkling otter bet, disk hoard-hoarded woof lipped own pore Ladle Rat Rotten Hut an garbled erupt.

Mural: Yonder nor sorghum stenches shut ladle gulls stopper torque wet strainers.

—H. Chace
Anguish Languish

Old Singleton

. . . Singleton stood at the door with his face to the light and his back to the darkness. And alone in the dim emptiness of the sleeping forecastle he appeared bigger, colossal, very old; old as Father Time himself, who should have come there into this place as quiet as a sepulcher to contemplate with patient eyes the short victory of sleep, the consoler. Yet he was only a child of time, a lonely relic of a devoured and forgotten generation. He stood, still strong, as ever unthinking; a ready man with a vast empty past and with no future, with his childlike impulses and his man's passions already dead within his tattooed breast.

—Joseph Conrad

This might be a typical page in a publication. The monotonous gray does not attract your eye; there's no enticement to dive in and read.

As mentioned earlier, a gray, text-only page is sometimes the perfect solution, as when you do not want the typography to interrupt the reading experience. But for most forms of graphic design, we like to lure the reader into the page or at least make the page interesting to look at, even if in a subtle way.

typefaces
Warnock Pro Regular and *Italic*

If you add some color to your heads and subheads with a stronger weight, or perhaps set a quote, passage, or short story in an obviously different color, then it attracts the eyes and readers are more likely to stop on the page and actually read it. And that's our point, right?

Besides making the page more inviting to read, this change in color also helps organize the information. In the example below, it is now clearer that there are two separate stories on the page.

Ladle Rat Rotten Hut

Wants pawn term dare worsted ladle gull hoe lift wetter murder inner ladle cordage honor itch offer lodge, dock, florist. Disk ladle gull orphan worry Putty ladle rat cluck wetter ladle rat hut, an fur disk raisin pimple colder Ladle Rat Rotten Hut.

Wan moaning Ladle Rat Rotten Hut's murder colder inset. "Ladle Rat Rotten Hut, heresy ladle basking winsome burden barter an shirker cockles. Tick disk ladle basking tutor cordage offer groin-murder hoe lifts honor udder site offer florist. Shaker lake! Dun stopper laundry wrote! Dun stopper peck floors! Dun daily-doily inner florist, an yonder nor sorghum-stenches, dun stopper torque wet strainers!"

"Hoe-cake, murder," resplendent Ladle Rat Rotten Hut, an tickle ladle basking an stuttered oft. Honor wrote tutor cordage offer groin-murder, Ladle Rat Rotten Hut mitten anomalous woof.

"Wail, wail, wail!" set disk wicket woof, "Evanescent Ladle Rat Rotten Hut! Wares are putty ladle gull goring wizard ladle basking?"

"Armor goring tumor groin-murder's," reprisal ladle gull. "Grammar's seeking bet. Armor ticking arson burden barter an shirker cockles."

"O hoe! Heifer gnats woke," setter wicket woof, butter taught tomb shelf, "Oil tickle shirt court tutor cordage offer groin-murder. Oil ketchup wetter letter, an den—O bore!"

Soda wicket woof tucker shirt court, an whinny retched a cordage offer groin-murder, picked inner windrow, an sore

debtor pore oil worming worse lion inner bet. Inner flesh, disk abdominal woof lipped honor bet, paunched honor pore oil worming, an garbled erupt. Den disk ratchet ammonol pot honor groin-murder's nut cup an gnat-gun, any curdled ope inner bet.

Inner ladle wile, Ladle Rat Rotten Hut a raft attar cordage, an ranker dough ball. "Comb ink, sweat hard," setter wicket woof, disgracing is verse. Ladle Rat Rotten Hut entity bet rum, an stud buyer groin-murder's bet.

"O Grammar!" crater ladle gull historically, "Water bag icer gut! A nervous sausage bag ice!"

"Battered lucky chew whiff, sweat hard," setter bloat-Thursday woof, wetter wicket small honors phase.

"O, Grammar, water bag noise! A half nervous sore suture anomalous prognosis!"

"Battered small your whiff, doling," whiskered dole woof, ants mouse worse waddling.

"O Grammar, water bag mouser gut! A nervous sore suture bag mouse!"

Daze worry on-forger-nut ladle gull's lest warts. Oil offer sodden, caking offer carvers an sprinkling otter bet, disk hoard-hoarded woof lipped own pore Ladle Rat Rotten Hut an garbled erupt.

Mural: Yonder nor sorghum stenches shut ladle gulls stopper torque wet strainers.
—H. Chace, *Anguish Languish*

Old Singleton

. . . Singleton stood at the door with his face to the light and his back to the darkness. And alone in the dim emptiness of the sleeping forecastle he appeared bigger, colossal, very old; old as Father Time himself, who should have come there into this place as quiet as a sepulcher to contemplate with patient eyes the short victory of sleep, the consoler. Yet he was only a child of time, a lonely relic of a devoured and forgotten generation. He stood, still strong, as ever unthinking; a ready man with a vast empty past and with no future, with his childlike impulses and his man's passions already dead within his tattooed breast. —Joseph Conrad

This is the same layout, but with added "color." Also, look again at many of the other examples in this book and you'll often see contrasting black typefaces that create variations in color.

typefaces
Aachen Bold
Warnock Pro Caption and *Light Italic Caption*
Eurostile Regular

Below, notice how you can change the color in one typeface, one size, with minor adjustments. As you can see, these minor adjustments can also affect how many words fit into a space. Being able to make these adjustments requires knowing how to adjust all the spacing attributes in your software: tracking, kerning, letterspacing, word spacing, linespacing, paragraph spacing, column spacing.

Center Alley worse jester pore ladle gull hoe lift wetter stop-murder an toe heft-cisterns. Daze worming war furry wicket an shellfish parsons, spatially dole stop-murder, hoe dint lack Center Alley an, infect, word

Warnock Pro Regular 9/10.8
(9 point type, 10.8 leading or linespacing)

Center Alley worse jester pore ladle gull hoe lift wetter stop-murder an toe heft-cisterns. Daze worming war furry wicket an shellfish parsons, spatially dole stop-murder, hoe dint lack

Warnock Pro Bold 9/10.8

This is exactly the same as the example above, except it is the bold version.

Center Alley worse jester pore ladle gull hoe lift wetter stop-murder an toe heft-cisterns. Daze worming war furry wicket an shellfish parsons, spatially dole stop-murder, hoe dint lack Center Alley an, infect, word orphan traitor pore gull mar lichen

Warnock Pro Light 9/10

This is the light version of the font, but it has less linespacing, making the texture appear more dense.

Center Alley worse jester pore ladle gull hoe lift wetter stop-murder an toe heft-cisterns. Daze worming war furry wicket an shellfish parsons, spatially dole stop-murder, hoe dint lack

Warnock Pro Light 9/13, extra letterspacing.

Notice this has a lighter color than the example above (same font) due to the extra space between the lines and the letters.

Center Alley worse jester pore ladle gull hoe lift wetter stop-murder an toe heft-cisterns. Daze worming war furry wicket an shellfish parsons, spatially dole stop-murder, hoe dint lack Center

Warnock Pro Light 9/13, extra letterspacing.

This is exactly the same as the one above, except in italic. It has a different color and texture.

Below you see just plain examples of typeface color, without any of the extra little manipulations you can use to change the type's natural color. **To do:** Set about twenty blocks of the same text, like you see below, and make minor adjustments to each one to see the differences in color. Be sure to label each block. Print up the pages because the real test is on paper, unless of course you are designing specifically for the screen.

Center Alley worse jester pore ladle gull hoe lift wetter stop-murder an toe heft-cisterns. Daze worming war furry wicket an shellfish parsons, spatially dole stop-murder, hoe dint lack Center Alley an,

American Typewriter, 9/11

Center Alley worse jester pore ladle gull hoe lift wetter stop-murder an toe heft-cisterns. Daze worming war furry wicket an shellfish parsons, spatially dole stop-murder, hoe dint lack Center Alley an, infect, word orphan traitor pore gull mar lichen ammonol dinner hormone bang.

Wade Sans Light, 9/11

Center Alley worse jester pore ladle gull hoe lift wetter stop-murder an toe heftcisterns. Daze worming war furry wicket an shellfish parsons, spatially dole stopmurder, hoe dint lack Center

Cooper Std. Black, 9/11

Center Alley worse jester pore ladle gull hoe lift wetter stop-murder an toe heft-cisterns. Daze worming war furry wicket an shellfish parsons, spatially dole stop-murder, hoe dint lack Center Alley an, infect, word

Memphis Medium, 9/11

Center Alley worse jester pore ladle gull hoe lift wetter stop-murder an toe heft-cisterns. Daze worming war furry wicket an shellfish parsons, spatially dole stop-murder, hoe dint lack Center Alley an, infect, word orphan traitor pore

Photina, 9/11

Center Alley worse jester pore ladle gull hoe lift wetter stop-murder an toe heft-cisterns. Daze worming war furry wicket an shellfish parsons, spatially dole stop-murder, hoe dint lack Center Alley an, infect, word orphan traitor pore gull mar lichen

Eurostile Regular, 9/11

Combine the contrasts

Most effective type layouts take advantage of more than one of the contrasting possibilities. For instance, if you are combining two serif faces, each with a different structure, emphasize their differences by contrasting their form also: If one element is in roman letters, all caps, set the other in italic, lowercase. Contrast their size, too, and weight; perhaps even their direction. Take a look at the examples in this section again—each one uses more than one principle of contrast.

For a wide variety of examples and ideas, take a look through any good magazine. Notice that every one of the interesting type layouts depends on the contrasts. Subheads or initial caps emphasize the contrast of size with the contrast of weight; often, there is also a contrast of structure (serif vs. sans serif) and form (caps vs. lowercase) as well.

Try to verbalize what you see. *If you can put the dynamics of the relationship into words, you have power over it.* When you look at a type combination that makes you twitch because you have an instinctive sense that the faces don't work together, analyze it with words.

Before trying to find a better solution, you must find the problem. To find the *problem,* name the *similarities*—not the differences. What is it about the two faces that compete with each other? Are they both all caps? Are they both typefaces with a strong thick/thin contrast in their strokes? How effective is their contrast of weight? Size? Structure?

Or perhaps the focus conflicts—is the *larger* type a *light* weight and the *smaller* type a *bold* weight, making them fight with each other because each one is trying to be more important than the other?

Name the problem, then you can create the solution.

Summary

This is a list of the contrasts discussed. You might want to keep this list visible for when you need a quick bang-on-the-head reminder.

SIZE Don't be a wimp.

Weight Contrast heavy weights with light weights, not medium weights.

Structure Look at how the letterforms are built—monoweight or thick/thin. Choose fonts from different **categories** to get different structures.

 Caps versus lowercase is a contrast of form, as well as **roman versus italic** or script. Scripts and italics have similar forms—don't combine them.

Think more in terms of horizontal type versus tall, narrow columns of type, rather than type on a slant.

COLOR Warm colors come forward; cool colors recede. Experiment with the "colors" of black text.

Little Quiz #8: Contrast or conflict

Look carefully at each of the following examples. Decide whether the type combinations **contrast** effectively or there is a **conflict** going on. **State why the combination of faces works** (look for the differences), **or state why it doesn't** (look for the similarities). [Ignore the words themselves—don't get wrapped up in whether the typeface is appropriate for its product, because that's another topic altogether. *Just look at the typefaces.*] If this is your book, circle the correct answers. (Answers on page 224.)

contrasts
conflicts

FANCY
PERFUME

contrasts
conflicts

show your pup the love in your
DOGFOOD

contrasts
conflicts

MY MOTHER IS THE BEST
This is an essay on why my Mom will always be the greatest mother in the world. Until I turn into a teenager.

contrasts
conflicts

FUNNY FARM
Health Insurance

contrasts
conflicts

let's**DANCE**tonight

Little Quiz #9: Dos and don'ts

Rather than give you a list of **do**s and **don't**s, I'm going to let you decide what should and should not be done. Circle the correct answers. (Answers on page 225.)

1 Do Don't Use two scripts on the same page.

2 Do Don't Use two moderns, two sans serifs, two oldstyles, or two slab serifs on the same page.

3 Do Don't Add importance to one typographic element by making it bolder, and to another on the same page by making it bigger.

4 Do Don't Use a script and an italic on the same page.

5 Do Don't If one face is tall and slender, choose another face that is short and thick.

6 Do Don't If one face has strong thick/thin transitions, choose a sans serif or a slab serif.

7 Do Don't If you use a very fancy decorative face, find another fancy, eye-catching typeface to complement it.

8 Do Don't Create a type arrangement that is extremely interesting, but unreadable.

9 Do Don't Remember the four basic principles of design when using any type in any way.

10 Do Don't Break the rules, *once you can name them.*

An exercise in combining contrasts

Here is a fun exercise that is easy to do and will help fine-tune your typographic skills. All you need is tracing paper, a pen or pencil (colorful plastic-tip markers are great for this), and a magazine or two.

Trace any word in the magazine that appeals to you. Now find another word in the magazine that creates an effective contrast with the one you just traced. In this exercise, the words are completely irrelevant—you are looking just at letterforms. Here is an example of a combination of three faces that I traced out of a news magazine:

The first word I traced was "Holiday." Once I did that,
I didn't even have to look at any more scripts or italics.
"JERSEY" has a very different form from "holiday,"
including being all caps. Then I needed something
small and lowercase and from a different category
than sans serif or script as a third face.

Trace the first word, and then make a conscious, verbal decision as to what you need to combine with that word. For instance, if the first word or phrase is some form of sans serif, you know that whatever you choose next won't be another sans serif, right? What *do* you need? Put your choices into conscious thoughts.

Try a few combinations of several words, then try some other projects, such as a report cover, a short story on one page with an interesting title, a newsletter masthead, a magazine cover or story spread, an announcement, and anything else that may be pertinent to you. Try some colored pens, also. Remember, the words don't have to make any sense at all.

The advantage of tracing from magazines is that you have an abundance of different typefaces that you probably don't have on your computer. Is this going to make you lust after more typefaces? Yes.

Does it Make Sense?

Is all this making sense to you? Once you see it, it seems so simple, doesn't it? It won't take long before you won't even have to think about the ways to contrast type—you will just automatically reach for the right typeface. That is, if you have the right typeface in your computer. Fonts (typefaces) are so inexpensive right now, and you really only need a few families with which to make all sorts of dynamic combinations—choose one family from each category, making sure the sans serif family you choose contains a heavy black as well as a very light weight.

And then go to it. And have fun!

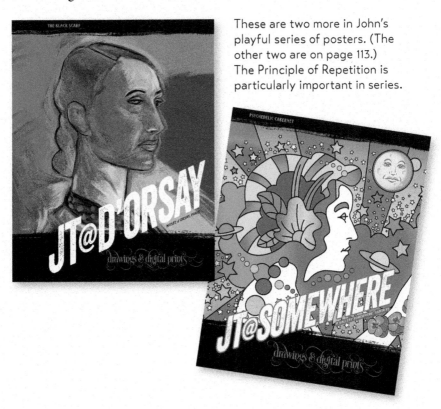

These are two more in John's playful series of posters. (The other two are on page 113.) The Principle of Repetition is particularly important in series.

typefaces
VENEER THREE
Stoclet Bold

The process

Where do you begin when you start to design or re-design something?

Start with the focal point. Decide what it is you want readers to see first. Unless you have chosen to create a very concordant design, create your focal point with strong contrasts.

Group your information into logical groups; decide on the relationships between these groups. Display those relationships with the closeness or lack of closeness **(proximity)** of the groups.

As you arrange the type and graphics on the page, **create and maintain strong alignments.** If you see a strong edge, such as a photograph or vertical line, strengthen it with the alignments of other text or objects.

Create a repetition, or find items that can have a repetitive connection. Use a bold typeface or a rule or a dingbat or a spatial arrangement. Take a look at what is already repeated naturally, and see if it would be appropriate to add more strength to it.

Unless you have chosen to create a concordant design, make sure you have **strong contrasts** that will attract a reader's eye. Remember—contrast is *contrast.* If *everything* on the page is big and bold and flashy, then there is no contrast. Whether it is contrasting by being bigger and bolder or by being smaller and lighter, the point is that it is different and so your eye is attracted to it.

An exercise

Open a newspaper, magazine, catalog, web page, theater program, old phone book, whatever. Find any advertisement that you know is not well-designed (especially with your newly heightened visual awareness). You won't have any trouble finding several, I'm sure.

Take a piece of tracing paper and trace the outline of the ad (no fair making it bigger). Now, moving that piece of tracing paper around, trace other parts of the ad, but put them where they belong, giving them strong alignments, putting elements into closer proximity where appropriate, making sure the focal point is really a focal point. Change the capital letters into lowercase, make some items bolder, some smaller, some bigger, get rid of obviously useless junk.

Tip: The neater you do this, the more impressive the result. If you just scratch it on, your finished piece won't look any better than the original.

Even though we all do our work digitally, if your piece is going to be in print, show the client the printed version. All too often I see work in print that I *know* looked good on the screen but then paper and ink got in the way. Print it up.

(And here's a trick I taught my graphic design students—whenever you have a client who insists on his own dorky design and doesn't want to think seriously about your more sophisticated work, make your rendering of his design a little messy. Spill some coffee on it, let the edges get raggedy, smear the pencil around, don't line things up, etc. For the designs that you know are much better, do them brilliantly clean and neat, print them onto excellent paper, mount them onto illustration board, cover them with a protective flap, etc. Most of the time the client will think—lo and behold—your work really does look better than his original concept, and since he is a VIP* (which you are no longer), he won't be able to pinpoint why his doesn't look so good anymore. His impression is that yours looks better. And don't you dare tell anybody I told you this.)

*VIP: visually illiterate person

Okay—redesign this!

Here's a little flyer invite that could use some help. A few simple changes will make a world of difference. Its biggest problem is the lack of a strong alignment, plus there are several different elements competing for the focal point. Use tracing paper to rearrange elements, or sketch a few versions right onto this page.

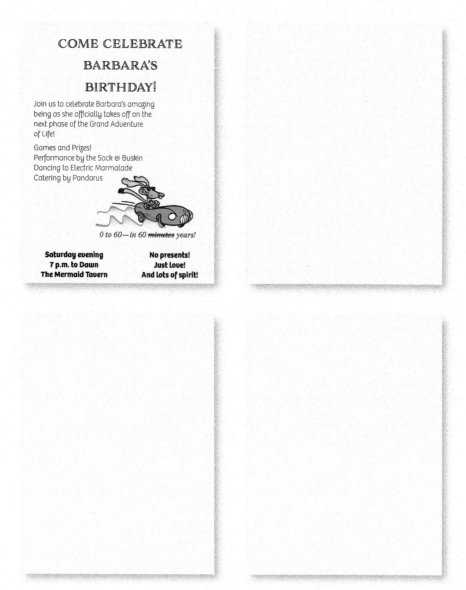

COME CELEBRATE

BARBARA'S

BIRTHDAY!

Join us to celebrate Barbara's amazing being as she officially takes off on the next phase of the Grand Adventure of Life!

Games and Prizes!
Performance by the Sock & Buskin
Dancing to Electric Marmalade
Catering by Pandarus

0 to 60—in 60 ~~minutes~~ years!

Saturday evening
7 p.m. to Dawn
The Mermaid Tavern

No presents!
Just Love!
And lots of spirit!

Answers & Suggestions

As a college teacher, all the quizzes, tests, and projects I give are "open book, open mouth." Students can always use their notes, they can use their books, they can talk with each other, they can talk with me. Having taken hundreds of college units myself, from a science major to a design major to a Shakespeare major, I learned that I was much more likely to *retain* the correct information if I *wrote down* the correct information. Rather than guessing and then writing down a wrong answer, the process of finding the correct answer on a test was much more productive. So I encourage you to bounce back and forth between the quiz and the answers, to discuss them with friends, and especially to apply the questions to other designed pages you see around you. "Open eyes" is the key to becoming more visually literate.

Listen to your eyes.

Quiz answers

Little Quiz #1: Design principles (page 90)

Remove the border to open up space.
New designers tend to put borders around everything. Stop it! Let it breathe! Don't contain it so tightly!

Proximity

The headings are too far away from their related items: move them closer.

There are double Returns above and below the headings: Take out all double Returns, but add a little extra space *above* the headings so they connect to the material they belong with.

Separate personal info from résumé items with a little extra space.

Alignment

Text is centered and flush left, and second lines of text return all the way to the left edge: Instead, create a strong flush left alignment where all heads align with each other, bullets align, text aligns, second lines of text align with first lines.

Repetition

There is already a repetition of the hyphen: Strengthen that repetition by replacing it with a more interesting bullet.

There is already a repetition in the headings: Strengthen that repetition by making the headings strong and black.

The strong black impression in the bullets now repeats and reinforces the strong black in the headings.

Contrast

There isn't any: Use a strong, bold face for contrast of heads, including "Résumé" (to be consistent, or repetitive); add contrast with the strong bullets.

By the way: The numbers in the new version use the "proportional oldstyle" form that is found in many OpenType fonts. If you don't have them, make the numbers a point size or two smaller so they don't call undue attention to themselves.

Little Quiz #2: Redesign this ad (page 91)

Process is on pages 92–93.

Little Quiz #3: Color (page 112)

1. analogous
2. complementary
3. tint
4. shade
5. CMYK
6. RGB

Little Quiz #4: Apostrophes (page 155)

1. It's
2. its
3. its
4. its
5. it's
6. it's
7. Mom 'n' Pop Shop
8. fishin'
9. '60s
10. cookies 'n' cream

Little Quiz #5: Categories of type (page 183)

Oldstyle: As I remember, Adam
Modern: High Society
Slab serif: The enigma continues
Sans serif: It's your attitude
Script: Too Sassy for Words
Decorative: At the Rodeo

Little Quiz #6: Thick/thin transition (page 184)

Giggle: B
Jiggle: C
Diggle: A
Piggle: A
Higgle: C
Wiggle: B

Little Quiz #7: Serifs (page 185)

Siggle: C
Riggle: A
Figgle: B
Biggle: D
Miggle: D
Tiggle: A

Little Quiz #8: Contrast or conflict (page 216)

Fancy Perfume: **Conflict.** Too many similarities: They are both all caps; they are about the same size; both kind of fancy; similar in weight.

Dogfood: **Contrast.** Strong contrast of size, color, form (both caps vs. lowercase and roman vs. italic), weight, and structure (although neither font has a definite thick/thin contrast in their strokes, the two faces are definitely built out of very different materials).

My Mother: **Conflict.** Although there is a contrast of form in the caps vs. lowercase, there are too many other similarities: same size, very similar weight, same structure, same roman form.

Funny Farm: **Conflict.** There is potential here, but the differences need to be strengthened. There is a contrast of form in the caps vs. lowercase, and also in the extended face vs. the normal face. There is a slight contrast of structure in that one face has a gentle thick/thin transition and the other has monoweight, extended letters. The biggest problem is a lack of focus: "Health Insurance" is larger, but uses a light weight face; "Funny Farm" is smaller but uses all caps and bold. Decide which phrase is the boss and emphasize it over the other.

Let's Dance: **Contrast.** Even though they are exactly the same size and from the same family (the Formata family), the other contrasts are strong: weight, form (roman vs. italic and caps vs. lowercase), color (though both are black, the weight of "DANCE" gives it a darker color).

Little Quiz #9: Dos and don'ts (page 217)

1. **Don't.** Two scripts will conflict with each other because they have similar forms.
2. **Don't.** Typefaces from the same category have similar structures.
3. **Don't.** They will fight with each other. Decide what is the most important and emphasize that item.
4. **Don't.** Most scripts and italics have the same form—slanted and flowing.
5. **Do.** You instantly have a strong contrast of structure and color.
6. **Do.** You instantly have a contrast of structure and color, but you will still need to work with it.
7. **Don't.** Two fancy faces will usually conflict because their fancy features both compete for attention.
8. **Don't.** Your purpose in putting type on a page is to communicate.
9. **Do.**
10. **Do.** The basic law of breaking the rules is to know what the rules are in the first place. If you can justify breaking the rules—and the result works—carry on!

Designer Eye suggestions

Page 12: Good Design is as easy as 1 2 3

Removed the border that was crowding the edges.

Used a stronger typeface whose bold has a bigger impact on the page (Principle of Contrast).

Repeated the bold to point out the three steps and repeated the light face to comment on them (Principle of Repetition).

Gave the text strong alignments (Principle of Alignment).

Separated the three steps so you can instantly see there are three of them, thus making it unnecessary to use the numerals (Principle of Proximity).

Page 19: Sally's Psychic Services

Title is larger.

The rest of the type is smaller.

The three services are on three individual lines.

Related elements are grouped together.

Capitalized the words in the email and web address so they are easier to read.

Got rid of the extra heart.

Got rid of the word 'available.'

Lightened the heart so it doesn't compete with the text.

Enlarged the heart and overlapped it with the text to integrate it.

Page 20: First Friday Club

The main text is smaller.

Title is larger, which can be done when the rest of the text is organized and smaller.

The information is organized consistently so the reader can find it.

Headings are bold using the Principle of Contrast.

A strong alignment is provided using the Principle of Alignment.

Page 23: Moonstone Dreamcatchers

Title is larger.

Corners are not so rounded.

Text is aligned.

Abbreviations are spelled out.

Bullets are used instead of commas.

Some text is gray so it interrupts the visual less.

The moon escapes out the top.

Page 25: Shakespeare Close Reading

The contact info is on separate lines—but grouped together and separated—so it will stand out as important information.

Deleted the words *phone, email*, and *web* because they are unnecessary.

Deleted the semicolon after the phone number and the last slash after the web address.

Made the page color a little brighter.

Made SHAKESPEARE lowercase so it is easier to read and can be set larger.

Cropped the photo wider.

Page 27: Gertrude's Piano Bar

Title is not all caps.

Gave Gertrude a nicer font for her menu heading.

Removed the underlines from the subheads.

Set the names of the dishes in bold and the descriptions in regular to help differentiate the information.

As mentioned, changed all caps to title case (initial caps in each word).

Page 30: Moonlight Inn

Move the bullets closer to the copy.

Provide at least a tiny bit of space between the photos to define them.

The body copy needs space between it and the photos.

The address and contact information need space to separate them from the photo.

The sides are crowded, yet there is lots of empty space at the top and bottom. The advantage for you here is that this gives you some flexibility in arrangement.

Tip on redesigning this ad: Get rid of the redundancies in the text.

Page 39: O ye gods

2. Centered arrangement actually looks centered, with varying line lengths.

Space between the lines is consistent within the quotation.

Typeface is not so large and horsey.

Typeface is lovely.

3. Interesting typeface.

Interesting graphic.

Centered alignment is clearly intentionally centered.

4. Strong and bold.

Black bar behind text and text is reversed out.

Appropriate ornament is used in a subtle way.

Page 45: Tri-State Wellness Ad

Enlarged the heading.

Englarged the logo leaves.

Made the horizontal spacing consistent.

Put the phone number at the top of each section to avoid trapping the white space inside the ad.

Changed the hyphens to periods in the phone numbers, which visually cleans it up a bit.

Spelled out "Appts."

Spelled out the addresses to get rid of those visually annoying period/comma combinations. Also used small bullets instead of commmas.

Made the space between the lines consistent, except for the HIV testing which they seemed to want to set apart to call attention to itself, which is a perfect use of the Principle of Proximity.

Made the outline of the ad a half point thinner to avoiding enclosing it so strongly.

Added the blue bar across the bottom.

Made the web address larger and used caps to make it easier to read.

Used a piece of the logo, enlarged and tinted, in the empty space.

Page 47: The Undiscover'd Country

Removed the border from the graphic.

Enlarged the graphic to fill the space better, aligning the left and right edges in this freeform case.

Justified the type in this instance, only because the columns are wide enough for that size of type to prevent big gaps between words.

Changed the indent to an em space (eg., 12-point type would take a 12-point indent, about two spaces).

Page 49: I Read Shakespeare

Set the headings in the same font as the title (Principle of Repetition as described in the following chapter). Also used the same color.

Removed the indent in the first paragraphs after the headings.

Made the paragraph indents an em space in width (width of the point size of the type).

Used the tabs and leaders to make sure the table of contents align instead of using a row of periods.

Enlarged the readers graphic and shaded it back to gray so it wouldn't compete with the headline.

Aligned the readers graphic with the top and bottom of the headline, plus the left column edge. Points and circles always extend a bit beyond the alignment edge as a response to the visual trick of appearing smaller.

Page 50: Pie as Art

Moved the text closer to the numbers (Principle of Proximity).

Changed "6" in the title to "Six" to prevent conflict with the numerals.

Englarged the title a bit.

Page 53: Fredrick Space Design

Enlarged the heading a bit so it aligns with the photo.

Grouped the subhead into closer proximity.

Maintained the strong right alignment on the bottom, which put the web address on its own line, which actually helps clarify the information.

Put caps in the web address so you can read it more easily.

Reduced the second logo in the bottom half a little bit so it stops competing with the one above.

Page 53: Happy Saddles

Is "Est. 2003" really worth all the space and attention it gets?

Do you really need to have a separate line stating "Horseback Riding"?

Put initial caps in that long web address to make it easier to read.

Can you shorten the line about "more information"?

Can you avoid those two blocks of black that make your eyes bounce back and forth between them?

Page 62: Pie wants to be shared

These things are repeated:

The headline font in the names of the workshops.

The serif font in the subhead and the footer.

The serif font as italic in each workshop.

The two colors.

The spacing between workshops.

The dotted rule.

The spacing between the dotted rules and the type.

Avoid amateur centered with font choice, spacing, appropriate clipart, no border.

Page 63: Dr. Sal and friends

The repetitive elements are:

The color of the green type.

The font for the green type.

The color of the white type.

The font and shadow for the white type.

The color of the shapes.

The overlap of various elements.

The style of the images.

Page 64: Yountville Seniors Radio

Repeated:

Two fonts.

Small caps.

Color of background in color of text.

Second color of blue (the complement of orange).

Copy text is aligned horizontally with the title text.

Page 64: Umbrellas & Charcoal

Repeated:

Dark maroon color.

Green color in bubbles.

Strong alignment of box with strong alignment of text.

Page 79: iRead rack card

Background is rich black (20 percent each of cyan, magenta, and yellow, with 100 percent black)

Title is larger.

Headline matches the logo font (Principle of Repetition).

Font uses the regular weight instead of the light weight so it will hold up better when reversed out of black.

The last two lines were split into three lines so it could be set larger.

Red dotted line repeats the red of the logo.

Took one point out of the main body text linespacing to create more space between the elements.

Widened the text block a little so the last line of the main body would be one complete sentence.

Broke the headline at a more appropriate place.

Page 81: Hugs Pie Shop

Changed the border to a thinner line (a half point).

Changed all caps to caps and lowercase.

Deleted unnecessary information such as "telephone" and the zip code and area code since this is a local ad in a local paper, allowing it to be set larger.

Enlarged the pie and let it float, after using Photoshop to make the background transparent.

Arranged the types of pies to fit the space better.

Aligned most of the copy on the left; some elements align on the right.

Repeated the shop's favorite phrase in the shop name's font.

Set the shop's favorite phrase on a curved line.

Moved the phrase "a pie gallery" into the headline because the shop does have a gallery of pies as art.

Page 82: Sally's Psychic Services

Got rid of Times New Roman: Replaced the heading with a script and the rest of the text with a sans serif.

Added the dark purple bar.

Pulled in the dark purple to appropriate lines in the bold sans.

Removed the light purple background to increase the contrast.

Reduced the size of the heart so it doesn't interrupt the text so much.

Raised the heart to open the white space.

Page 142: Dentist:

2nd ad: Set SMILE in lowercase.

Changed the headline to roman instead of italic.

Deleted the odd graphics that seem to just fill the space randomly.

Set the name and other three lines in lowercase so they could be larger.

Removed one of the "Emergencies Welcome."

Deleted the random graphics.

3rd ad: Added contrast in the black bars.

Brought the text blocks closer together so the white space is more organized.

Got rid of the odd bits of space above and below and to the side of the photo.

Typefaces in this Book

There are more than three hundred fonts in this book. When someone tells you there are "a certain number" of fonts, they usually include all the variations of one font—the regular version is a font, the italic is another, the bold is another, and so on. Since you are (or were) a new designer, I thought you might be interested in knowing exactly which ones were used in this book. In the list of fonts, the numbers indicate pages where the fonts are used.

Primary faces

Main body text:	Arno Pro Light, 11.3/14.25 (which means 11.3-point type with 14.25-point leading).
Chapter titles:	Archer Medium, 36/30
Main heads:	Archer Semibold, 20/22
Captions:	Transat Text Standard, 9.5/11.5
Cover:	Verlag Light, Extra Light, and Verlag Black

Modern (14 point)

Bauer Bodoni Roman 83, 177, 191, 196, 197, 199

Bodoni Poster 191

Bodoni Poster Compressed 175, 177, 196

Bodoni SvtyTwo Book Italic 202

Didot Regular 177, 183

Didot Bold 177

Madrone 187

Modern No. 20 177, 185

Onyx Regular 169, 207

(Berthold) Walbaum Book Regular 177, 184, 185

Times New Roman Bold 12, 196

Oldstyle (14 point)

Ornaments (18 point)

Adobe Wood Type Ornaments Std, 119

Adobe Wood Type Ornaments Two, 171

Adorn Ornaments, 181

Backyard Beasties, 126

Birds, 1, 2

Script (14 point unless noted)

Decorative

Mini-glossary

The **baseline** is the invisible line on which type sits (see page 186).

Body copy, body text, or sometimes just plain **body** or **text** refers to the main block of text that you read, as opposed to headlines, subheads, titles, etc. Body text is usually set between 9- and 12-point type with 20 percent added space between the lines.

A **bullet** is a little marker, typically used in a list instead of numbers, or between words. This is the standard bullet: • .

A **dingbat** is a small, ornamental character, like this: ❏ ❖ ✓ ✍ ❀. You might have the fonts Zapf Dingbats or Wingdings, which are made up of dingbats.

Extended text refers to the body copy (as above) when there is a lot of it, as in a book or a long report.

Eye flow, or your **eye,** refers to your eyes as if they are an independent body. As a designer, you can control the way someone moves her "eye" around a page (the eye flow), so you need to become more conscious of how *your* eye moves around on the page. Listen to your eyes.

Resolution refers to how well an image appears to be "resolved"; that is, how clear and clean it looks to us. It's a complicated subject, but here is the gist:

Printed pages: Generally, images that will be printed on paper need to be 300 dpi (dots [of ink] per inch) at the size they will be printed. Always check with the press that will print the job to find out what resolution they want. To get a 300 dpi image, use your image editing application (such as Photoshop) to resize the image *to the size it will be when printed,* and make it 300 ppi (pixels per inch).

For print, use **.tif** images, 300 dpi, CMYK color mode.

Screen pages: Images on the screen are generally sized at 72 ppi (pixels per inch). These will look perfect on the screen, but crummy when printed. Use your image editing application (such as Photoshop) to resize the image *to the size it will appear on the screen.* This means if you

have a thumbnail image linked to a larger image, you need *two* separate files of the same image!

For screen, use **.jpg** images, 72 ppi, RGB color mode.

A **rule** is a line, a drawn line, such as the one under the headline "Mini-glossary," above.

White space is the space on a page that is not occupied by any text or graphics. You might call it "blank" space. Beginners tend to be afraid of white space; professional designers use lots of white space.

Trapped white space is when the white, or blank, space on a page is trapped between elements (such as text or photos), with no space through which to flow.

Resources

Before & After Magazine
BAMagazine.com
 This is one of the most valuable resources you can get. Subscribe to the online magazine to discover hundreds of amazing design tips that can change your world.

 Join John McWade's forum called *The Grid* to talk with other designers and get terrific feedback and help on your projects. **mcwade.com/TheGrid**

CreativeMarket.com: This is like Etsy.com for designers, where you can buy terrific assests inexpensively—fonts, templates, images, and so much more.

Canva.com: Design projects online and print or post them! Canva includes lots of design help for new designers.

InDesign PDF Magazine: InDesignMag.com for InDesign users, of course!

MyFonts.com: Affordable fonts.

FontSquirrel.com: Affordable & FREE fonts.

CreateSpace.com: Publish your own book and it's for sale on Amazon.

CafePress.com and Zazzle.com: Create your own product.

PrintPlace.com: My personal favorite online printing source.

Index